# AUSTRALIA

*A Photographic Journey*

TEXT: **Ian Jarrett**

CAPTIONS: **Fleur Robertson**

DESIGNED BY: **Teddy Hartshorn**

PRODUCTION: **Ruth Arthur**

DIRECTOR OF PRODUCTION: **Gerald Hughes**

CLB 2999
© 1992 Colour Library Books Ltd., Godalming, Surrey, England.
All rights reserved.
This 1992 edition published by Crescent Books,
distributed by Outlet Book Company, Inc., a Random House Company,
40 Engelhard Avenue, Avenel, New Jersey 07001.
Printed and bound by Graficromo s.a., Cordoba, Spain
ISBN 0 517 07349 8
8 7 6 5 4 3 2 1

# AUSTRALIA

## *A Photographic Journey*

## Text by
## IAN JARRETT

## CRESCENT BOOKS
### NEW YORK

As I sit writing these words in Fremantle, Western Australia, the office workers are leaving the old colonial buildings in Phillimore Street to head home to enjoy the last of the day's sunshine. It has been another warm, balmy day in Western Australia, with the state's top temperature of 116 degrees being reached in the Pilbara iron town of Goldsworthy.

Along the Fremantle waterfront, the crews of the 39-feet yachts, sunburned, disheveled and exhausted, are returning for another day's practice in preparation for the world fleet championships being sailed in the choppy waters of the Indian Ocean. At the Lombardo's restaurant complex, squeezed among the brightly-painted fishing boats at the water's edge, the early diners are looking at menus and choosing between local blue manna crabs or the dhufish. In the colorful gold town of Kalgoorlie, 370 miles from Perth, miners in shorts and heavy boots head for the Boulder Block Tavern to swill the red dust out of their throats with glasses of ice-cold Swan lager.

Across the country, 2,700 miles away in Sydney, a noisy, excited crowd is engrossed in a game of cricket. It is 8 pm in Sydney, and those not screaming encouragement at the Sydney Cricket Ground are moving into the city center for the evening's entertainment, perhaps in the fascinating Rocks area, birthplace of the nation, or maybe at a smart restaurant overlooking the harbor. What has happened in Sydney today? The evening paper carries a story on severe summer storms which brought hail across a wide area of the city.

On the Gold Coast, in the south east corner of Queensland, the pace is quickening at the Conrad International Hotel and Jupiters Casino as casually-dressed gamblers chase fortunes on the blackjack tables. By now, the sun has set over Ayers Rock in the Northern Territory, the stockmen are pulling off their boots after another arduous day, bedtime stories are being read to the children of the outback, the traveling carnivals are luring remote communities with their bright lights, and the nighttime cover is being pulled over this incredible country.

Tomorrow, the great Australian adventure will begin all over again, but now it is time for the country to count its blessings. Ruggedly beautiful, romantic and mineral-rich. Untamed, unsullied and unlimited in its ability to surprise and stimulate. The gold diggers and the grape pickers, the business tycoons and the cray fishermen, the wheat farmers and the sheep-shearers, the dockside workers and the iron-ore miners, all are united in believing that they have been given a special place on this earth in which to pursue their dreams.

Australia is a large and complex land of 3 million square miles, supporting a population of 16 million, 70 percent of whom live in the five mainland state capitals of Sydney, Melbourne, Brisbane, Perth and Adelaide. Lucky is the man, if he exists, who can say that he has seen all of Australia. Most of us merely peep behind the curtain here and there, and become more enchanted with each new discovery. Like the Europeans who came freely to Australia, or were transported there in convict ships some 200 years ago, the modern-day adventurer feels a compulsion to go on in search of the myriad, sometimes mystical, experiences which this ancient continent has to offer.

Australia can be the sight of Sydney Harbour Bridge and the Opera House in early morning from the bow of the Manly ferry. It can be the awesome isolation of a 100,000 acres Queensland cattle station, where the nearest neighbor might be 250 miles away. It can be an abandoned gold town in the rust-colored outback of Western Australia, where corroding machinery and long-discarded beer bottles evoke memories of the leathery old men who tried to dig dreams out of the dirt. It can be the spectacular Ayers Rock sunset, listening to Aboriginals' tales of their ancestors. It can be the sight of buffalo on the Marrakai Plains, Northern Territory, or crocodiles on the South Alligator River. It can be the little alpine village of Banjo Paterson's "Man from Snowy River" country, breathing the pure, cool air 4,500 feet above sea level. The list goes on, and for every settler, every visitor, there is a special memory, a moment frozen in time, a personal experience to be locked away and cherished.

No-one should think they have been to Sydney or Melbourne or the Gold Coast and seen Australia. Not when they haven't cruised the Murray Riverina region in New South Wales, or slept under the stars at Waterfall Creek in Kakadu National Park, Arnhem Land, or experienced the wilderness of the Franklin River National Park in Tasmania.

Yet, as beautiful and beguiling as these places are, they are just sweeps of the brush on the extraordinary canvas that is Australia. It is a land of richness and breathtaking contrast. A land of wildflowers, like the kangaroo paw, bachelor's button, mountain eyebright and spider orchid. It is a land of birds, like the blue-winged kookaburra, Albert lyre bird, Major Mitchell cockatoo, Regent bower bird, dancing brolga and spangled drongo. It is a land of mammals and reptiles, like the saltwater crocodile, thorny devil, tiger snake, koala, camel, wild buffalo and kangaroo.

It is the land of the spectacular, like Katherine Gorge, a magnificent river canyon in inland Australia, and Ayers Rock, 500-600 million years old – a giant red gemstone rising 1,142 feet above the plain from a 5-mile circumference. It is a land of strange-sounding places: Humpty Doo, Coober Pedy, Smiggin Holes, Barrow Creek, the Bungle Bungles and Mudgeeraba. It is a land of legendary people, bushrangers like Ned Kelly, Mad Dan Morgan and Captain Moonlight, whose spirit, if not their lawlessness, lives on today in a population which has had to battle hard to establish its new frontiers.

Two hundred years after the arrival of the first settlers, the task today for its cosmopolitan population – immigrant Greeks, Turks, Slavs, British, Italians, Vietnamese and Dutch – is to take the baton and keep the country moving away from parochialism, and towards proud and purposeful unity.

## WESTERN AUSTRALIA

Western Australia, the biggest of all the states, occupies a third of the continent's land mass, sprawling over more than 1.6 million square miles and several climate zones. If many people – and I am including Australians – find it hard to comprehend the vastness of the country, then they are equally staggered by the size of Western Australia. You can fly for three hours in a modern jet and still be over Western Australian soil; you can drive for days and still be inside the state's boundaries. Superimposed on a map of Western Europe, Western Australia would stretch north to south from Oslo to Madrid and east to west from Dublin to Milan. Or, to draw another comparison, it is three and a half times bigger than Texas. This is the scale of Western Australia. And yet little more than 1.4 million people populate this enormous area, and just over a million of them live in the state capital, Perth.

The tyranny of distance has made Perth the most isolated capital in the world. Adelaide, its nearest big city neighbor, is 1,056 miles to the east on the other side of the vast emptiness of the Nullarbor Plain. To the west is the great expanse of the Indian Ocean. To the south, the Southern Ocean, next stop Antarctica. And to the north, several thousand miles away, Indonesia. Perth is as close to Singapore as it is to the eastern gateway of Sydney, where Australia's founding fathers stepped ashore to colonize New Holland.

While this isolation has inherent disadvantages, it has had its benefits, too. Western Australia's flora and fauna, hemmed in by the natural barriers of sea and desert, have evolved in an environment unaffected by outside influences. Thus, many of its 8,000 or so varieties of wildflowers are unique to the state, most of them to the southwest corner. They have been given exquisitely appropriate names: the long-stemmed green and red kangaroo paw (Western Australia's floral emblem); the delicate spider orchid; the appealing donkey orchid; the rare carnivorous Albany pitcher plant. There are many, many more and in spring they carpet the countryside in a riotous floral rainbow, a canvas that applauds Mother Nature's handiwork.

Then there are the forests of karri and jarrah – among the world's most durable hardwoods and again unique to this botanic wonderland. The karri is

a tree of immense beauty, growing up to 300 feet high, with up to a twenty-foot girth. In the lush underworld below the green canopy are many rare animals and birds. You might be lucky enough to catch a glimpse of the numbat, a member of the marsupial family. This shy and reclusive creature, with its distinctive black and white stripes and long tail, is nowadays confined to a couple of relatively small areas of forest.

Visiting this "Garden of Western Australia" quickly destroys the popular overseas misconception that Australia is a barren, sunburnt land, a harsh and unforgiving environment covered in little more than spinifex. Here, in the southwest corner, is rolling countryside as green and lush as you will find in Virginia. There are fast flowing streams where you can fly-fish for rainbow trout; tranquil valleys covered in ferns and shrouded in mist; fruit-laden orchards; rugged mountains providing panoramic views of fertile farming land.

Here, too, are vineyards producing premium quality wines which have won world acclaim; quaint forest towns at Pemberton and Manjimup; coastal resorts like Dunsborough, Yallingup and Denmark; spectacular, rugged granite cliffs presenting a rampart to the pounding Southern Ocean rollers, and secluded, white sandy beaches. These are just some of the striking images and not-to-be-forgotten experiences awaiting the visitor.

For a sharply contrasting image take a trip some 370 miles east of Perth to the gold mining town of Kalgoorlie. "Kal', as it is affectionately known by the locals, was created in the heady, turn-of-the-century gold rush boom which injected new life into the colony. The population of Western Australia doubled every five years following Irishman Paddy Hannan's gold discovery in the early 1890s. There were 100-plus mines within the area, then measured as the richest square mile on earth. In the fevered Kalgoorlie of that time, before the pipeline from the coast was built, water cost $6 a gallon and French champagne 20 cents a bottle.

In the 1970s, when gold prices plummeted, Kalgoorlie's heartbeat slowed just as dramatically. But, with the resurgence of gold's value, the town's pulse quickened and, having learned hard economic lessons from the slump, it is again a prosperous and thriving community. Major new discoveries have been made, and previously uneconomical mines have been brought back into operation.

"Kal', with its wide streets and old-style hotels (it once boasted a hotel on every corner), today retains the romance and atmosphere of the early boom days. At the Hainault Tourist Mine you can actually see how gold was originally mined. There are displays of old and new mining techniques, as well as of gold-pouring. Well worth including in any visit to the goldfields is the nearby town of Coolgardie, which has been preserved as a monument to the good ol' days. Others, like Gwalia, Broad Arrow and Orra Banda, have become ghost towns.

Two-up, a traditional Australian form of gambling, is another of Kalgoorlie's big drawcards. Until recently illegal, two-up has been played in the bush outside the town for years. The police mostly turned a blind eye to the game (as they do to the town's four brothels), occasionally launching raids to keep up appearances. Despite being given legal status, in Kalgoorlie alone, the game is still played in the same tin-roofed venue 5 miles from town. Today, too, women are allowed to participate.

In the tropical far north of Western Australia the countryside and scenery change yet again. This area has been described as the last frontier, a sparsely populated wilderness region which has still to be explored by many Australians, let alone by the wider world. Minerals, which have played such a crucial role in Western Australia's development, thrust the Kimberley region onto the international stage when the world's biggest deposits of diamonds were discovered there in 1981. This is a land of great physical beauty – table-top mountains, rugged gorges, towering waterfalls and stunning coastal scenery. Close to the Northern Territory border is a geological wonder which has been

rediscovered in recent years. The Bungle Bungles are a haunting moonscape of soft sandstone weathered over millions of years to form dome-shaped, bee-hive mountains.

Man has also contributed to the physical grandeur of the area. The Ord River was dammed in the 1960s in a bold bid to provide irrigation water for pioneering farmers. The lake this created, Lake Argyle, holds nine times the water of Sydney Harbour. It has become a popular water playground for increasing numbers of tourists.

There is only a handful of towns in the remote Kimberley. Broome is the most flamboyant and fascinating. In the 1900s the town was the pearling capital of the world, and attracted a polyglot population – Malays, Chinese, Japanese, Indonesians, Filipinos and Europeans. Many of their descendants still live in Broome, though these days it is tourism which has become the major industry following the decline in demand for pearls.

Broome has a tropical, exotic atmosphere with many oriental landmarks to remind you of its colorful, multi-cultural heritage. Mangrove swamps and beautiful beaches enhance the town's charm and appeal, as do the extraordinary tides which leave vessels marooned like beached whales as the water recedes almost to the horizon.

Southwest of the Kimberley is the Pilbara, Western Australia's "red heart', where men and machines mine mountains of iron ore in the Hamersley Range. The Hamersley Range is famous also for its magnificent gorges around the inland town of Wittenoon, once an asbestos mining center. Here, over millions of years, rivers have sliced through the soft rock like a wire cheese cutter, leaving chasms of sheer rockface hundreds of feet deep.

Further south, in the neighboring Gascoyne region, is Exmouth, a renowned game-fishing center, where you can test your skills against marlin, Spanish mackerel and a host of other fighting varieties. Several hundred miles inland is Mount Augustus, the largest monolith in the world, twice the size of Ayer's Rock. Further south is Shark Bay, where a family of dolphins regularly comes into the beach to be hand-fed by excited tourists wading in the shallows.

Southbound again and we arrive in the Mid West, a region of fertile farmlands, historic mining towns, stunning coastal cliffs and river gorges, and the Houtman Abrolhos Islands, graveyard to many ships which foundered on the reefs as early as 1629. These same reefs today provide a rich harvest of rock lobster which titillate the palates of gourmets in Japan, Europe and North America.

Now we are back in Perth, surely one of the world's most visually beautiful modern cities, basking in an average of eight hours sunshine daily throughout the year. Perth is a sparkling jewel, its skyscraper towers shimmering in the waters of the majestic Swan River as the waterway flows past the city doorstep to the port city of Fremantle. Perth is pollution free, with clear blue skies, refreshingly clean air, wide, tidy streets and a river which has not been tainted by industrial waste. It is a magnificent aquatic playground that is jealously protected by the locals, who go there to swim, water-ski, sail and fish.

It is not hard to see why the inhabitants are so proud of their flourishing, wealthy city. Modern five-star hotels, a casino, oceanside leisure complexes, art galleries, entertainment centers and a thriving commercial and retail heart are evidence of Perth's growing maturity as an international city. In terms of distance, Perth is isolated, but it is very much a city keeping pace with the outside world. International airlines and modern communications have seen to that.

It has been said that Perth is one of the world's best kept secrets, but the America's Cup, yachting's premier trophy, prized open the doors to reveal her blue-watered brilliance.

SOUTH AUSTRALIA

First, a curious fact which always surprises me about South Australia. It is the driest state in a continent not noted for its rainfall. I have always found that hard

to accept when strolling down King William Road and across the River Torrens towards the Adelaide Oval cricket ground. But, beyond the parks and gardens and the churches and well-ordered residential areas, are vast expanses of unpopulated arid desert – an alien land which serves to highlight Adelaide's coastal greenery.

Adelaide is an oasis of culture, fine wine, food and fun – an understated city of subtle tones, beautiful churches, calm and conservatism. The days when its staidness was a bit of a joke among the brasher Australians of Sydney and Brisbane have disappeared as Adelaide has built on its best features to reach a point today where many of its attractions, including its new casino in the old railway station, are envied throughout the rest of the country.

The Festival Centre, overlooking the River Torrens, has managed to achieve the near-impossible and equal Sydney's wonder-of-the-world Opera House. The complex, whose final stage was opened by the Queen in 1977, combines a 2,000-seat concert hall, two smaller theaters, an outdoor amphitheater and a huge plaza displaying the largest outdoor work of art in Australia – the dramatic sculptures of West German artist Otto Hajek.

If Otto's ambitious art is something of a shock when seen for the first time, you can always take yourself down to the riverbank, perhaps to hire a pedal boat, while you work out what it all means. And if you're still not sure, then you could lose yourself watching the spider monkeys in Adelaide Zoo, or stroll along Hindley Street among the restaurants and slightly naughty night clubs, where the city tries to throw off its maiden-aunt image.

Adelaide is a stroller's city. You walk a bit, stop a while, munch a sandwich in the park, stretch out around the water, close your eyes and let the bustle of the Rundle Street shopping mall fade into the background. Relaxation comes quickly, and when you open your eyes again it might be time to peep behind Adelaide's green-sleeved city and look towards the hills where another, different world emerges among the pleasant, English-style countryside.

Mount Lofty, a gentle half-hour drive from the city, rises 2,297 feet and gives a splendid view over Adelaide, particularly at night from Windy Point. Up here, among the rainbow-colored parrots, the air is freshly scented with forest flowers and the lingering salt-water breezes of the ocean. Up here, too, tucked away in the folds of the hills, are the little European-style villages where Italian and German traditions flourish strongly, seemingly held in a time warp, oblivious to the twentieth-century bustle of the big city just down the road.

Further away, to the northeast of Adelaide, is the Barossa Valley, where much of Australia's wine is produced. There are now vineyards and wineries in every state and mainland territory of Australia – even in the Northern Territory around Alice Springs – but for consistency and quality it is hard to match the wines of South Australia and the Hunter Valley in New South Wales.

In the Barossa Valley and in the Clare Valley, in the McLaren Vale, south of Adelaide, and in the rich red "terra rosa" volcanic soils of Coonawarra, wines of outstanding quality are produced, and are being acclaimed as such throughout the world. Along the Murray River, downstream from the South Australia-Victoria border, the Riverland area – which includes the towns of Renmark, Berri, once a sheep-station but now a center for fruit juice and dried fruit production, Loxton, Waikerie and Morgan – produces around 38 percent of Australia's grapes.

But it is the Barossa Valley, where more than 30 wineries are squeezed into an area some 25 miles long and between three and seven miles wide, which attracts the most interest. First settled in the 1840s by German immigrants driven out of Prussia and Silesia by religous persecution, the Barossa (originally spelled Barrosa – Hill of Roses) soon established itself as exceptional wine-growing country.

Today you almost expect to see the Rhine River flowing past, so strong is the German influence in the region. The food here is mettwurst and blutwurst and sauerbraten, the music is Bavarian brass and the vineyards themselves have

names like Krondorf, Kaiser Stuhl, and the more recently founded Wolf Blass. Bethany was the first German settlement in the valley, although Tanunda is, today, the most German of the valley towns and some of the early settlers' cottages remain in the Ziegenmarkt – Goat Square.

Further north beyond the Barossa, past the vineyards and the orchards, the spectacular Flinders Ranges give way to South Australia's arid heart – mile after mile of inhospitable, flat scrub country. It was here that the late Donald Campbell attempted a land speed record – on a lake. This was possible as, apart from the rare occasions when it is in flood and becomes a dangerous inland sea, Lake Eyre is a dry, salt-pan wilderness.

The South Australian outback includes much of the Simpson Desert, prohibited Aboriginal reserves, and the opal-mining settlements of Coober Pedy and Andamooka, where residents live underground to get relief from the extreme temperatures.

Australia is a contrast of climates and colors and landscapes, and in South Australia the differences come into even sharper relief. Away from the rocky, red-hot interior, the state can offer Australia's greatest river, the Murray, as it flows its last 400 miles to the sea.

From Waikerie, gateway to the Riverland, the Murray winds its way through vineyards, orchards, wheatfields, market towns, picnic areas and eucalyptus trees before flowing into Lake Alexandrina and finally disappearing into the Southern Ocean near Goolwa.

South of Adelaide, as the hills extend towards the Fleurieu Peninsula, there is another facet of South Australia. Saw-tooth rocks, buffeted by the high waves of the Southern Ocean, little bays and hidden inlets, steep cliffs and surfing beaches provide a magnificent seascape. This is the coast where the whalers once plied their trade, and where smugglers brought their illicit cargoes ashore before moving the contraband to Adelaide. Inland, there is the productive wine-growing region of the Southern Vales, while out to sea is Kangaroo Island – named by Matthew Flinders but first charted by the French explorer Nicholas Baudin. Around 90 miles long and 20 miles wide, Kangaroo Island is the third biggest island in Australia and – although it is little more than 60 miles from Adelaide – its isolation has allowed natural, rugged beauty and native wildlife to survive unspoiled.

This, then, is South Australia: the festival city of Adelaide; the paddle-steamered splendor of the Murray and the grape-strung richness of the Barossa; the desert mountain beauty of the Flinders Ranges and the harsh expanses of the interior. A State of dramatic and dazzling variety.

NORTHERN TERRITORY

The Aboriginal races have lived in Australia for tens of thousands of years, driven to a strange new land from southeastern Asia to roam a harsh, eerie, unfamiliar desert landscape. There is nowhere in Australia where the Aboriginal spirit lives on as it does in the Northern Territory, a vast untamed region of giant monoliths, lost canyons, gorges, rare animals, dancing birds, contrasting colors and staggeringly-beautiful sunrises and sunsets.

The Northern Territory covers more than 0.8 million square miles and is five times as big as Britain, four times as big as Japan and twice the size of Texas. A quarter of its 143,000 population are Aboriginal and this is their land – the land of the Dreamtime.

Dreamtime is the time before time. The time even before the Dreaming, the Aboriginal's spiritual understanding of all that he knows, of all that has been passed on to him since birth.

This is the land of legends and myths, and to cross the Northern Territory from the Red Centre to the Top End, the tropical north, is to pass through time itself. It is a silent, mystical world of sacred caves containing ancient tribal art; of unexplored, burning desert; of meteorite craters and tropical glades, billabongs and lagoons. Man has been here for around 50,000 years, but the Red

Centre remains majestically aloof, awesome in its power to swallow up the senses and store its secrets in the desert dust. Only nature has the capacity to change things here. Man can but come and look and learn and be humbled.

Here the Aboriginals tell their Dreamtime tales, of the old blind woman Mundungkala, who burst through the earth's surface bearing the tribes in her hands. In the darkness she created the dawn of man by scattering the figures across the flat earth. The wind, the rain, the stars, the birds and the animals provide the source of these myths, which helped to establish and preserve the nomadic Aboriginal way of life.

There is the legend of Tiddalik, the giant frog, who awoke one morning with a raging thirst and drank all the fresh water, turning the tropical green center into the arid heart of Australia. With the other animals in despair, the eel, Nabunum, began to dance and when Tiddalik laughed, water flowed out from his mouth to replenish the lakes and rivers.

Another legend explains how a girl who loved dancing was saved from the north wind by two spirits from the lake who transformed her into a brolga, a showy, long-legged bird whose remarkable courtship dance is still one of the wonders of outback Australia.

Today's dreamers come in the air-conditioned luxury of Australian Pacific coaches, or barrel along in Japanese four-wheel drives, or sway through the sand dunes on camels ($50 a day, unlimited mileage), absorbing some of the mysticism and spirit of the Never, Never Land. They follow in the footsteps of the great explorers like John McDougall Stuart, John Ross, Ernest Giles and the pastoralists, railway workers, telegraph line men and miners who fought their way across this harsh, unrelenting land. At Chambers Pillar, a giant sandstone monolith, the names of these early explorers are scratched into the soft rock. Names like John Ross, the second explorer to cross the continent from south to north during the 1870 route-planning expedition for the Overland Telegraph Line, and W.M. Hayes and Mrs Hayes, who came this way in 1889.

The early explorers were followed by the miners who came north from South Australia in search of rare gemstones. The rubies they were looking for turned out to be garnets, but those who stayed began searching for gold. In 1887 they found alluvial deposits at Arltunga and, ten years later, reef gold was discovered in the nearby White Range. By the early 1900s, their dream – like the dreams of so many others in this strange land – disappeared, but today the old gold town at Arltunga, two hours drive from Alice Springs, has been restored and declared an historic reserve.

Alice Springs itself remains the heart of the Red Centre. Cradled at the foot of the MacDonnell Ranges, the town was founded by William Whitfield Mills in 1871 while he was surveying a route for the Overland Telegraph Line. He chose a dry river bed as the site for a telegraph repeater station and named it in honor of Sir Charles Todd, the South Australian Superintendent of Telegraphs. The nearby waterhole was named after his wife, Lady Alice.

Today's Alice might not be the New Yorkers' idea of sophistication, but in a land older than civilisation itself, the town is an oasis of comfort and charm and the unexpected. Just like the pioneers one hundred years ago, today's residents have learned to adapt to their environment. They even hold the Henley-on-Todd regatta here – in a dry river bed. The boats are bottomless and the crews stand inside. No one has to worry about wind shifts or sailpower as they scamper to the finishing line.

Here, perhaps more than anywhere else in Australia, the outback people have developed a grim humor and bold eccentricity for their situation. Their isolation is accepted and their fortitude has been passed down by the early explorers, many of whom now rest in the Old Pioneer Cemetery in George Crescent and the Alice Spring Cemetery in Memorial Drive. In the latter is the grave of Harold Lasseter, who died in the desert in 1931 while searching for "Lasseter's Lost Reef" of gold.

Memories of those dramatic early pioneering days are recorded in Alice at

places like the Old Timers' Museum on the Stuart Highway, the John Flynn Memorial Church and the Adelaide House and Radio Hut, where Australia's first Inland Mission Medical Centre opened in 1926. Here, too, is the home of the Royal Flying Doctor service, the brainchild of John Flynn, without which the people of the vast outback region of Australia would not be able to survive.

Yet for most visitors the biggest single attraction of the Red Centre remains the awesome sight of Ayers Rock, rising like a red shrine from the desert plain and mulga woodland of Uluru National Park. The Rock and the nearby Olgas are the peaks of otherwise buried rock masses which hold spiritual significance for the Aborigines of the Yankuntjatara and Pitjatjatjara tribes. Much of Central Australian Aboriginal mythology can be found in rock paintings and sacred sites which are now protected by the national park authorities. An Ayers Rock sunrise or sunset, when the colors of the sandstone change magically, is one of the greatest visual and spiritual experiences available to man.

Nineteen miles away, the Olgas appear from the distance like giant marbles, arranged roughly in a circle rising up from the plain. This natural phenomenon – together with places like Standley Chasm, sheer cliff walls with an average width of fissure of around 16 feet – provide the traveler with breathtaking views.

Further north, in the Tablelands between the Centre and the Top End, past Barrow Creek (population eleven), is the gold-mining town of Tennant Creek, where in the 1920s men tried to hammer and chisel their fortunes out of granite outcrops. The Eldorado, largest of the early mines, closed down in 1958 after producing around 6,125 ounces of gold.

At Kakadu National Park, 140 miles east of Darwin, there are some superb examples of Aboriginal art at Nourlangie Rock and Obiri Rock. The Jim Jim Falls (a 705-foot drop) and the Twin Falls are spectacular sights in an area of outstanding scenery.

Humid Darwin, bombed by Japanese planes in 1942 and devastated by the 155mph winds of Cyclone Tracey on Christmas Day, 1974, has shown its resilience by bouncing back as a bustling, cheerful tropical city. Darwin, one of the heaviest-drinking cities in the world, is the home of an annual boat race in which the craft are constructed entirely of beer cans. A condition of entry is that all the cans' contents must have been previously consumed by the crews.

Outback Australia is altogether a story about survival. The Aborigines who came and hunted for food, the explorers who came to unravel its secrets, and the stockmen, the drivers and the miners who followed the trail, have been united in their determination to accept the rigors and come back for more.

It is a bewitching wilderness. A land of the fearless and the foolhardy, the dreamer and the divine.

VICTORIA

Victoria ... the Garden State, but also, surely, the state of adventure, of fashion, good food and elegance.

Victoria's 172,402 square miles lie at the southeast corner of the Australian continent. It is the smallest of the mainland states, making up less than three percent of Australia, but here, they will tell you with pride, it is quality and not quantity that counts. The climate may not be as good as it is on the west coast, but then a quarter of all people in Australia have decided that Victoria's forested mountains, wild coastline, rolling wheatlands and prosperous city living more than make up for the odd bout of inclement weather.

Victoria – and especially Melbourne, with its grand architecture – is outwardly more conservative than other Australian states, but don't be deceived, because under the cloak of formality is a vibrant, cosmopolitan world of high finance, fashion, carnival and good living. European in appearance, Melbourne – named after Queen Victoria's first prime minister – reflects the character and heritage of more than one hundred different cultures, brought here by people who have made their own special contributions to the style and

pace of the city.

Gold first brought the migrants to Melbourne, and those who struck it rich in nearby fields began to build for themselves a city which would reflect their prosperity. In the 1880s, "Marvellous Melbourne" was the place to be. The planners responded to the excitement of the era by designing on a lavish scale. Parks, gardens, wide boulevards and ornate architecture secured the city's future as the capital of stylish living.

It did not take long for the manufacturers, financiers and entrepreneurs to make their mark, and the foundations for long-term prosperity were laid. Today, Melbourne is the base for many of the nation's major financial institutions, which have seen no good reason to move away from a city which breathes good taste.

Yet buildings without people are bread without butter, and Melbourne's cosmopolitan mix has brought vitality, color, excitement, new songs, dances, music and food to the city. More than 35 percent of Melbourne's residents arrived as a result of post-Second World War migration, so don't be surprised if your vegetables are sold to you by a Greek, your meat by an Italian and your coffee by a Turk. These are just some of the people who have arrived from foreign lands to enrich this corner of Australia with their culture.

In its turn, the city has responded by providing its residents with a wonderful environment in which to live, particularly around the banks of the River Yarra, where walkers, cyclists, joggers and dreamers escape the city bustle. A fifth of the inner city area is given over to parkland and gardens, most of it within a short stroll of the commercial heart. The splendor of the Royal Botanic Gardens, 100 acres of landscaped greenery, brings the gardens of the world to Melbourne's doorstep.

Despite the attractions of the city, few can resist the lure of the Dandenongs, 19 miles from Melbourne, where refuge is offered in picturesque little towns, country restaurants, picnic grounds and cosy tearooms serving Devonshire cream and scones. The Dandenongs is an endlessly fascinating region of giant trees, rhododendrons, tree ferns, leafy glades, lyre birds, parrots, the Puffing Billy narrow-gauge railway and historical buildings like the Edward Henty Cottage, home of the first permanent settler in Victoria, which today is furnished in the period of the 1850s, and classified by the National Trust. Here, too, is the William Ricketts Sanctuary, where dozens of hand-carved sculptures of Aboriginal faces peer out of the dense, green foliage. The Grampian Ranges, in the southwest of the state, provide a different panorama, with high plains giving way to the spectacular scenery of rugged peaks.

In Melbourne's bayside suburbs, the English influence is strong, and place names like Brighton, with its row of brightly-colored, privately-owned bathing huts, Chelsea, Hampton and Sandringham – originally Gypsy Village but re-named in honor of the Royal Estate by the local landowner in 1888 – give clues to Victoria's historical links. Thomas Alexander Browne, author of "Robbery Under Arms', and the poet Adam Lindsay Gordon are both buried in Brighton cemetery.

Further south, as Beach Road skirts Half Moon Bay, the scuttled HMAS *Cerberus*, ironclad flagship of the former Victorian Navy, now serves as a breakwater; and on the Mornington foreshore there is a cairn which marks the landing of Matthew Flinders, navigator and commander of HMS *Investigator*, on April 28, 1802. Mornington Peninsula is Melbourne's holiday playground and it includes popular resorts like Rye and Rosebud, Dromana, Dorrento and Portsea. There is modern history here, too, for Australia's Prime Minister, Harold Holt, disappeared without trace while swimming at Cheviot Beach on December 17, 1967.

Across the entrance to Port Phillip Bay, the Bellarine Peninsula – and most especially Geelong, Victoria's second biggest city – was the favorite entry point for the prospectors who joined the gold rush to Ballarat in the 1850s. Now that turbulent era is immortalized in the reconstructed goldfield at Sovereign Hill.

Geelong is an important city, recalling memories of the rich merchants' way of life in the 1850s at places like Barwon Grange, built for J.P. O'Brien, a merchant ship owner, and The Heights, a classic example of more than 100 buildings in Geelong and the surrounding area that have been classified by the National Trust. Industry dominates Geelong today, but for those who persevere there are still historical treasures to be found.

But there is more, much more, to Victoria. There is the magnificent Snowy River scenery which inspired the ballads of Banjo Patterson. There is the starkly beautiful coastline and unique bushland of Wilson's Promontory. There is the rich grazing country of Gippsland and the expanse of the Gippsland Lakes, which form the largest inland waterways in Australia. There are wineries, historic towns, the winding Murray River with its paddle steamers and the majestic mountain resorts like Mt. Hotham, Falls Creek, Mt. Buffalo, Mt. Buller and Mt. Baw Baw. And, of course, there are the fairy penguins of Phillip Island, whose evening parade as they waddle out of the sea and across Summerland Beach is a magical sight.

But perhaps the trip around Victoria should finish back in Melbourne, at the Moomba – an Aboriginal word which, roughly translated, means "let's get together and have fun." Every March the festival attracts thousands of people from all over the state who want to do just that. The highlight, a three-hour street parade, is a Victorian celebration of their good fortune in being part of this glorious Garden City.

## TASMANIA

Tasmania, a green speck slipping off a golden continent, is the other Australia. A land of strawberries and scallops, apples and alpine meadows, lavender and mountain lakes.

It is no bigger than England, a country with which, physically, it has so much in common. The hop fields, quaint fishing villages, leafy glades, tea shops, rhododendron gardens and old churches recall a more gracious age when people had time to enjoy the natural beauty around them.

In the dramatically beautiful southwest, the Last Wilderness has changed imperceptibly since the first Tasmanians sheltered in Kutikina and Deena Reena Caves on the Franklin River around 20,000 years ago. Forests occupy more that 40 percent of Tasmania's land mass, and in the isolated southwest region man can but take tip-toe steps into the enchanting, hidden world of foaming rivers, rain forests, rapids and ravines, ancient Huon pine trees and alpine meadows flowing down from rugged, weather-beaten mountains.

The forests and rivers will share some of their secrets, but only with the most experienced bush-walkers or canoeists. No one can treat this area with anything other than total respect. The forests link this remote little island with the past, a time 37,000 years ago when marsupials, giant wombats and kangaroos roamed the swamps. Man followed some 17,000 years later at a time when the Bass Strait was exposed, allowing access from the mainland. Melting ice brought the floods which isolated Tasmania, allowing flora and fauna, extinct in other parts of the world, to flourish here. Huon and King Billy pines, blackwood, wattles and sassafras have given Tasmania its green-fringed canopy of splendor. The Tasmanian tiger, or thylacine, is thought to be extinct now, but the Tasmanian devil, an elusive, nocturnal animal, can still be sighted in the more remote bush areas.

More than anything else, the contrasts of Tasmania give it appeal and enchantment. The well-ordered, simple beauty of Hobart beneath the shadow of Mount Wellington; the shrouded stillness of the drowned Lake Pedder; the mosaic green and chocolate-brown countryside around Devonport; the fountains and Victorian bandstand of Launceston; the thermal pools and ferny glades of the Hartz Mountains; the English oaks and green lawns of Port Arthur ... these are some of the glories of Tasmania.

It was Abel Tasman who first discovered these riches in 1642 and claimed

Van Diemen's Land – named in honor of the then governor of the Dutch East Indies – for Holland. Colonisation came later. The British, following a familiar pattern, moved in quickly when there were rumors about the French settling in southern Tasmania. An expedition under Lieutenant John Bowen set sail from Port Jackson, New South Wales, landing in Van Diemen's Land at Risdon, now a suburb of Hobart, on September 7th, 1803. His party of 49 included 24 convicts.

It was the beginning of a dark period of Tasmanian history. A penal settlement was established at Port Arthur, on the Tasman peninsula, in 1830, and 12,500 convicts endured an often brutal life here until they were transferred to Hobart in 1877. Connecting the peninsula to the mainland is a narrow strip of land, just 1,345 feet across, known as Eaglehawk Neck. Here the military rulers introduced a savage guard system, using dogs to prevent prisoners from escaping to the mainland.

The first railway in Australia ran from Taranna to Long Bay near Port Arthur, a distance of roughly 4 miles, and it was the convicts who were made to push the carriages along the line. Escape from the tyranny was near impossible – although Martin Cash and others managed it in 1843 – and many of the convicts and settlers who died were buried on the Isle of the Dead at the entrance to the bay at Port Arthur. The Isle of the Dead is the last resting place for more than 1,600 convicts and 200 free settlers and soldiers.

Today, peaceful Port Arthur and the beautiful areas of southeast Tasmania hold the memories of those harsh colonial days. Elegant Richmond, 16 miles from Hobart, contains Australia's oldest freestone road bridge, the Old Gaol and Court House, all built in the 1820s. At New Norfolk, founded by Norfolk Islanders in 1813, St. Matthews Church is the oldest existing church building in Tasmania. The town is at the center of an extensive rural area and anyone who has toured the hop fields of Kent, in England, will find a lot of similarities here.

Hobart, astride the lovely Derwent River, is Australia's second-oldest capital, and when the locals claim that it is one of the most beautiful harbor capitals in the world, there are few who would want to argue. The old colonial character of Hobart touches hands with modern-day Tasmania in streets like Salamanca Place, where old Georgian warehouses are now occupied by shops and restaurants, and Battery Point, the original seamen's quarters of the city.

Battery Point was named after a battery of guns placed on a promontory next to the present docks, to protect the settlement from the French. The guns were never used against invaders, but the powder magazine and signal station still exist. Many of the buildings from the original village are as they were in the 1830s and 1840s, along with some of the public houses which catered to the sea captains, merchants and fishermen who moved into the area in the middle of the last century. In Macquarie Street and Davey Street, too, the past is lovingly preserved, but amid all this colonial splendor Hobart has not stood still. The Wrest Point Casino in Sandy Bay, Australia's first casino, is proof that the city can look forward as well as back.

Beyond Hobart the rich seam of Tasmanian landscape spreads out around the Derwent as it flows through hop fields, ancient forests and green lawns. Mount Field National Park, 48 miles from Hobart, includes the famous 130-foot Russell Falls and, slightly further afield, the area around Lake Dobson provides a winter wonderland for skiers.

Inland from Hobart is little England, a land of apple and pear orchards, green pastures and vineyards. All this set against the snow-capped Hartz Mountains, where the national park was described by Sir Edmund Hilary as "some of the wildest and most spectacular scenery I have ever seen." Here your nostrils are filled with cool mountain air while your eyes feast on rain forests and alpine wildflowers. The blackjack tables and roulette wheels of Wrest Point seem a million miles away as nature spreads its own cards on the table.

The national parks are the emeralds in Tasmania's tiara. Ben Lomond, home of Tasmania's best skiing fields, Franklin and Lower Gordon, where the wild rivers run below the massive white quartzite peak of Frenchman's Cap; Cradle

Mountain and Lake St. Clair, Australia's deepest natural freshwater lake; Rocky Cape National Park, where the wildflowers, parrots and honeyeaters complete the kaleidoscope, and the South West National Park, largest in the state, where mountain peaks, glacial tarns, eucalypt forests and button grass plains lure the adventurer deeper into the wilderness.

History is everywhere in Tasmania. In the north, around the Tamar Valley, among the old homesteads and gold mining ruins; in Devonport at the Maritime Museum; in Launceston among the merchant warehouses, and along the unspoiled east coast beaches where the whalers once came.

Tasmania is a marvelous surprise wrapped up in a little package. It is Australia in a nutshell.

### AUSTRALIAN CAPITAL TERRITORY

It might be easy to get sidetracked away from Canberra and the Australian Capital Territory by the sophistication of Sydney and the magic of Melbourne, but to ignore Australia's seat of government would be a mistake.

Of course, Canberra is neat and tidy. Of course, it is inland and has little colonial history to fall back on. Of course, it has no dusty nooks and crannies to add character, nor any ancient monuments to peer at. But every city needs time to find its place in the world, and Canberra has made massive strides since 1908 when it was selected as the site for the national capital. An American architect won the international competition to design the city, and in 1913 it was given its name after an Aboriginal word meaning "meeting place.'

Parliament first met there in 1927, but the intervention of World War II slowed progress and it wasn't until well into the 1950s that the pace of Canberra really picked up. Latest figures show the population of the 1,469 square miles of Australian Capital Territory as 253,000, which is remarkable growth considering that, in 1960, the figure was around 55,000.

Canberra is developing its own character, and there are fewer complaints these days of a city lacking soul – but not public servants! Twelve million trees and shrubs have provided color; imposing embassy buildings have given it class. The artificial Lake Burley Griffin divides the city between the north, where residential areas proliferate, and the south, where the government buildings, including the National Gallery, the High Court and the National Library, are concentrated within the parliamentary triangle envisaged by its designer, Burley Griffin.

The apex of this triangle will be the new Parliament House. The "temporary" old Parliament House will be retained and will no doubt become a tourist attraction to rank with the Australian War Memorial at the foot of Mount Ainslie. The museum has an enormous amount of war memorabilia – books, photographs, paintings, sketches and diaries – but perhaps its most impressive exhibit is one of the Japanese miniature submarines which slipped into Sydney Harbour during World War II. Canberra has tried both to collect history around it, particularly in the National Library, and to acknowledge it with the spectacular water memorial to Captain Cook – a jet of water in Lake Burley Griffith which shoots to 460 feet in height and can be seen from virtually everywhere in the city.

The bonus for the people of Canberra is that they can have all this clean, uncluttered city living and still escape to the nearby Snowy Mountains when public service life gets too much for them. The National Library holds the Jindabyne Tapes, an oral history of the real men from Snowy River, immortalized in Banjo Patterson's famous ballad. Departing residents from the old town of Jindabyne, before it was submerged beneath Lake Jindabyne, were interviewed about the identity of the Man from Snowy River, and popular opinion held that Patterson had created his daring horseman from many of the real characters who galloped through the wild mountain ranges.

Today, though, Canberra is very much a living city, building its own history and its own legends.

## NEW SOUTH WALES

Much has been written about the twin glories of Sydney – the stunning, sail-like concrete curves of the Opera House and the magnificent Harbour Bridge. And in all those words, no one has yet managed to overstate the stimulus it affords the senses. Those who have made comparisons between the compelling majesty of India's Taj Mahal and the awesome splendor of Joern Utzon's masterpiece on Bennelong Point are surely close to the mark when they claim that the Opera House, opened in 1973, 14 years after work began, is the eighth wonder of the world.

Sydney is a magical place, a sparkling, invigorating, string-of-pearls city. There is style and sophistication here. There is commercial vitality and cultural awareness. There is raffishness and there is ritz. There is history and there is hullabaloo. There is Bondi Beach and Harry's Cafe de Wheels in Woolloomooloo, Doyle's seafood restaurant at Watson's Bay, nighttime Kings Cross, the famous Sydney cricket ground and the Victorian elegance of Paddington.

Australia's oldest, liveliest and most spectacular city has come a long way since Captain Cook passed by without stopping in 1770. Cook, poor fellow, anchored in Botany Bay, a few miles to the south, pausing briefly to name the vast expanse of Sydney Harbour in honor of George Jackson of the British Admiralty.

On Monday, January 26, 1788, Captain Arthur Phillip, commander of the first convict fleet, arrived in Botany Bay but moved on to Port Jackson because of its better anchorages and greater protection. The first settlers established themselves in Sydney Cove, where Circular Quay is today. The nearby Rocks area is an endlessly fascinating link with Australia's colonial past. The Rocks was the site of Australia's first prison, barracks and hospital and, although many of its buildings were pulled down during an outbreak of bubonic plague at the end of the last century, the area has been sympathetically restored.

The restored Cadman's Cottage, built in 1815, is Sydney's oldest existing building, and the Argyle Centre, convict-built in the 1820s, is now home to arts and crafts displays. If you need reminding of how tough life was for those early convicts, take a look at Argyle Cut and think what it must have been like, day after day for 16 years, as the prisoners gouged a passage out of the solid rock. The Rocks is where it all started, and today it is the best place to orientate yorself in this radiant city.

Spread out are the charms and surprises of a city which combines the best aspects – but few of the drawbacks (if you don't count the Harbour Bridge traffic jams) – of other great cities around the world. Sydney has a special atmosphere which can be sensed in a moment while sitting on a bench on the shores of Farm Cove reading a newspaper, listening to the Sunday afternoon speakers haranguing the crowds at the Domain, strolling through Kings Cross, taking a water taxi to Rose Bay, or listening to free entertainment in Martin Place.

Everybody is offered the opportunity of discovering what this city means to them. Whether it's the head-spinning panorama from the Manly ferry, the view over the entrance to Sydney Harbour from the top of the North Head, the lushness of the Botanical Gardens or the beautiful, bikini-clad girls on Bondi Beach, there is something here to suit every taste. From the plushness of Vaucluse, through the high style of Point Piper to the dazzling shopping delights of Double Bay, the cacophony of Kings Cross and the trendy charm of Paddington, this lucky city has come a long way in 200 years.

If, like me, you never tire of Sydney, you should remember that New South Wales has more to offer than a bridge and an opera house. There is the near-tropical north, the Snowy Mountains, 800 miles of outstanding coastline, and the marvelous Murray Riverina region, where inland Australia was pioneered by the settlers and then plundered by bushrangers like Ned Kelly, Mad Dan Morgan, Captain Moonlight and Frank Gardner.

The Murray Riverina includes the major cities of Albury and Wagga Wagga, the mighty waters of the 1,600-mile Murray and the 1,000-mile Murrumbidgee (an Aboriginal word meaning "big water"), the little townships of Corowa and Mulwala and Wentworth, the latter situated near the junction of the Murray and the Darling, Australia's second largest and second most important river.

This is the old bandit country where, in 1879, Ned Kelly held up the local police station and robbed the bank at Jerilderie, and where the notorious Captain Moonlight was tried in Gundagai's 1859 court house. Gundagai's other famous monument is a sculpture of the celebrated dog who, in the bush ballad "sat on the tuckerbox, five miles from Gundagai." There's Hay, where Cobb and Co. built their coaches, and Hell, where you find the One Tree Pub, and there's the Merriwagga Black Stump bar, tallest in the land, where thirsty horsemen could take a beer without leaving the saddle.

The Riverina is an outstanding area, both for its historical associations, its legends, its superb river playgrounds and for the Murrumbidgee Irrigation System which has transformed the area west of the Snowy Mountains into a flourishing land of vineyards, cotton fields, orchards and rolling green pastures. Henry Lawson, asked by the government to write about the virtues of the new irrigation scheme, penned a letter to a friend in 1916 in which he told of "a spread of green, all chequered off, with little homes and trees and clear, green-fringed canals and channels, just like English brooks, set in a midst of a bare-scorching dusty red and parched yellow Dead Land that's a lot older than Egypt."

The Murray was discovered by the explorers Hume and Hovell during an ambitious overland trip from Sydney to Melbourne in 1824. Six years later, Captain Charles Sturt "rediscovered" it and changed its name from the Hume to the Murray after a British Colonial Secretary. Hume had to be content with his name on the highway linking Australia's two largest cities. The Murray region is irrigated by the waters of the Snowy Mountains, the roof of Australia, where Mt. Kosciusko towers majestically to 7,343 feet.

James Spencer lived here in the rugged mountain country in the 1840s, and his exploits as a daring horseman, stockman and pioneer are believed to have been the inspiration for Banjo Paterson's famous ballad, "The Man from Snowy River'. Paterson listened to the campfire tales of the old stockmen of the Snowy and wove the characters of their stories into his own ballads. The high passes and treeless valleys no longer echo to the hoofbeats of the flying horses. Today, up among the snowdrifts, it is the swish of skis that ruffles the brilliant white blanket of the Snowys.

Away from Sydney, the Murray Riverina and the Snowy Mountains, New South Wales has still more to offer. The magnificent wines of the Hunter Valley, Australia's largest iron and steel works at Newcastle, the "Silver City" of Broken Hill, the high plateau of the New England region, the sweeping beaches of the north coast towards Queensland and the secret bays and inlets of the south.

Simply, it's a great state to get into.

## QUEENSLAND

Queensland – the Sunshine State – lays claim to being Australia's premier holiday destination. It is big, boisterous and brash. Yet, at times, it can be quirkily conservative in a way which can put it out of step with the rest of the country. This is not to say that Queenslanders are any less friendly or less hospitable than their fellow Australians. You will be welcomed just as warmly in your travels around this state of surprise.

Within its 1 million square miles, Queensland is a land of striking contrasts: of outback desert and tropical rain forest, of rugged mountains and endless flat plains, of surfing beaches and baked salt pans, of historic towns and modern high-rise resorts, of kangaroos and crocodiles. But, for the majority of Australians, and for that matter many overseas visitors, Queensland is the Gold

Coast and the Great Barrier Reef.

The Gold Coast – a 20-mile strip tucked into the southeast corner of Queensland – is a high-rise holiday playground based around sand, sun and surf. It is a heady mix – the English seaside resort of Brighton, Spain's Costa del Sol and California's Disneyland all rolled into one. It is blousy and brazen, gaudy and glamorous, a lucky dip of candyfloss fun and caviar good living. The Gold Coast is a mecca for the beautiful people who have turned it into Australia's holiday capital. And, if the Gold Coast is not to everyone's taste, it makes no apologies. Tourism is the reason the Gold Coast was created, and the city fathers will tell you they are simply providing what the visitors want. The endorsement of this policy lies in the three million plus tourists who annually visit the coastal strip. And the thousands of "southerners" who each year migrate north to spend their retirement years enjoying life in this balmy, sub-tropical paradise.

Further up the coast is the jewel in Queensland's tourism crown, the marine wonderland of the Great Barrier Reef. The reef, stretching for more than 1,000 miles along the eastern coastline of Queensland, is formed by more than 350 varieties of exotically-colored live coral. Surely no other place in the world can offer snorkelers and scuba divers such a fantastic underwater experience. Fish of every size and hue dart among the fascinating coral formations.

But you don't have to don a wet suit to enjoy this technicolor extravaganza. Queensland's tourism operators have developed craft which allow you to explore the reef without getting your toes wet. Townsville entrepreneur Doug Tarca was the first to introduce a semi-submersible craft to the reef. This innovative Queenslander developed the boat because he wanted everyone – young, old, fit and disabled – to share in the magic of the reef. His yellow submarine, called the *Manta*, is moored to a pontoon on the John Brewer Reef some 40 miles from Townsville. You get there from the mainland on a giant 250-seat catamaran, a high speed journey which includes a succulent seafood and salad buffet lunch. Once at the reef, you board the *Manta* (it takes up to 50 passengers) for a fascinating encounter with the myriad forms of marine life and the colorful coral.

If the Great Barrier Reef is the state's crown, then the many islands dotted along the coast are her jewels. These are the idyllic islands of which dreams are made – swaying palms, brilliant white sandy beaches, secluded coves, sleepy reef-protected bays, lush vegetation, exotic fruits and equally exotic birds and flowers.

There are few places on earth to match the Whitsunday Islands for enchanting beauty. They lie between the rain forested hills of the Whitsunday coast and the coral ribbon of the Great Barrier Reef. You can cruise through the Whitsunday Passage, anchoring by an uninhabited island to go scuba diving and snorkeling in the turquoise waters. You can charter cruisers, sail on crewed yachts, sign on for island-hopping camping cruises or join a sophisticated cruise boat.

If you're a confirmed landlubber, then there is a choice of island resorts where you can enjoy a pampered, carefree existence. Try Hamilton Island, where an international standard resort has been created to cater for the pleasure seekers who want five-star facilities on their island retreat. Or Daydream Island. Or Hayman Island. Or Lindeman Island. Or Brampton Island. Or one of the numerous other resort islands strung along the coast, each enticing you with their special charms.

Queensland's picturesque coastal towns and inland centers can be full of surprises, too. Places like Bundaberg, a major sugar-producing center and home of the famous local rum of the same name. The town also has a niche in history as the home of the pioneer aviator Bert Hinkler, who made the first epic solo flight between England and Australia in 1928.

Places like Mon Repos Beach, where three kinds of turtle come ashore each year to lay their eggs. Places like historic Gayndah, inland from Bundaberg and

one of the oldest towns in the state, or Kilkivan, where you can fossick for gemstones, and the volcanic crater lakes in the Coulston Lakes National Park. Places like Winton, a town of 1,300 people on the Rockhampton to Mt. Isa road. It was on a station near Winton that Australia's celebrated poet-songwriter Banjo Patterson wrote his now famous ditty, "Waltzing Matilda." And it was here, too, that Australia's international airline, Qantas, had its humble beginnings.

Places like Townsville, the third largest city in Queensland, with a population of 80,000. This port city serves the vast mineral- and agriculturally-rich hinterland of northern Queensland. From the dominating landmarks of Castle Hill you get splendid, panoramic views of the city and across to Magnetic Island. Townsville has many charming old buildings and an excellent mall full of interesting shops where you can browse and, if the fancy takes you, buy. Or you can simply sit back and watch the others having a good time. Places like Nerada, where you can visit Australia's only tea plantation and climb Mt. Bartle Frere, Queensland's highest mountain.

And Cairns, the major center in Queensland's tropical far north. A relaxed, friendly city which marks the end of the Bruce Highway and the railway line from Brisbane. From here you can visit Green Island, a delightful coral cay resort, venture north into the wilderness area of the Cape York Peninsula, or explore the magnificent rain forest areas of the Atherton Tableland. Highly recommended is the scenic train ride from Cairns through breathtaking Barron Gorge up into the mountains to Kuranda, a journey of 20 miles. Kuranda itself is a cool, green, tropical delight of native shrubs, ferns and flowers.

Port Douglas, north of Cairns, is also well worth visiting. It is a picture postcard town with many fine old buildings, interesting little shops and restaurants and a truly superb beach. This once quiet fishing hamlet has been discovered by the wider world and is now a thriving tourist destination.

There are many tough mining towns and remote communities in the interior. Probably, the most famous of these is Birdsville, the end of civilisation before you head off along the Birdsville track across the forbidding Simpson Desert into South Australia. For fairly obvious reasons, it's the Birdsville Pub which has given this tiny settlement of 200 hardy inhabitants a special place in Australian folklore. Here you buy your last draught beer for hundreds of miles or, alternatively, slake your thirst if you've come the other way.

The capital of this state of contrasts and color is Brisbane, Australia's third largest city, with a population of 1.25 million. Situated in the southeast corner of the state, close to the New South Wales border, Brisbane has a distinct tropical feel about it, particularly on balmy summer nights when the warm, moist air gently hugs you.

To many overseas visitors Brisbane, probably more than any other capital, is likely to fit their image of an Australian city. The city skyline, unlike Sydney and to a lesser extent Melbourne, is not dominated by rows of office towers, and it still retains the atmosphere, if not quite the appearance, of a big country town. There is a strong Australian influence in much of its architecture, particularly in the suburbs. It is not uncommon to see houses with wide verandahs under corrugated iron roofs, and weatherboard houses perched on stilts to let the air circulate underneath and provide some respite from the intense summer heat.

Brisbane is a charming, gentle city with a friendly, warm smile; a city where you feel welcome and comfortable rather than lonely and intimidated.

This, then, completes our brief tour of a continent of, above all, contrasts – at once awe-inspiring and welcoming, forbidding and friendly. A land that, while reflecting the origins of its inhabitants, still retains the unique qualities that the very name – Australia – evokes.

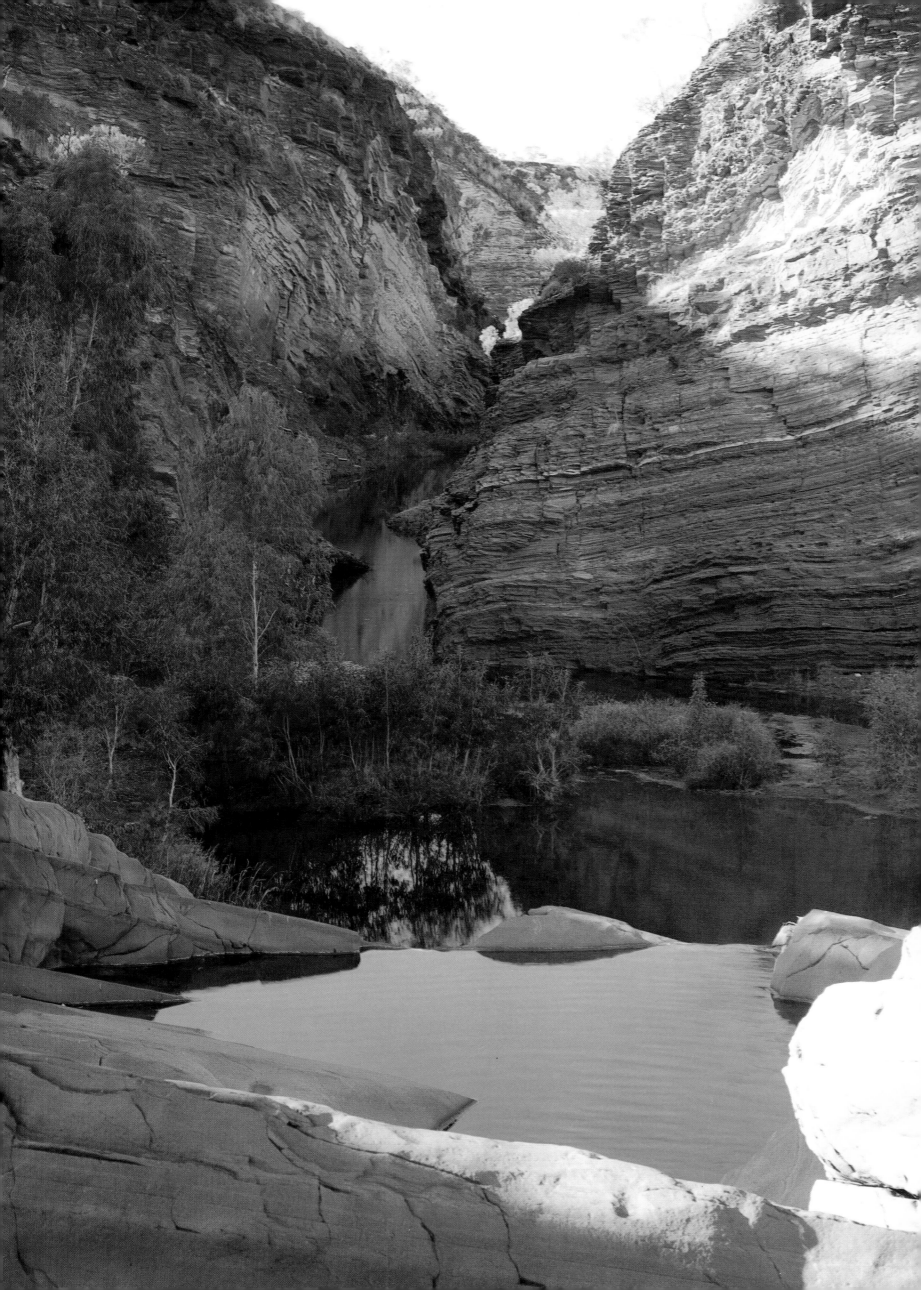

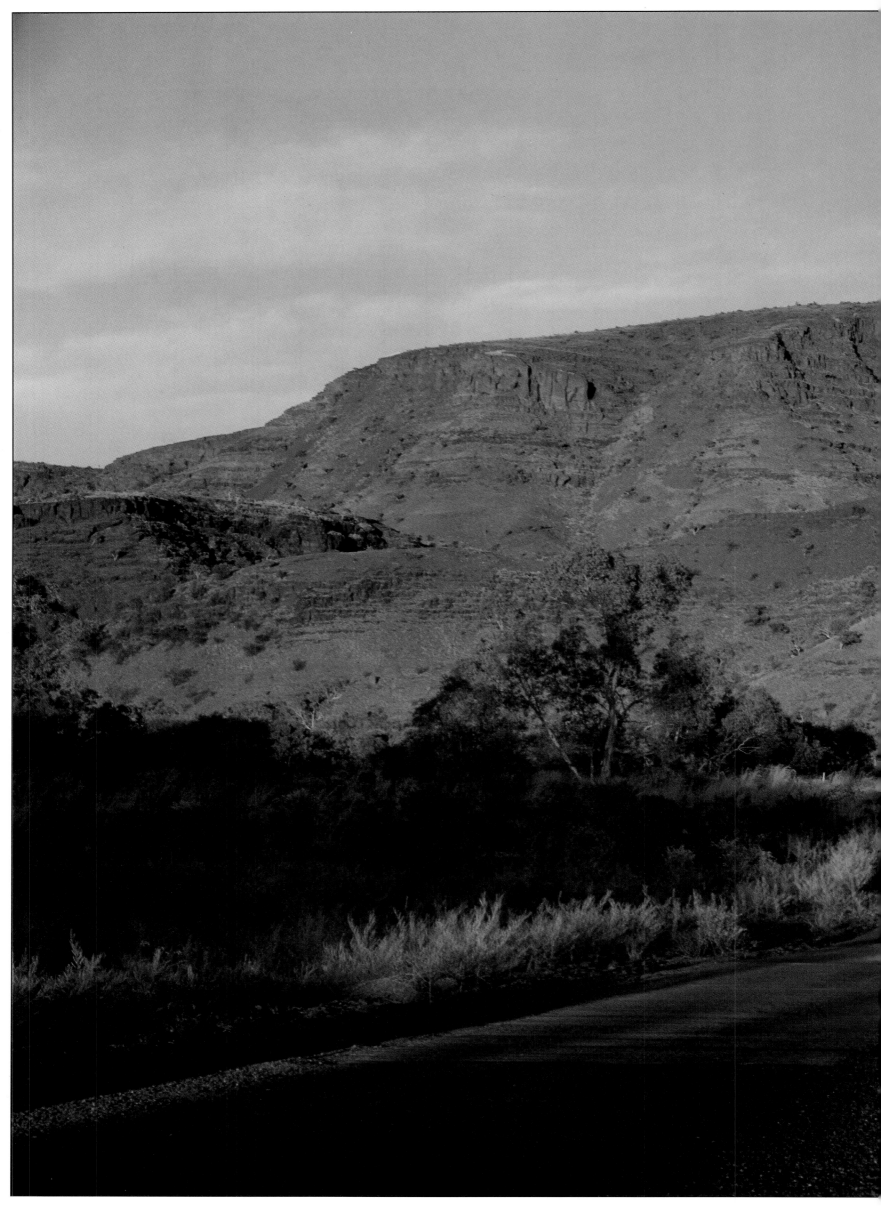

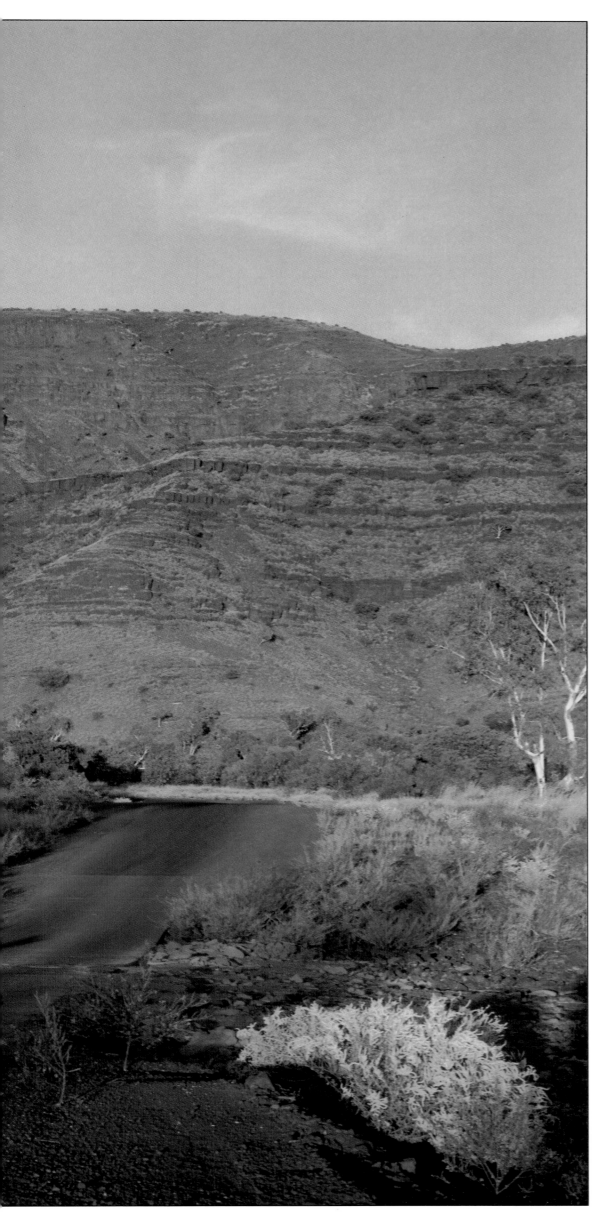

*Previous page: one of the cool, still pools that are a feature of the gorges of the Hamersley Range, and (left) glowing like a red-hot coal against the pale sky, a rock face in the range, typical of the area's mineral-rich terrain. The buckled earth here is equal in age to the oldest land found anywhere in the world. Iron ore is particularly plentiful, as is asbestos and, in taking advantage of this, mining is slowly opening up the Pilbara district in the northern part of the state. Most visitors to the national park, however, come to experience the land's startlingly vivid colors and strange twists and turns, which make this collection of mountains, plateaux and gorges some of the continent's most impressive.*

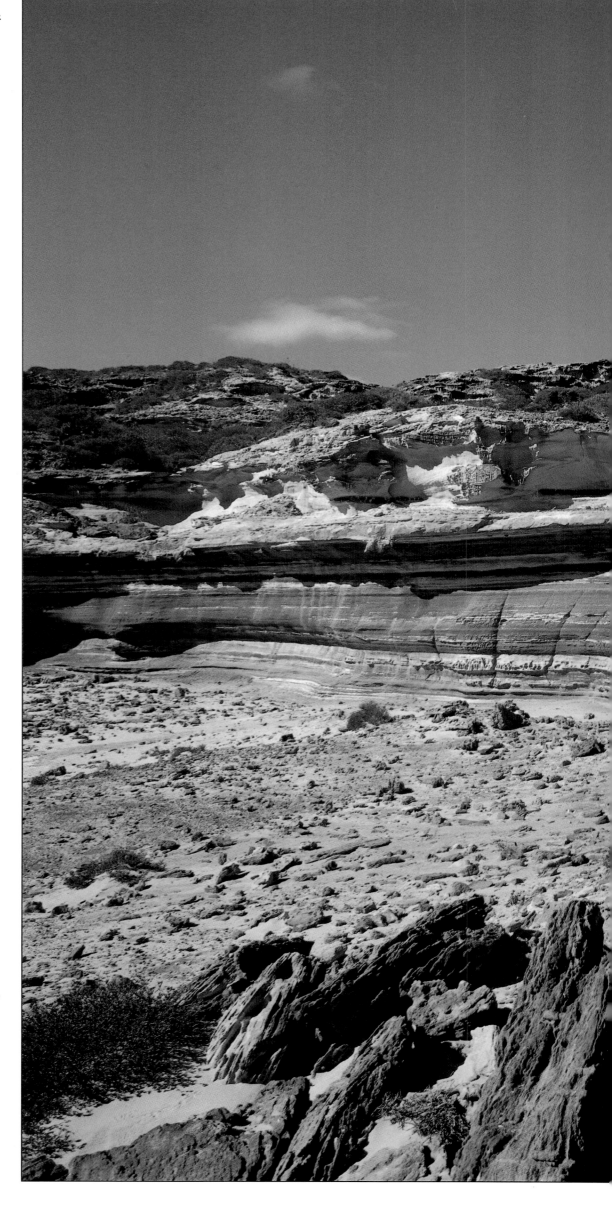

*Resplendent in red and gold, a wealth of geological phenomena (right) is to be found in Kalbarri National Park, which lies some ninety miles north of Geraldton. The park is famous for its colored cliffs – both those to be found on the Indian Ocean coast (overleaf) and those inland along the Murchison River Gorge. The banding of these rocks is due to the erosion of the layers of multi-colored sandstone that underlie the region. In 1629 Australia's first European "residents" arrived here – two mutineers who were unceremoniously put ashore by a Dutch sea captain, glad to be rid of them. Their fate is unrecorded.*

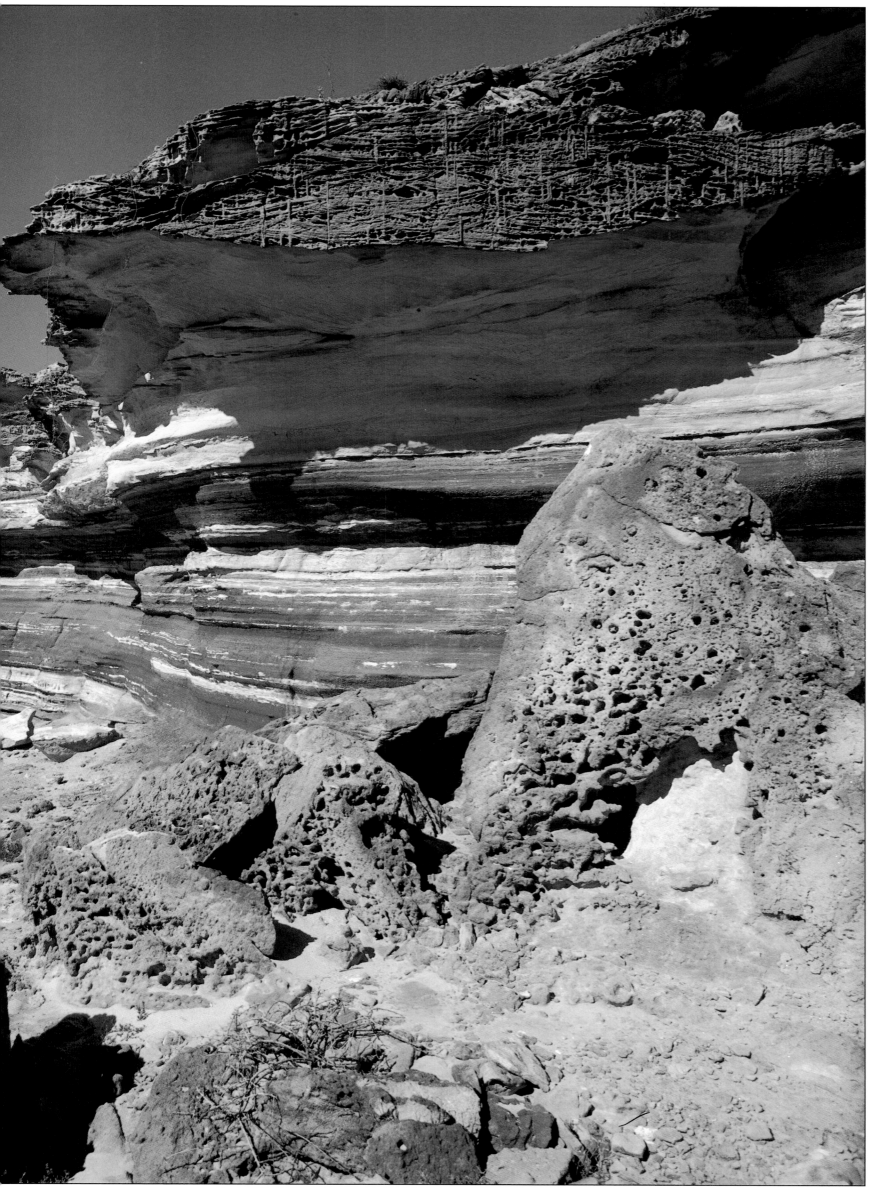

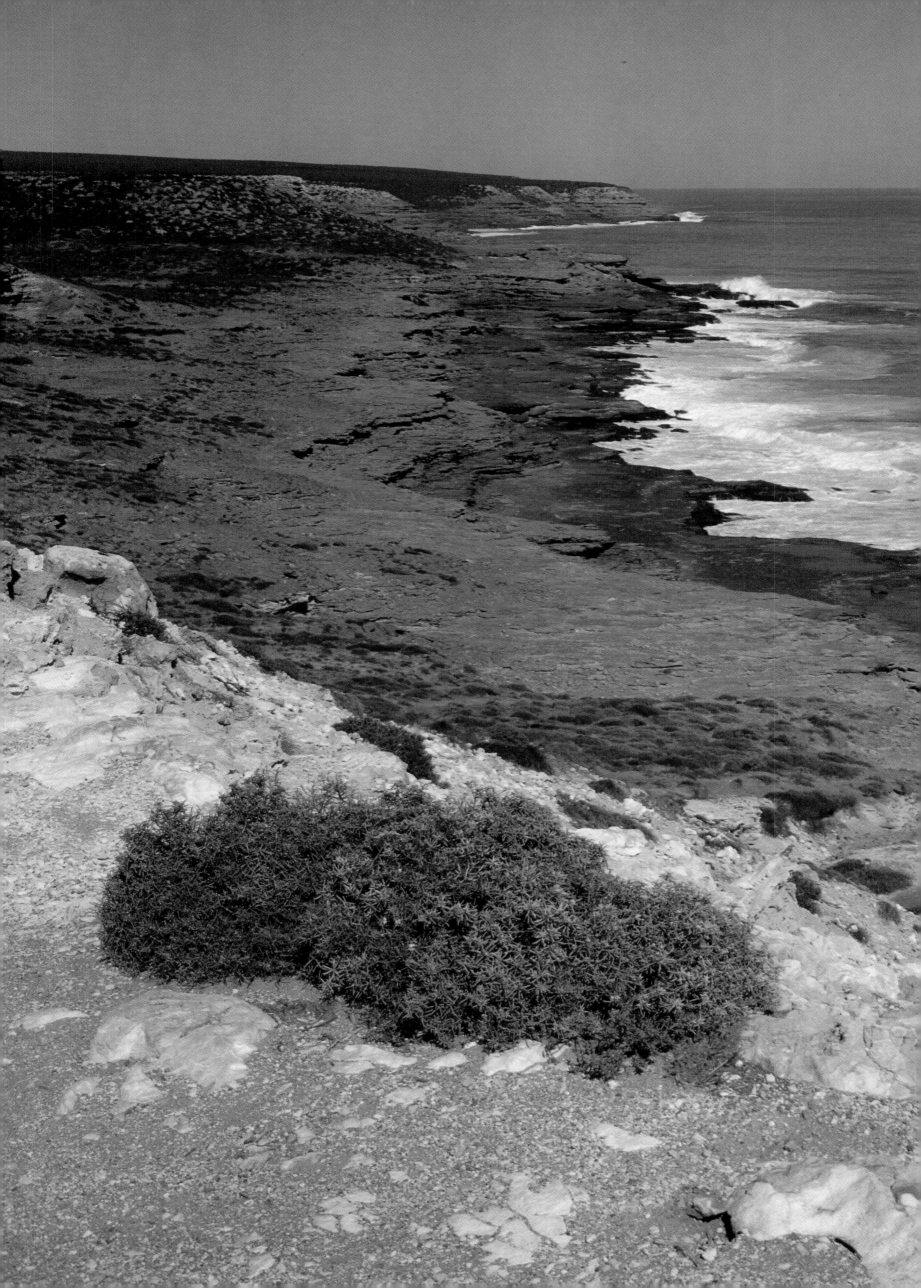

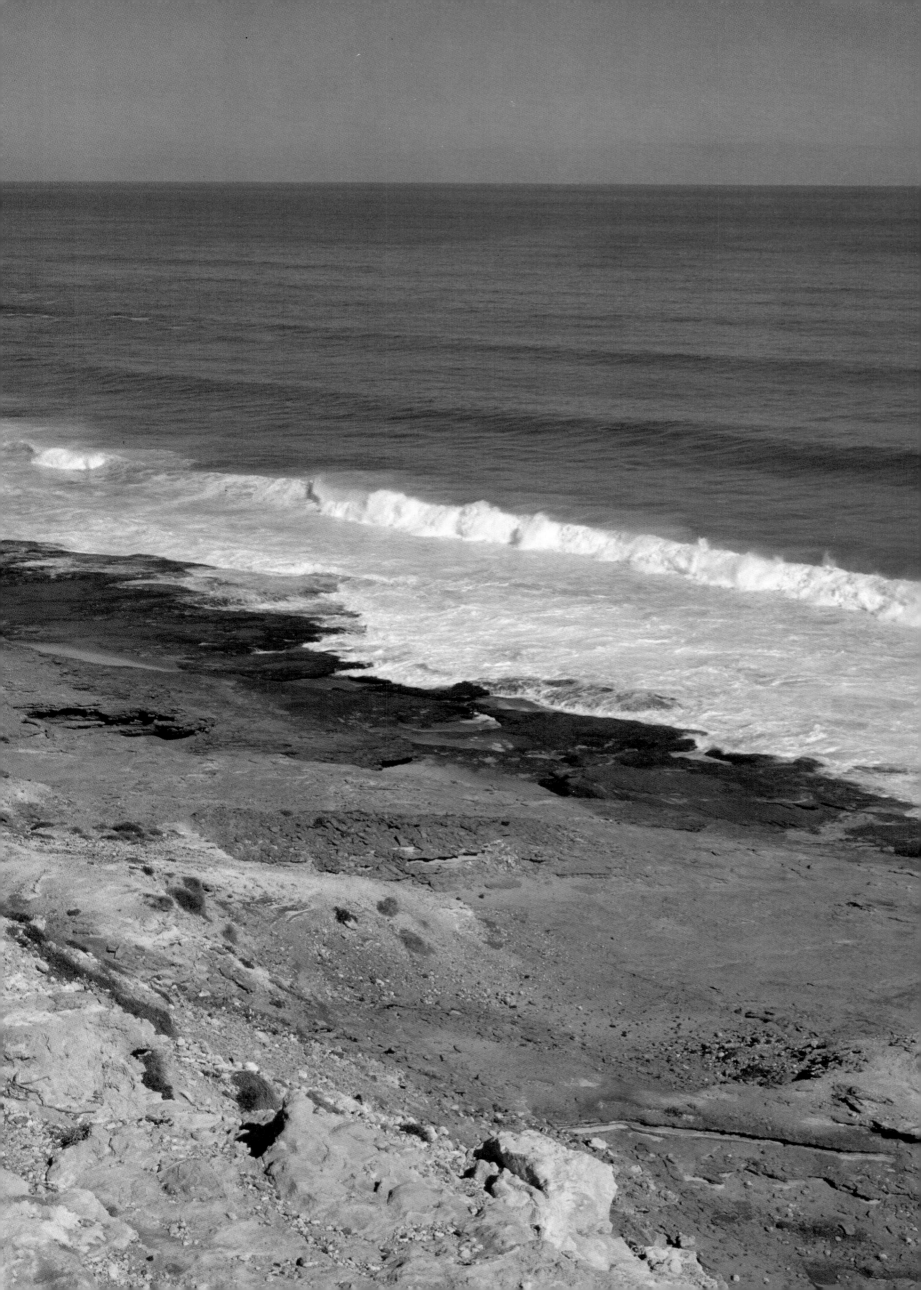

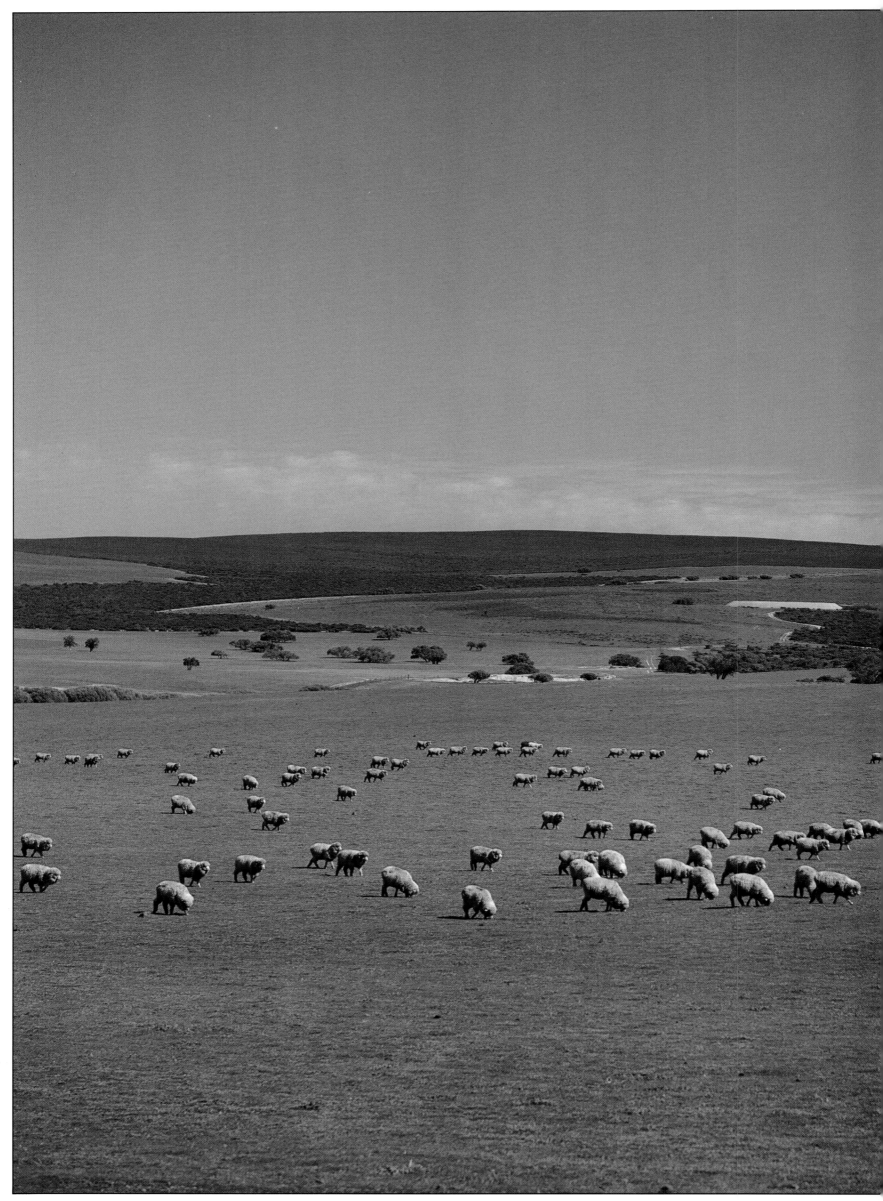

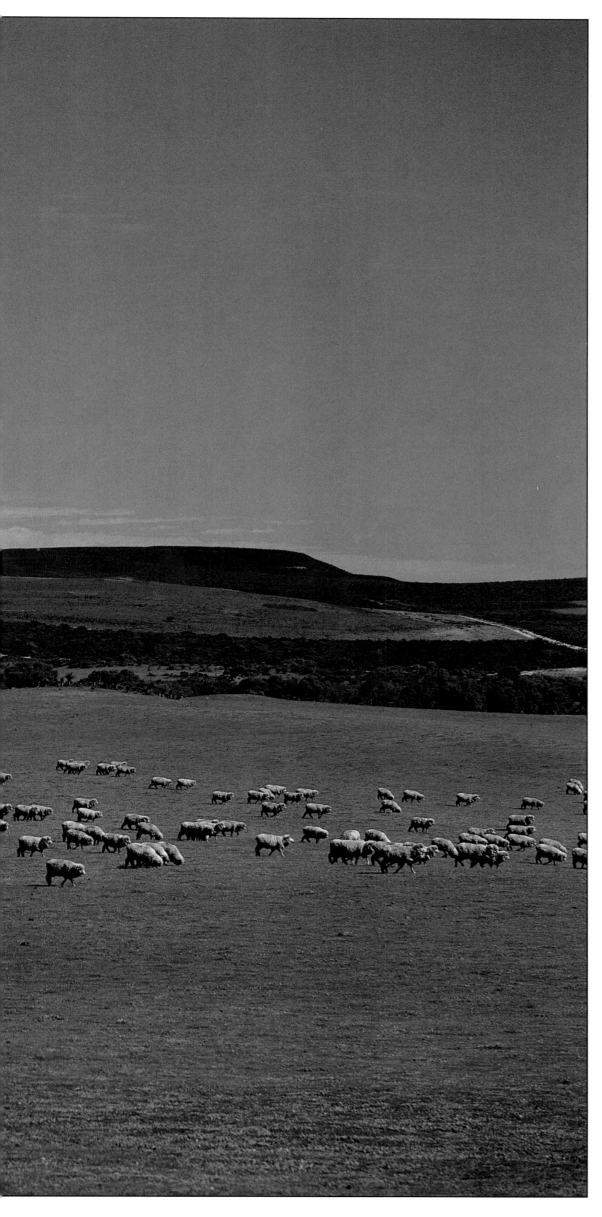

*Left: a sheep station inland from the tiny coastal town of Jurien, which lies midway between Geraldton and Perth. There are ten times more sheep in Australia than people and, unsurprisingly, the country's wool production is considerable, comprising thirty percent of the world's entire output. Overleaf: the pinnacle formations that are the highlight of Nambung National Park, not far from Jurien. The first Europeans to see these rock pillars believed them to be the ruins of an ancient city. The truth of their origins is even stranger – they are the fossilized remains of the roots of plants that grew on the dunes about 30,000 years ago. When the plants died, having been buried by sand, their root channels were filled by lime and other minerals carried by rainwater. Deposits continued to build up in these channels until the dunes moved again and exposed the now extremely thick and hardened underground stalagmites to the wind. Erosion blew them smooth, although here and there, broken pillars reveal the network of calcified roots.*

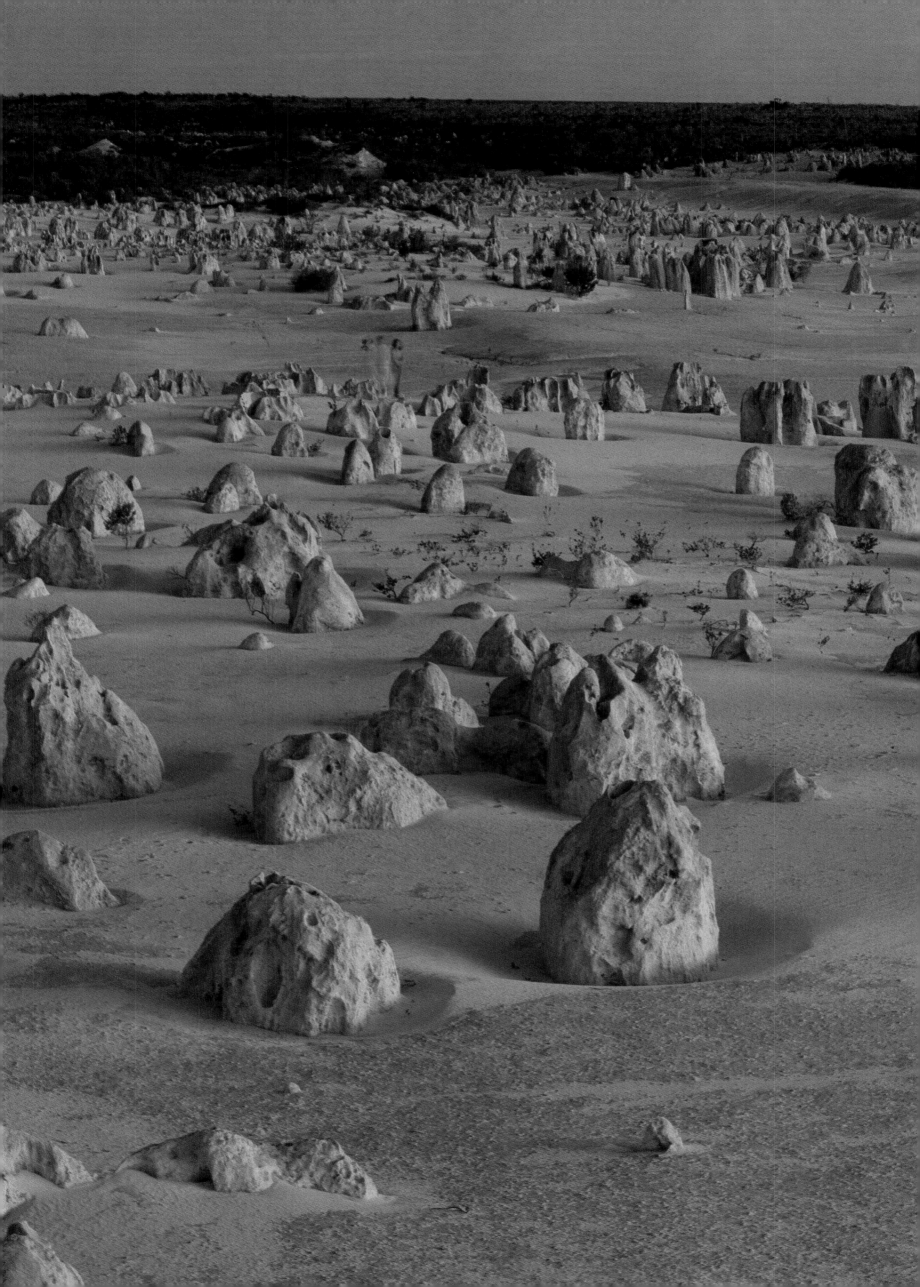

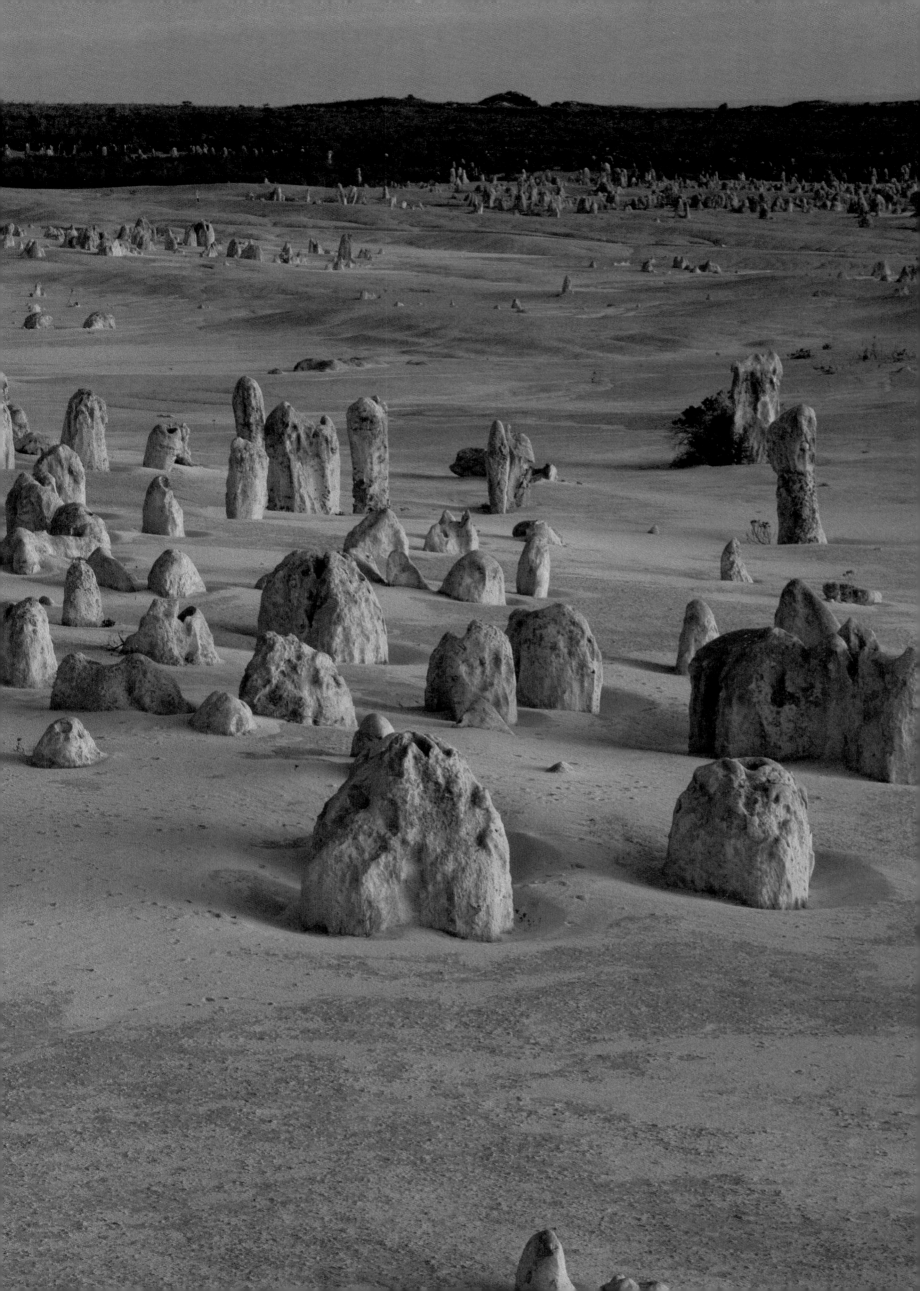

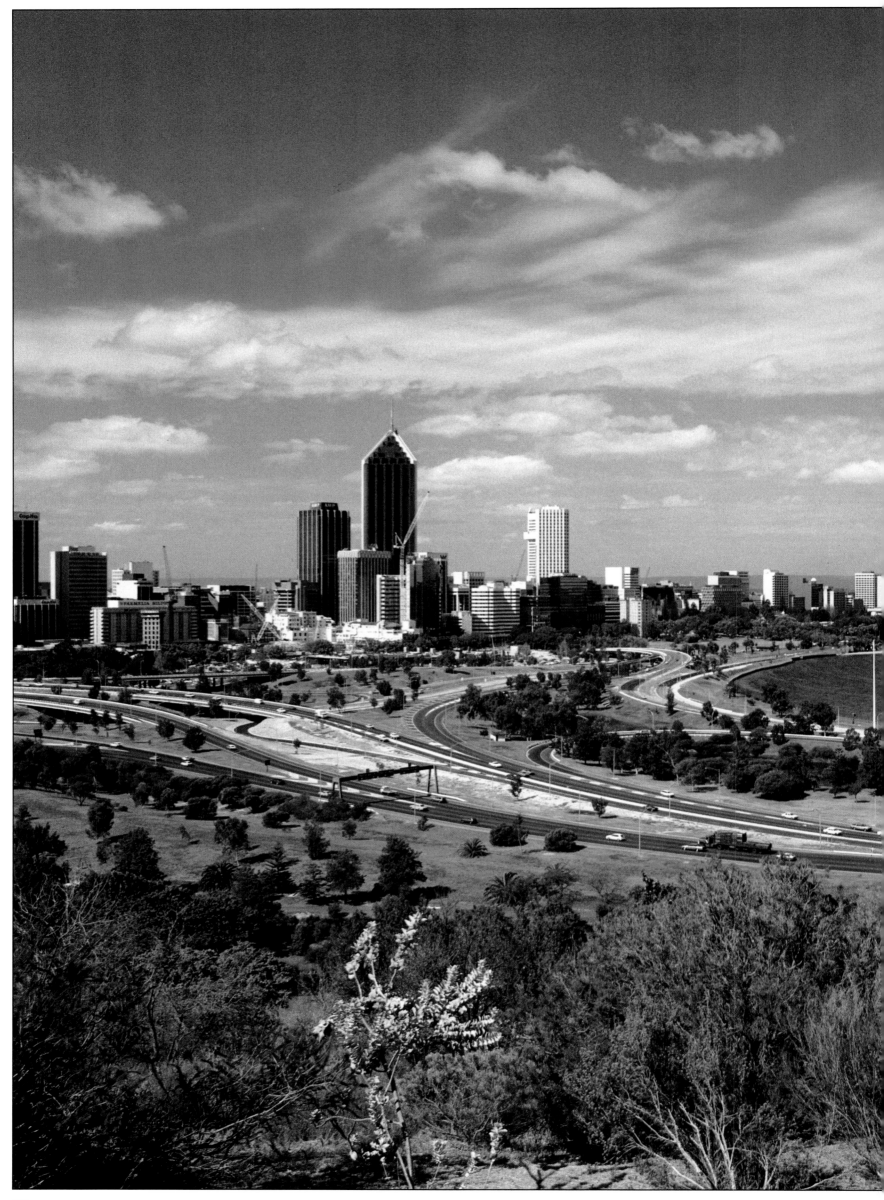

# WESTERN AUSTRALIA

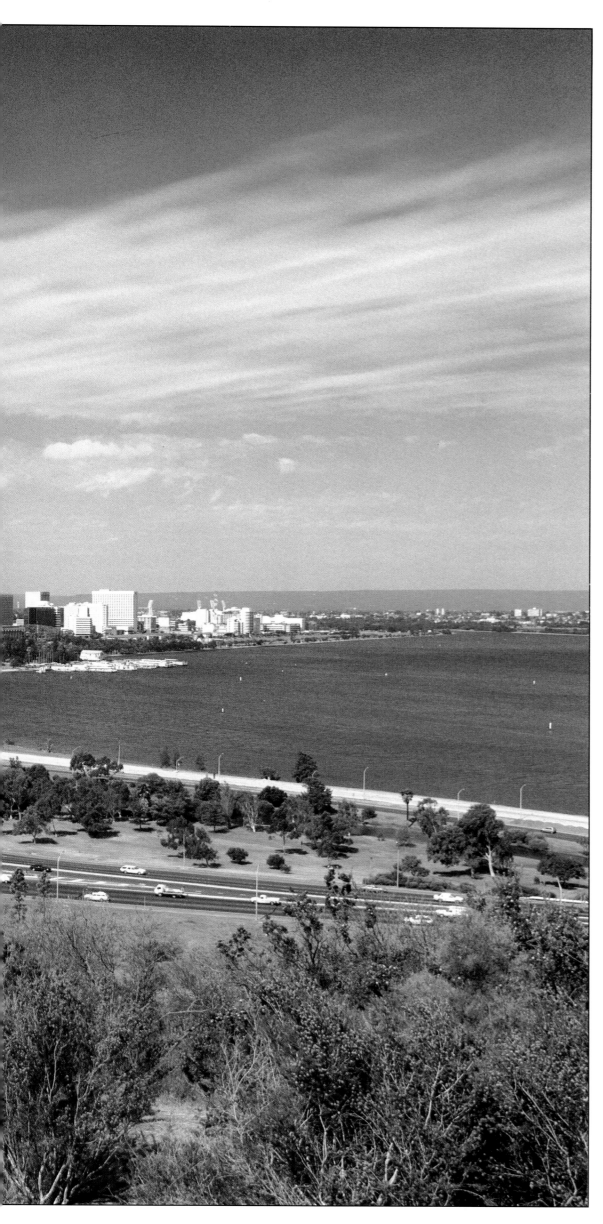

*Left: the skyline of what has been called "The Most Isolated City in the World" – Perth, the capital of Western Australia. Such a horizon of glass and steel reflects the wealth of a state that is rich enough, as a result of its vast mineral reserves, to survive as a separate country should it secede from the rest of Australia. Nearer to Bali than to Sydney, Perth is superbly set on the Swan River close to the Indian Ocean. Its climate is Mediterranean, its surroundings green and its people assertive, forward-looking and proud. When astronaut John Glenn was due one night to fly over Perth during his first orbit of the earth, the city's residents turned on all their lights to salute him. His nickname for Perth of "City of Lights" is, in many ways, still apt.*

# WESTERN AUSTRALIA

*The town of Kalgoorlie (right), east of Perth, is at the center of the Australian gold-fields. The wealth brought to the town in the nineteenth-century by the discovery of gold is reflected in the elegant buildings which line its streets. Overleaf: the geological curiosity known as Wave Rock, near Hyden in the Central Hinterland. Part of a huge granite dome that has been dramatically scoured by erosion, Wave Rock is some fifty feet in height. Its spectacular curve is emphasized by the colorful natural chemical stains washed down it by rain.*

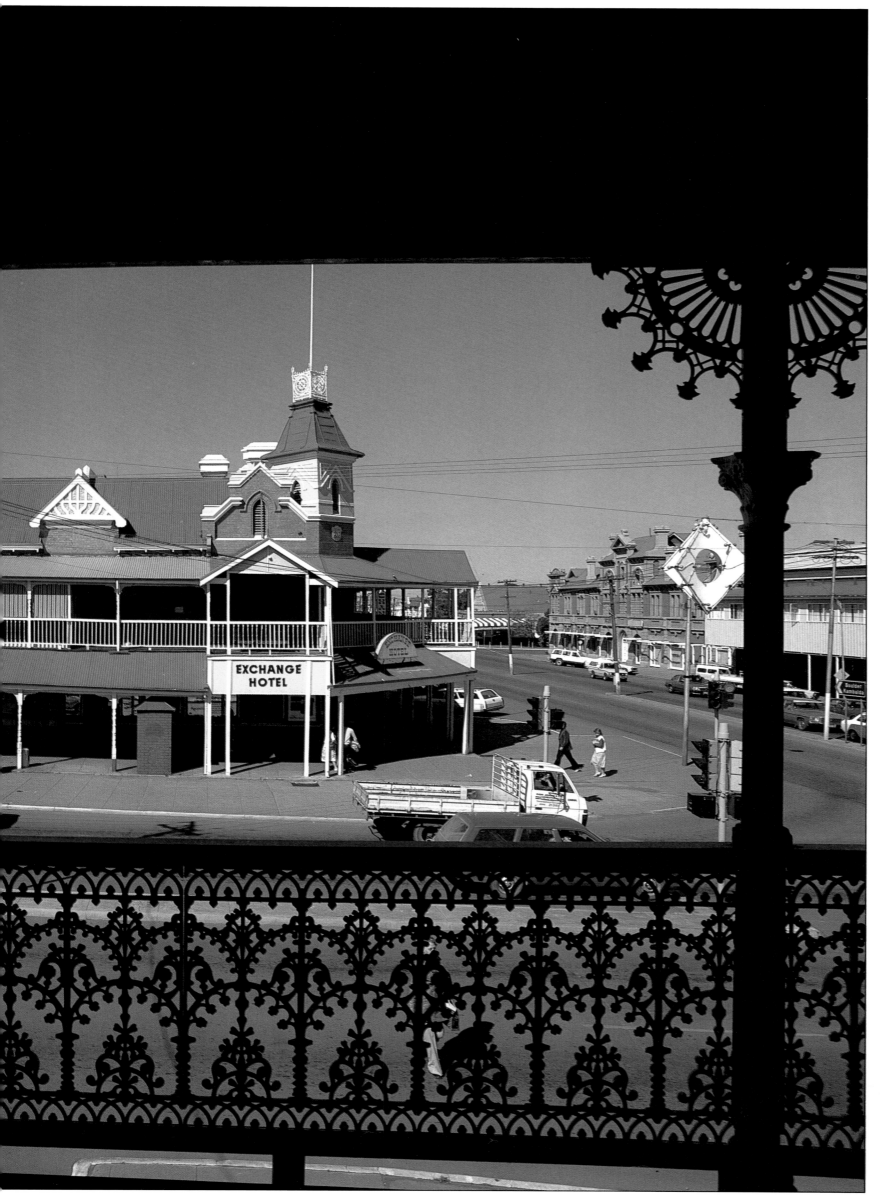

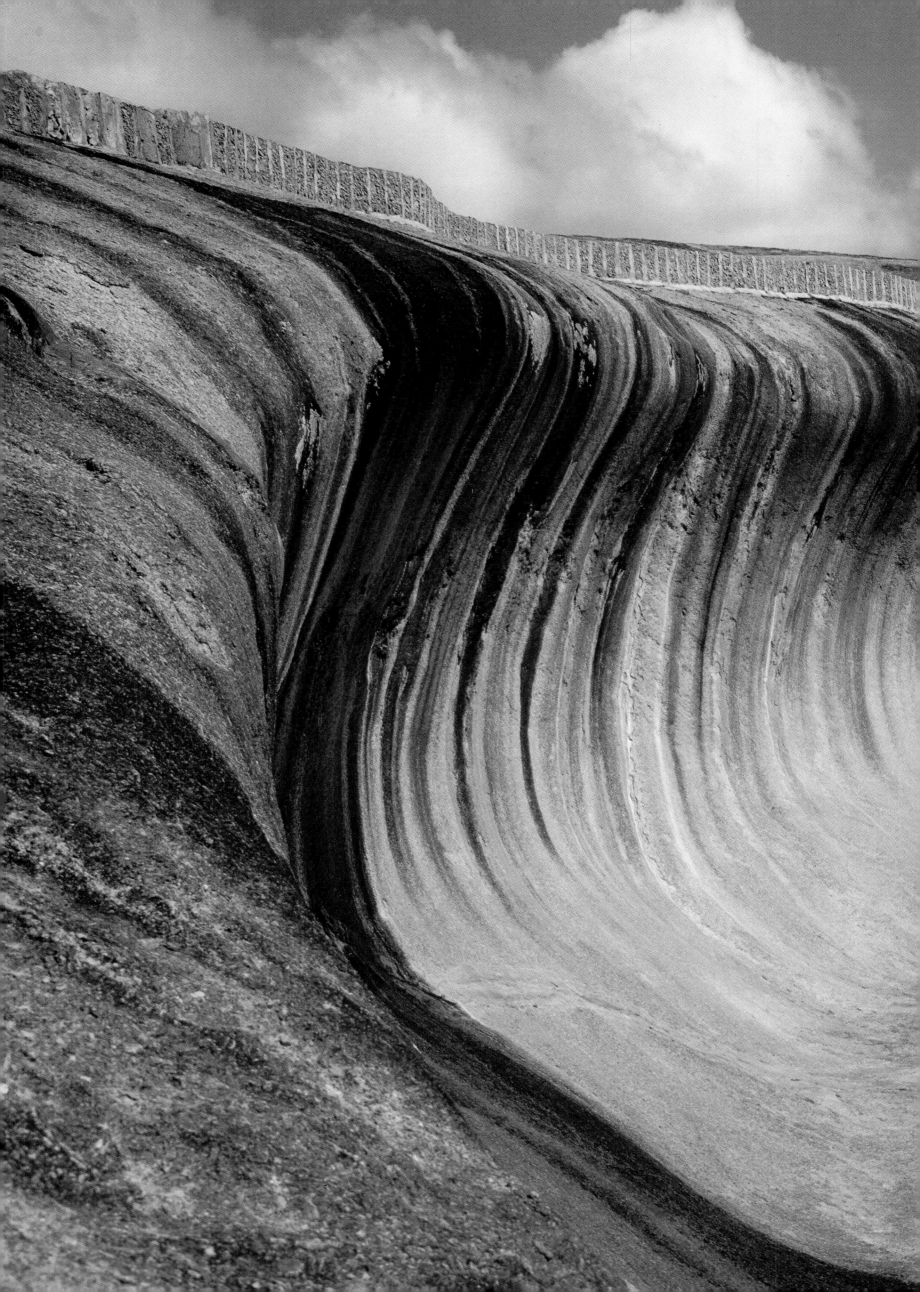

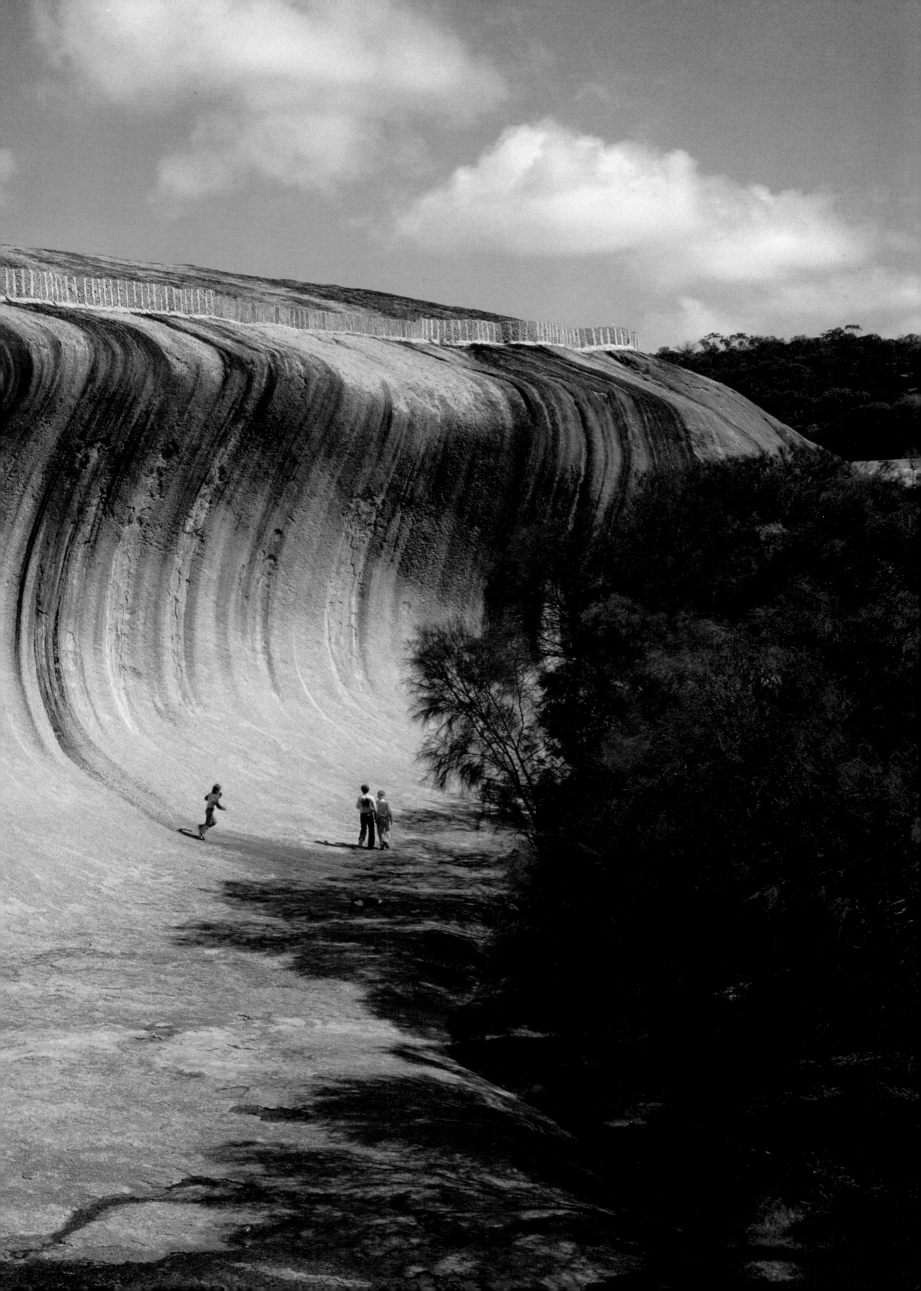

# SOUTH AUSTRALIA

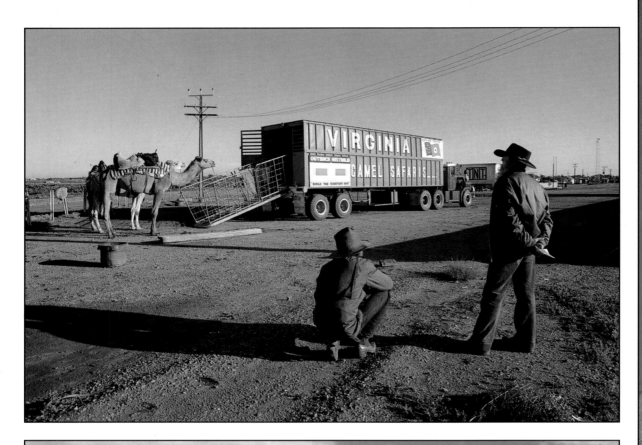

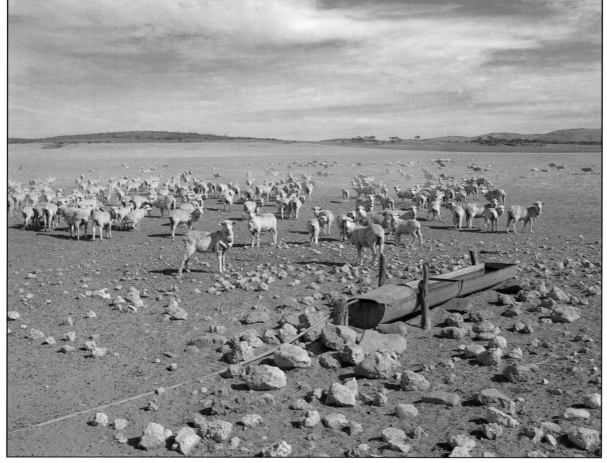

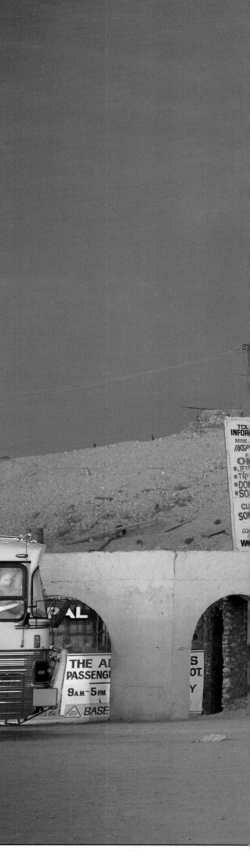

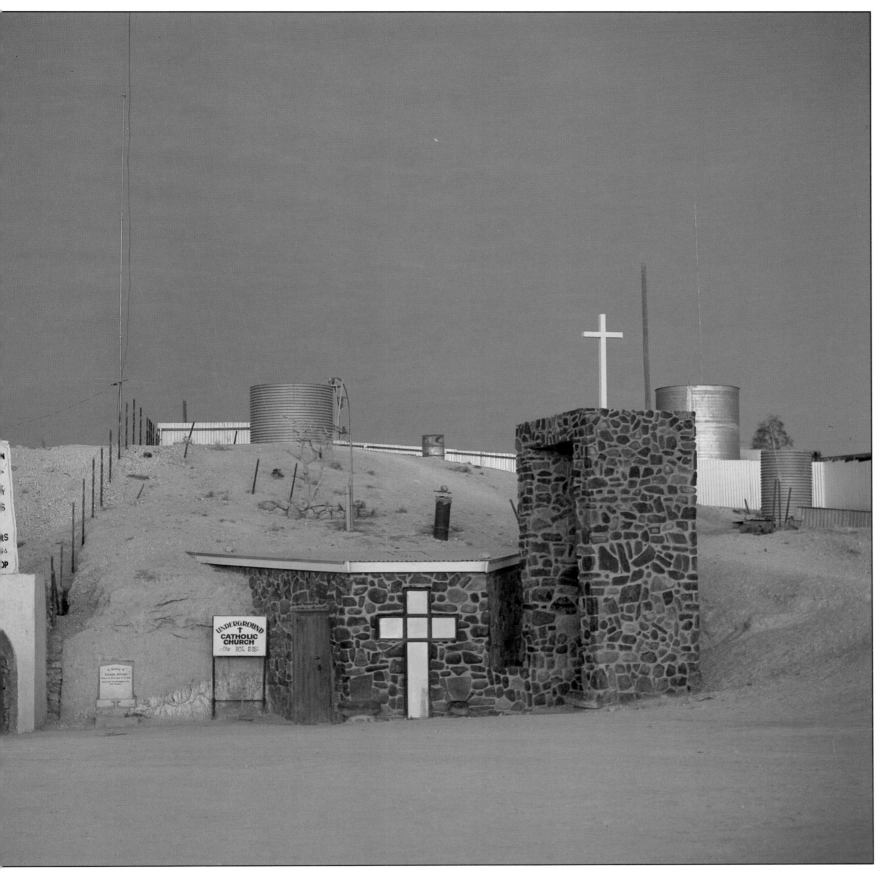

*Above: the Catholic church at Coober Pedy. Coober Pedy is one of the Outback's most famous towns. Its name means "white man in a hole in the ground" – an Aboriginal reference to the extensive opal-mining operations here, but an equally good desciption of the way the inhabitants live. As summer temperatures often soar to 113°F, Coober Pedy people have resolved to live underground. The rock is easily excavated, which has assisted the creation of a hotel, a bar and a museum, as well as many homes and shops. Above left: camel safaris, a novel feature of the Outback, and (left) sheep gathering around a life-supporting water trough in a dusty wilderness outside Cowell. In the more arid parts of Australia it takes forty acres to graze a single "jumbuck" – the Australian term for sheep – and so ranches are often spread over thousands of square miles.*

# SOUTH AUSTRALIA

*Although its name is a corruption of the Spanish for Hill of Roses, all the Barossa Valley (above) has in common with Spain is the excellence of its wine. The valley's climate and soil make it ideal for grape cultivation, and Barossa's vintners have gained a worldwide reputation. Persecuted Lutherans from Silesia and Prussia came here in the first half of the nineteenth century and by 1850 had pioneered wine-making with European grapes. Their success encouraged others. The Barossa Valley has retained its Germanic air, and grape-growing has spread so that today fine ports and dry white wines are produced just a few minutes' drive from Adelaide's city center. A tangle of fallen eucalyptus (above right) in Willowie Forest Reserve, the searing whites and blues of a saltpan (right) in the Outback beyond the town of Penong, and the arid gold and purple of Wilpena Flat (overleaf) in Flinders Ranges National Park, north of Hawker, are just a selection of the contrasting landscapes to be found in this varied state.*

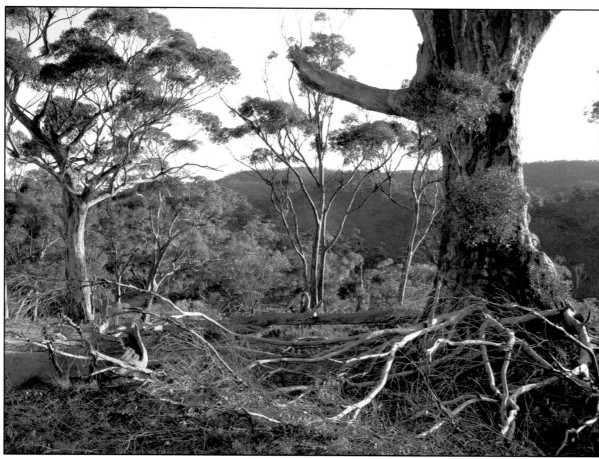

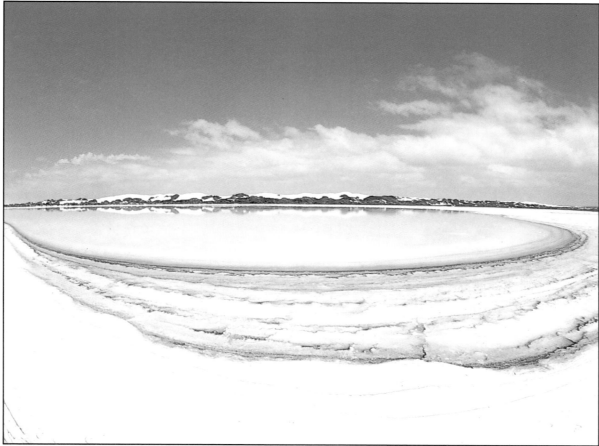

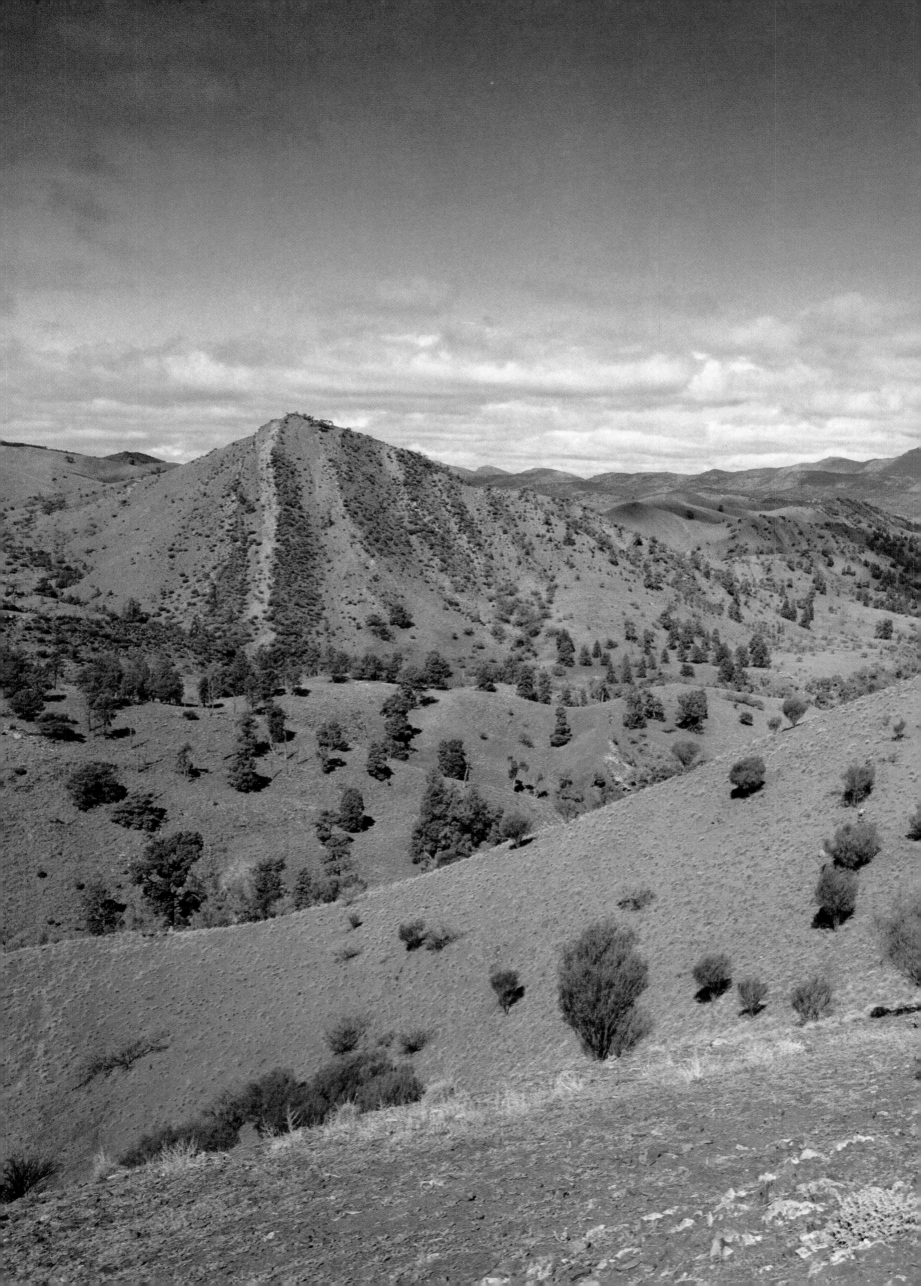

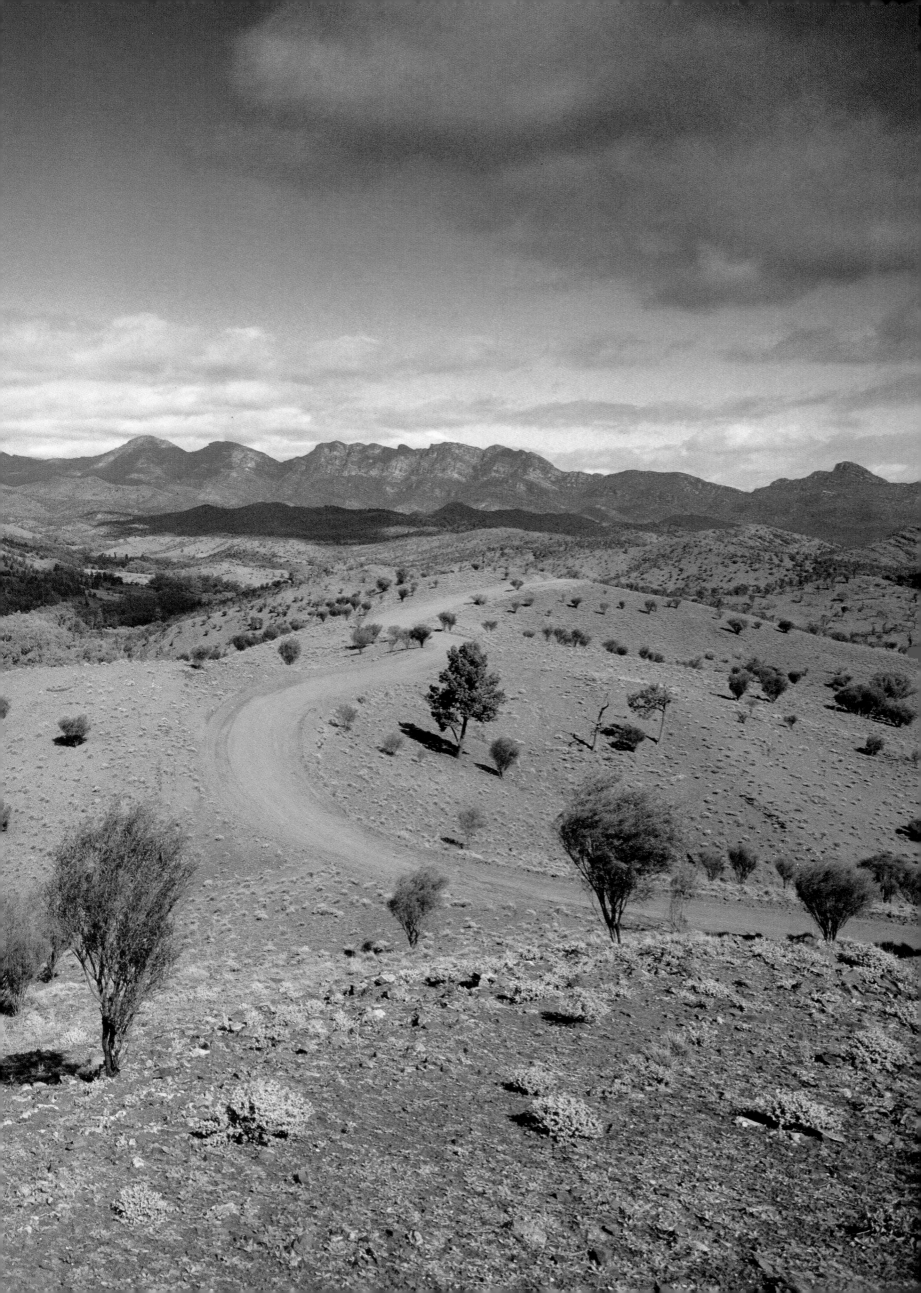

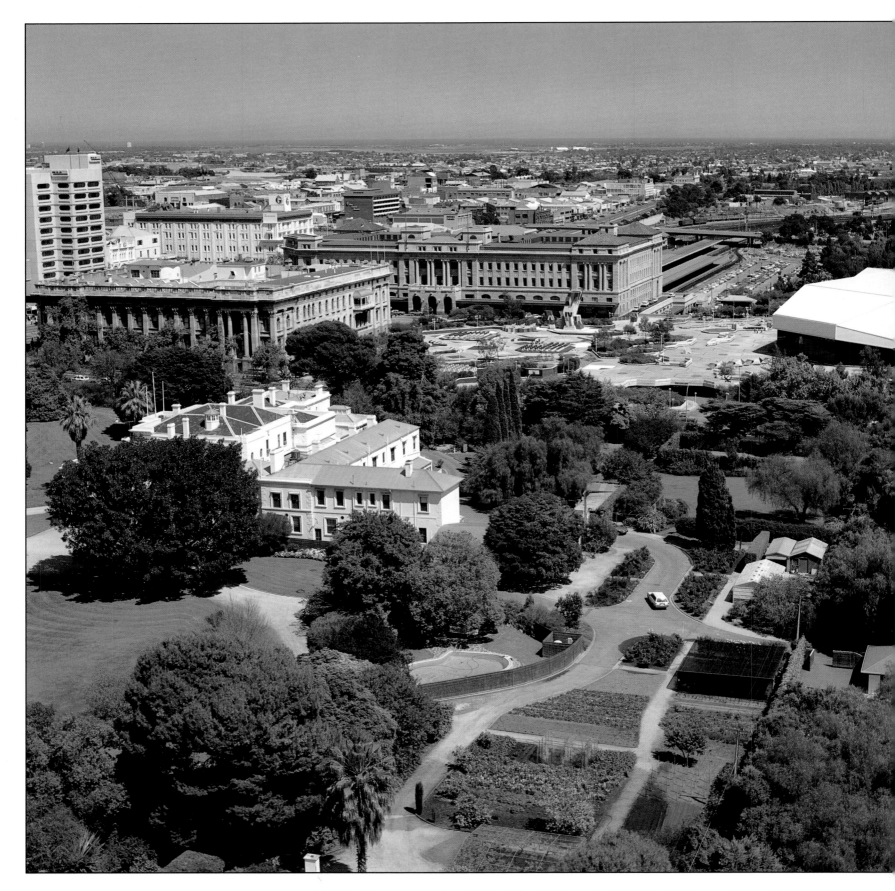

*Adelaide (these pages and overleaf) rejoices in two major festivals – the Barossa Valley Vintage Festival, which is held in odd-numbered years, and the two-week feast of ballet, theater, opera and music that comprises the autumn Festival of Arts, held on even-numbered years. The quality of these functions – the arts festival is Australia's premier arts event – have earned South Australia's capital the name "The Festival State," and its Festival Centre (above and right), a complex that includes a concert hall and an open-air amphitheater, comes into its own at this time. St. Peter's Church of England Cathedral (above right and overleaf), the headquarters of the Anglican church in South Australia, is recognized as being one of the loveliest in the country.*

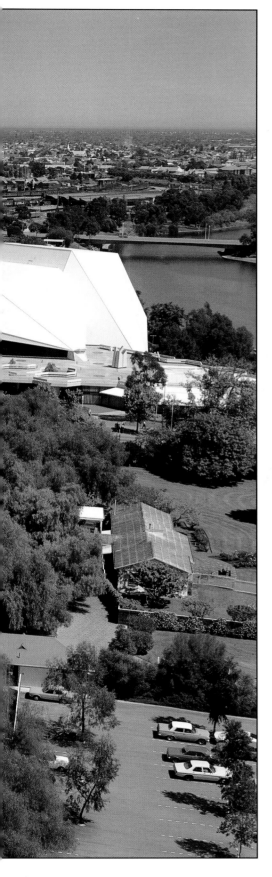

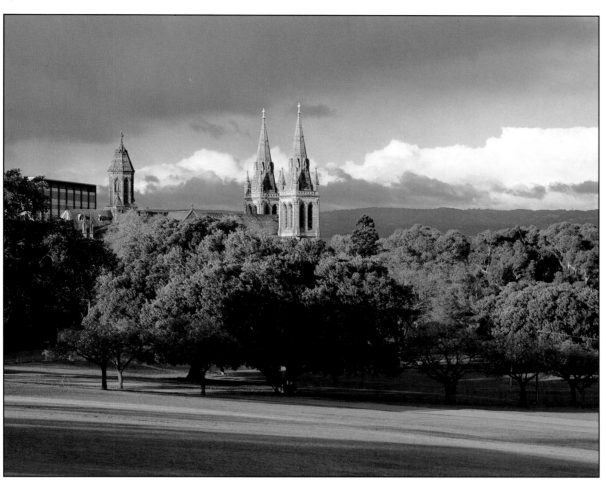

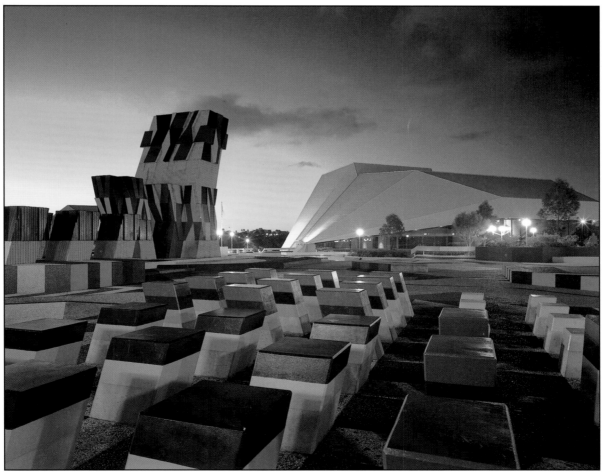

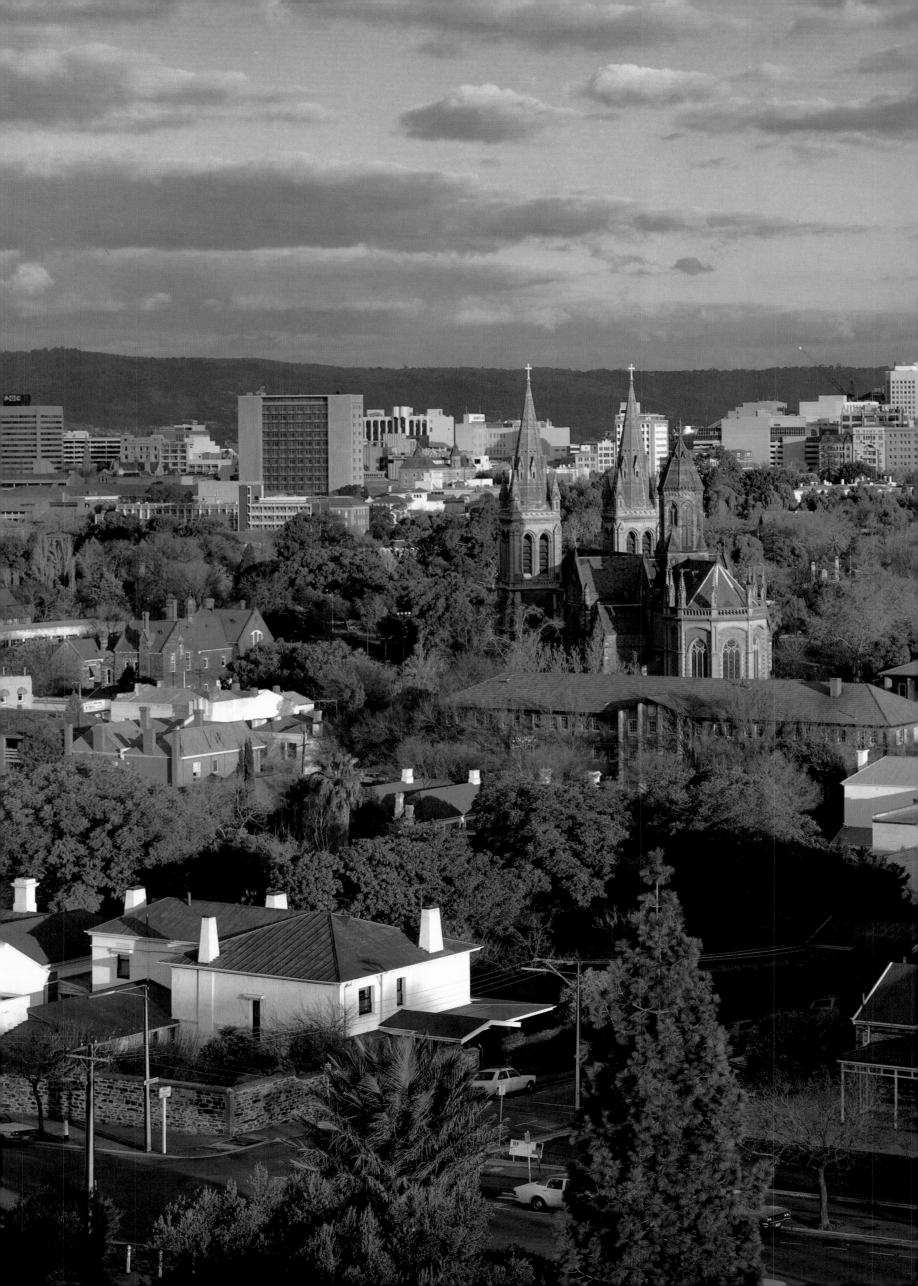

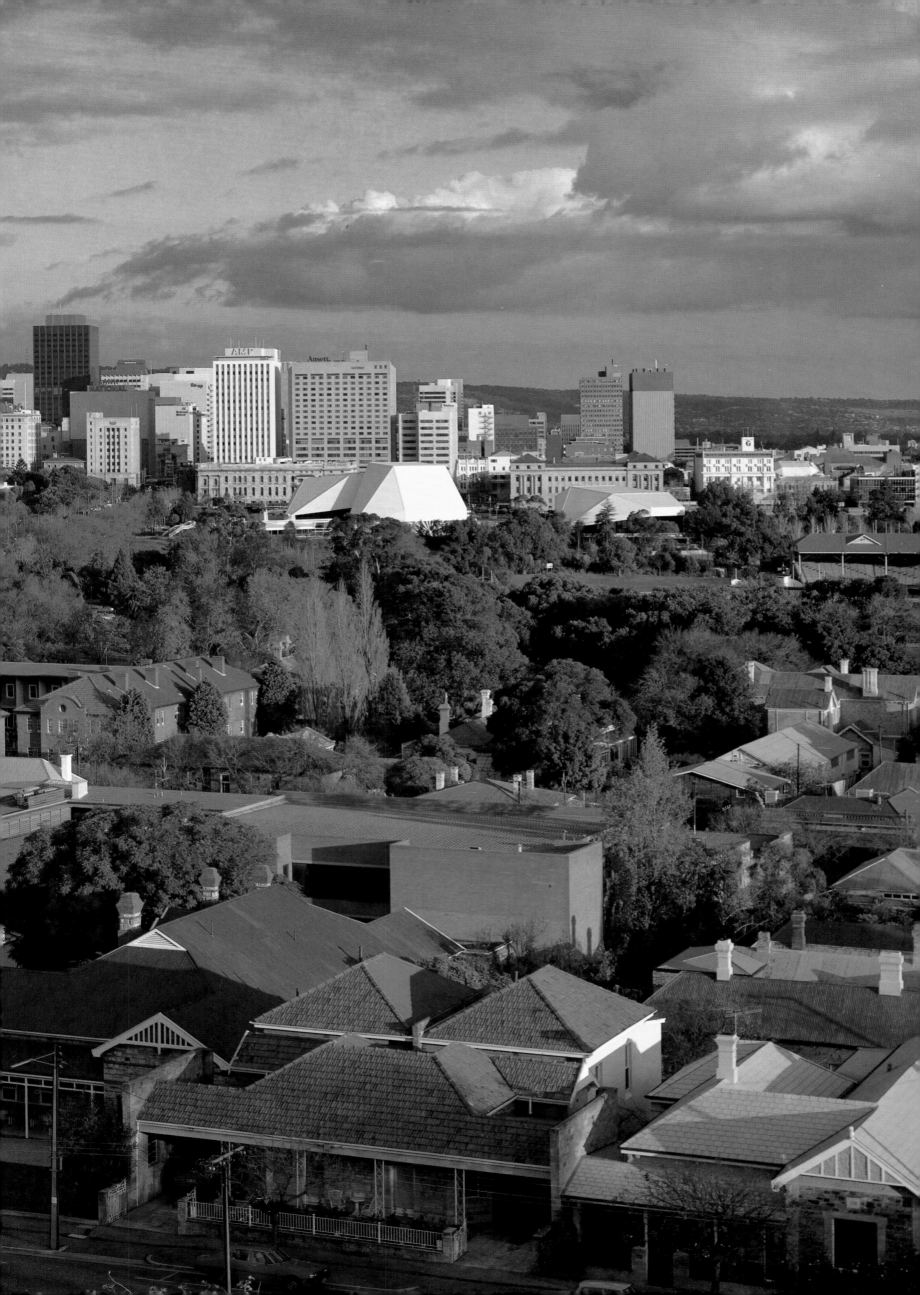

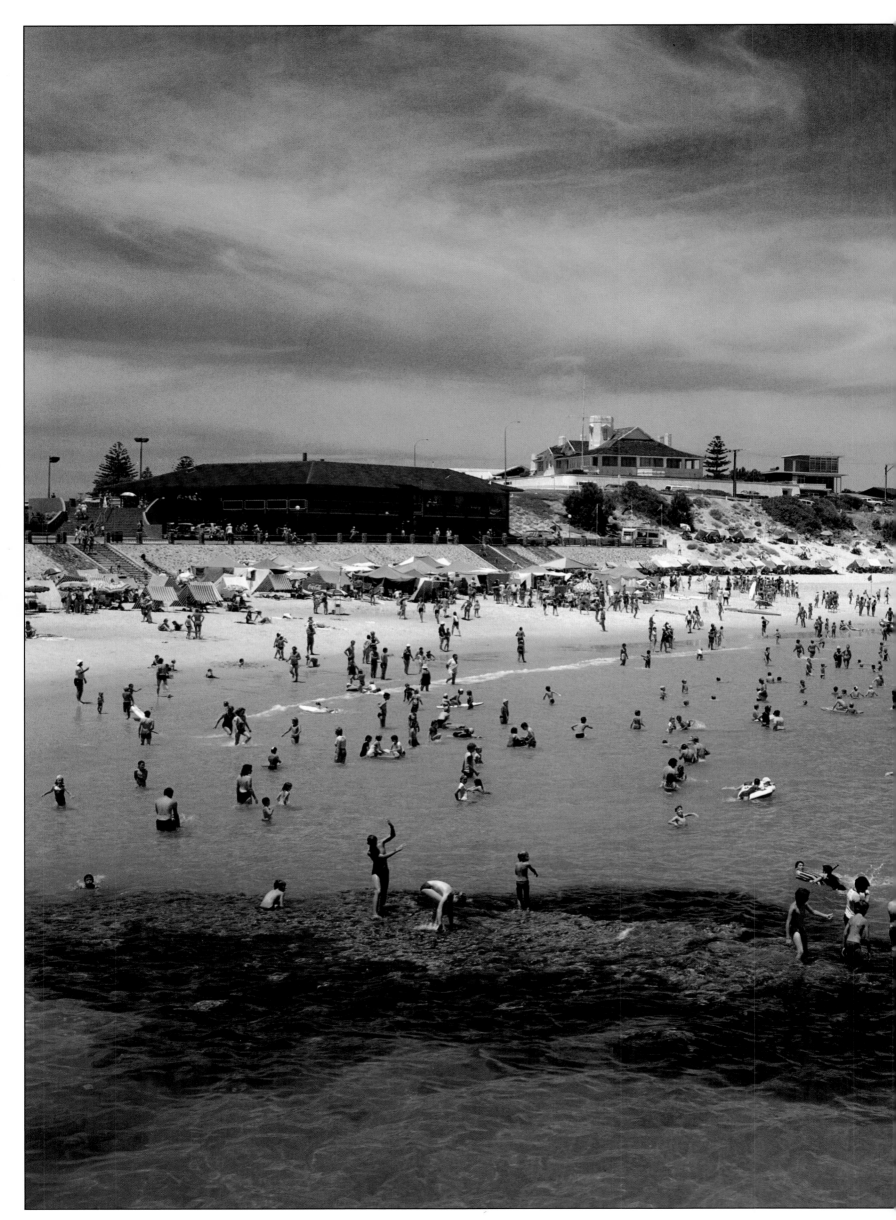

*Left: Christies Beach, a popular resort near Port Noarlunga on the Fleurieu Peninsula south of Adelaide. Such wide, sandy beaches attract daytrippers from Adelaide. Magnificent surfing and fishing can be had off the Fleurieu Peninsula – dubbed "Blue Fin Country," the waters along the entire length of South Australia's coast make every kind of sea sport possible. Big game fishing has yielded a 2,663 pound white pointer catch in the past – a world record – and commercial fishing is big business. The use of spotting aircraft has increased the efficiency of professional fishing operations and catches today include tuna, shark, and Australian salmon.*

49

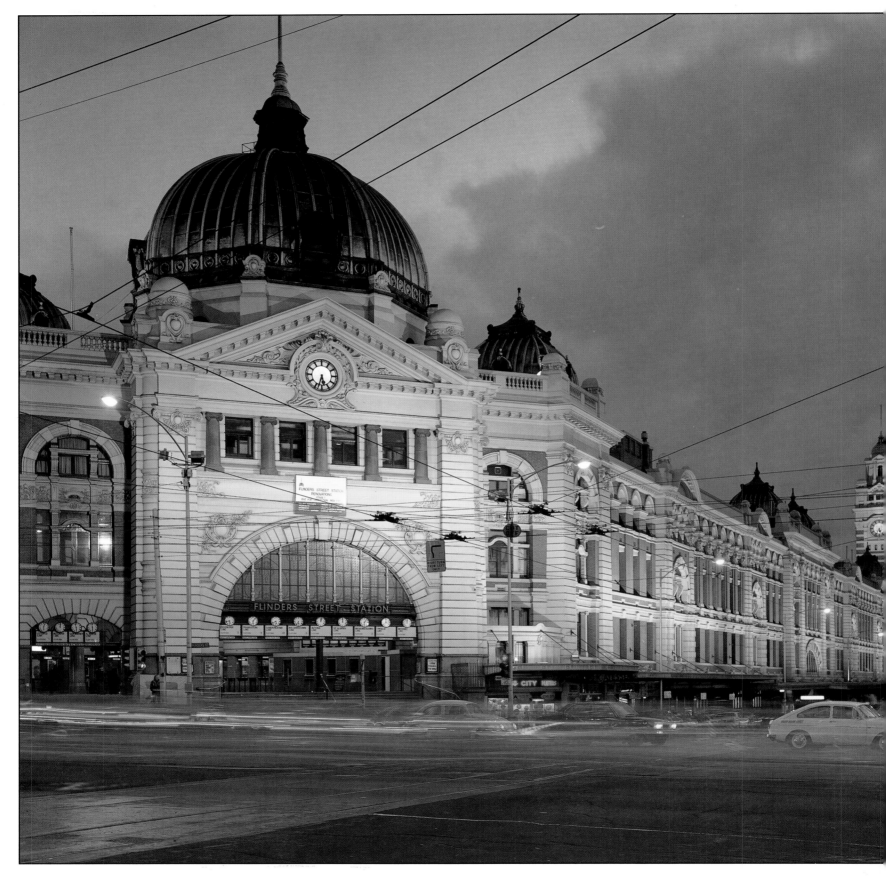

*Above and overleaf: Flinders Street Station in the heart of Melbourne, the capital of Victoria. This station and the city's Exhibition Building (right) display a type of nineteenth-century architectural opulence quite common in this, the seat of Australia's establishment and the country's most stately city. Not everything about Melbourne is traditional, however; the city boasts a thriving financial sector that centers on an area of modern skyscrapers, while across the Yarra River from Flinders Street Station gleams the very stylish Victorian Arts Centre (top right). The center's white metal spire soars to almost 400 feet and can be seen from virtually everywhere in Melbourne, but the main buildings lie below ground – a decision taken to avoid spoiling the beauty of the surrounding land. A performing arts museum, a major art galley, a fine concert hall and three theaters are just part of this vast, multi-million-dollar complex, a fitting addition to a city that can justifiably claim to lead Australia in the performing arts.*

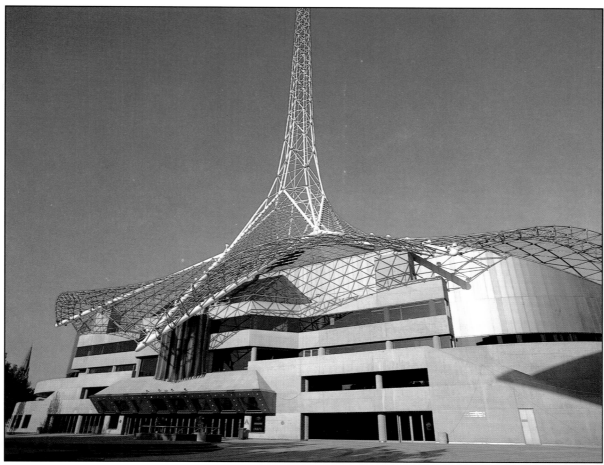

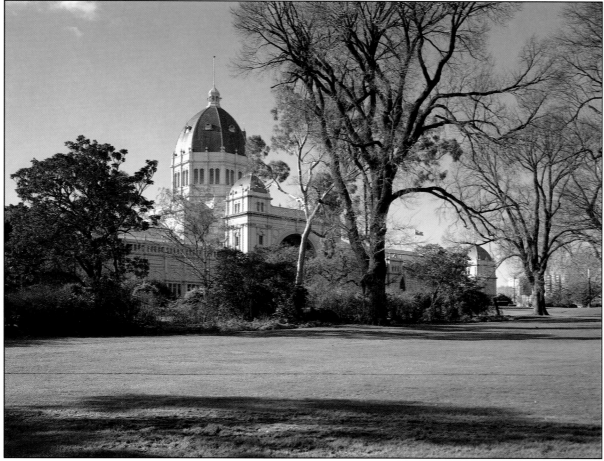

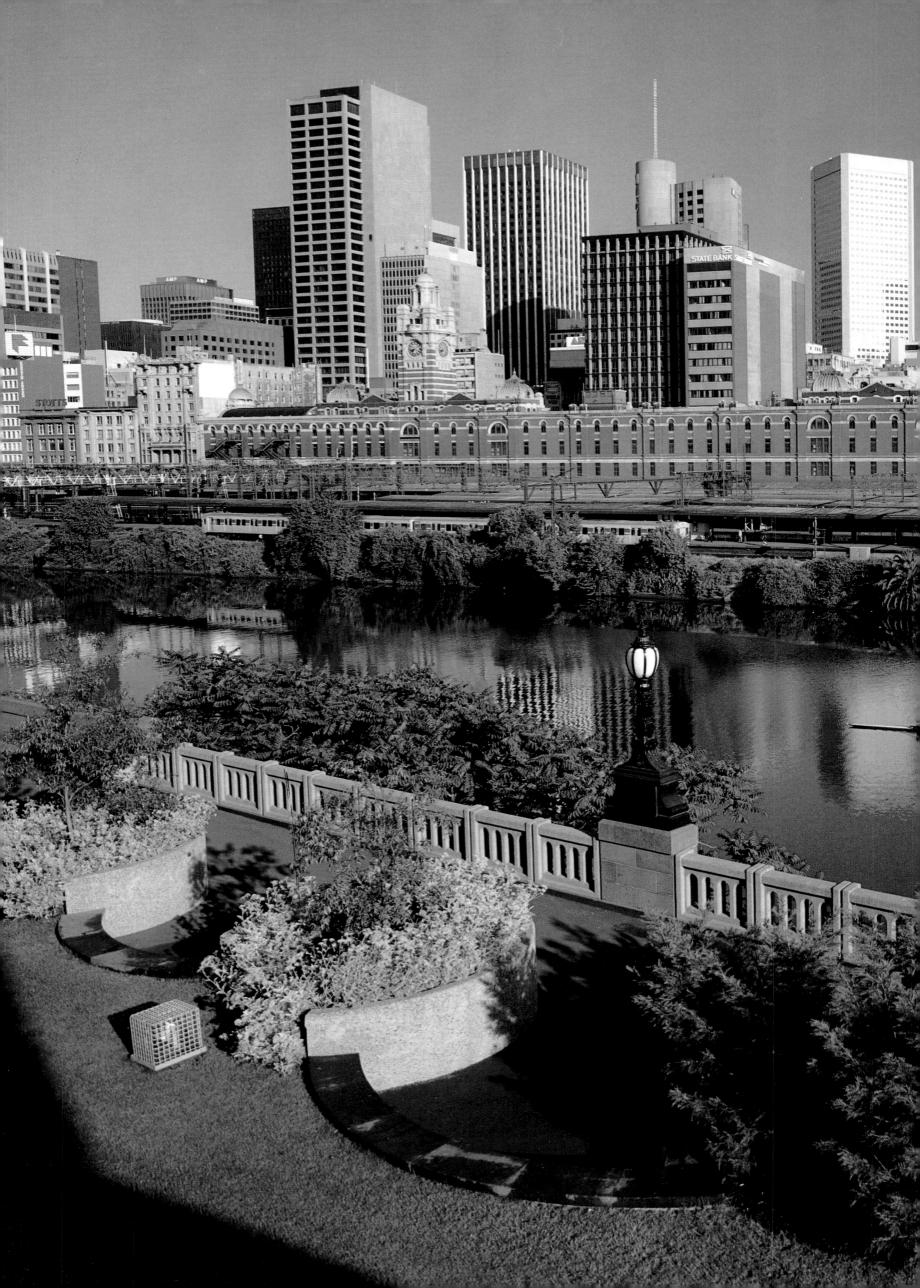

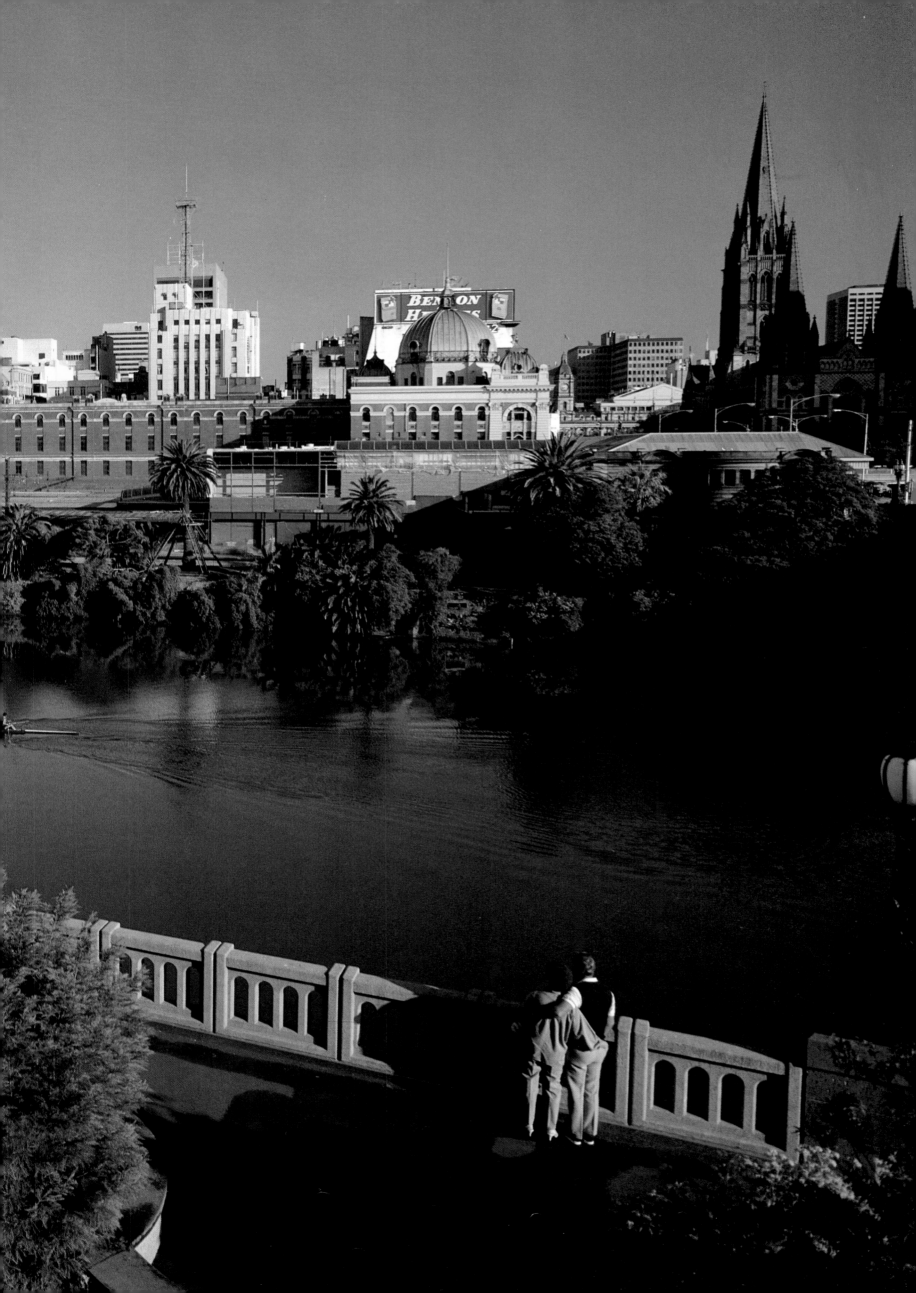

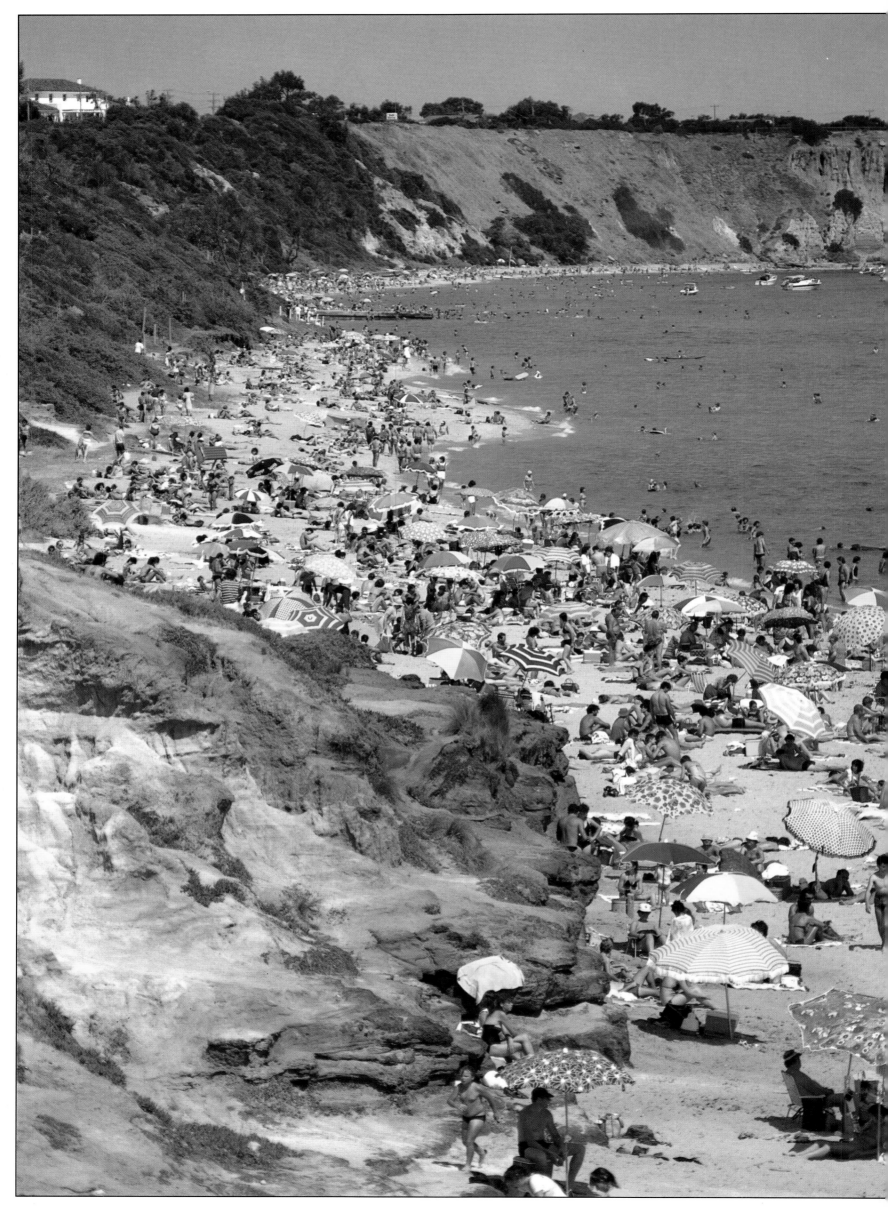

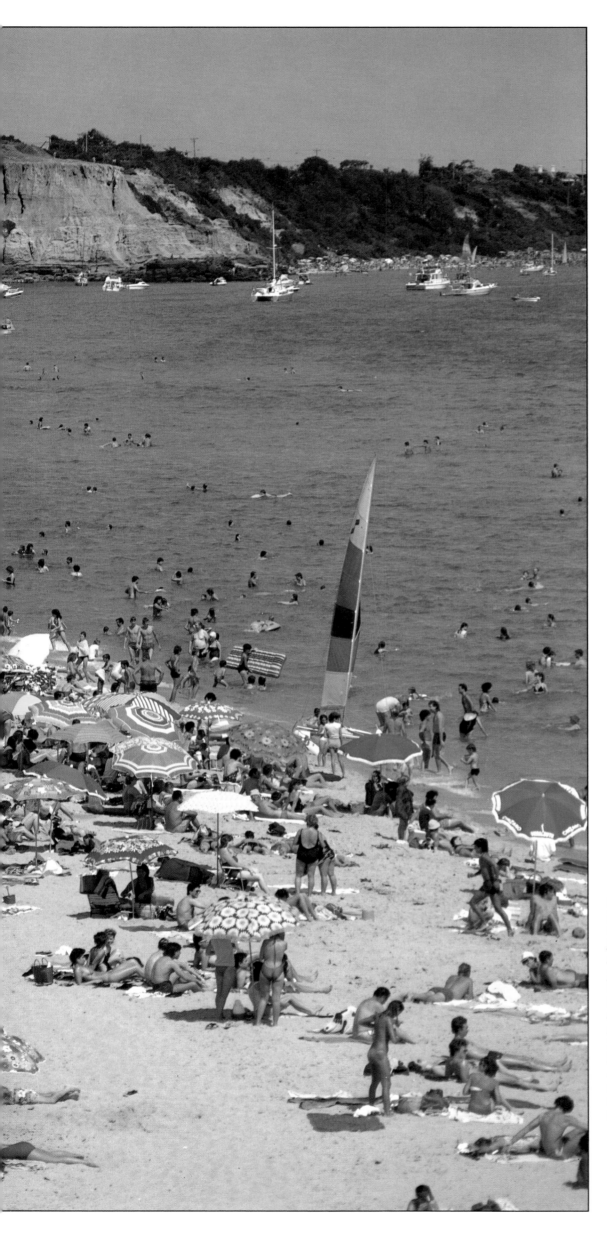

*Crowds stake their sunshades on Sandringham Beach, a recreation area close to Melbourne on the east side of Port Phillip Bay known as the Mornington Peninsula. Melbourne can boast sixty miles of splendid bathing beaches along this peninsula, nearly all with calm water, shady trees, and picnic grounds. Port Phillip Bay is on the quiet side of the peninsula – on the ocean side of Mornington, which faces Bass Strait, the seductively beautiful beaches have claimed lives. Though it is tempting to do so, tackling the heavy surf here can be extremely dangerous: the Australian Prime Minister, Harold Holt, disappeared while swimming off Cheviot Beach in Bass Strait in 1967 – so strong are the currents there that his body was never found.*

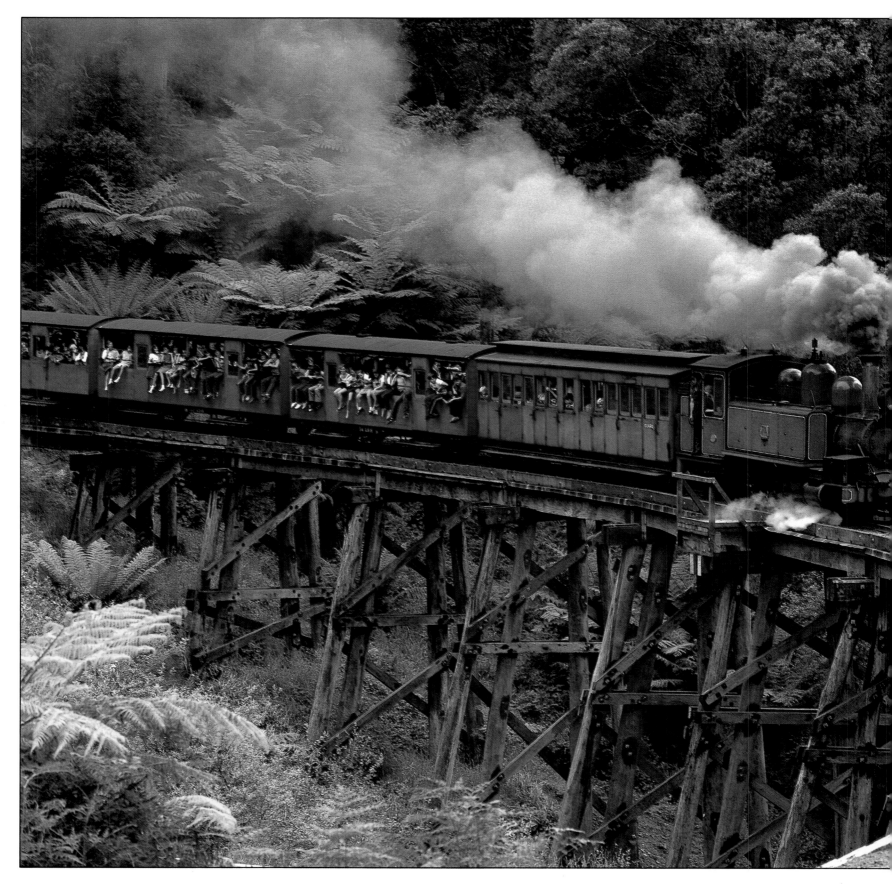

*Above: Puffing Billy, a famous vintage steam train staffed by volunteers that operates along an eight-mile track through the forests of the Dandenong Ranges. These mountains, which lie twenty miles east of Melbourne, are an extension of the Great Dividing Range. Always popular with visitors for their cool climate and lush vegetation, the hills provide a sanctuary for a variety of native wildlife too. Above right: a post office in the Swan Hill Pioneer Settlement, a collection of exhibits that comprises one of the best outdoor museums in the state. Here costumed staff operate, among other attractions, a blacksmith's, a steam workshop, a general store and a bakery, all in early colonial buildings. Right: a Sovereign Hill stagecoach, one of the features in a recreated gold-mining town near Ballarat. In 1853, when gold was discovered in the Owens River valley, dozens of such mining towns were built and three million ounces of gold were mined in fourteen years.*

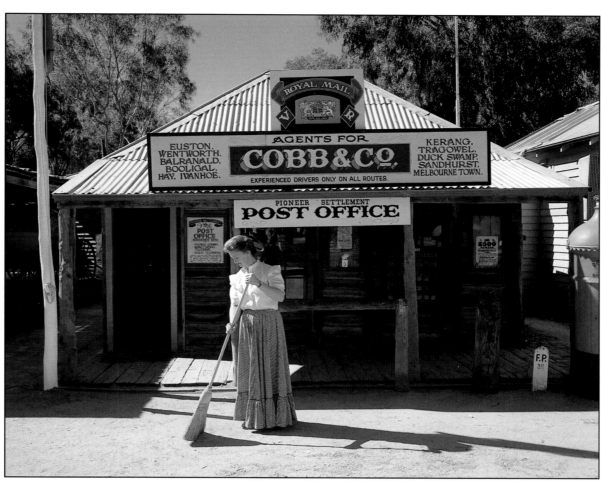

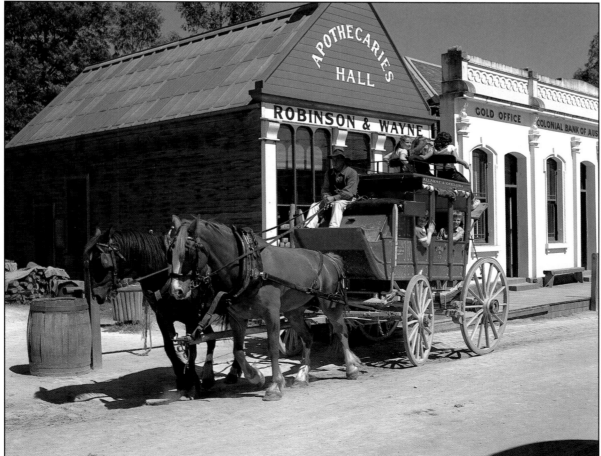

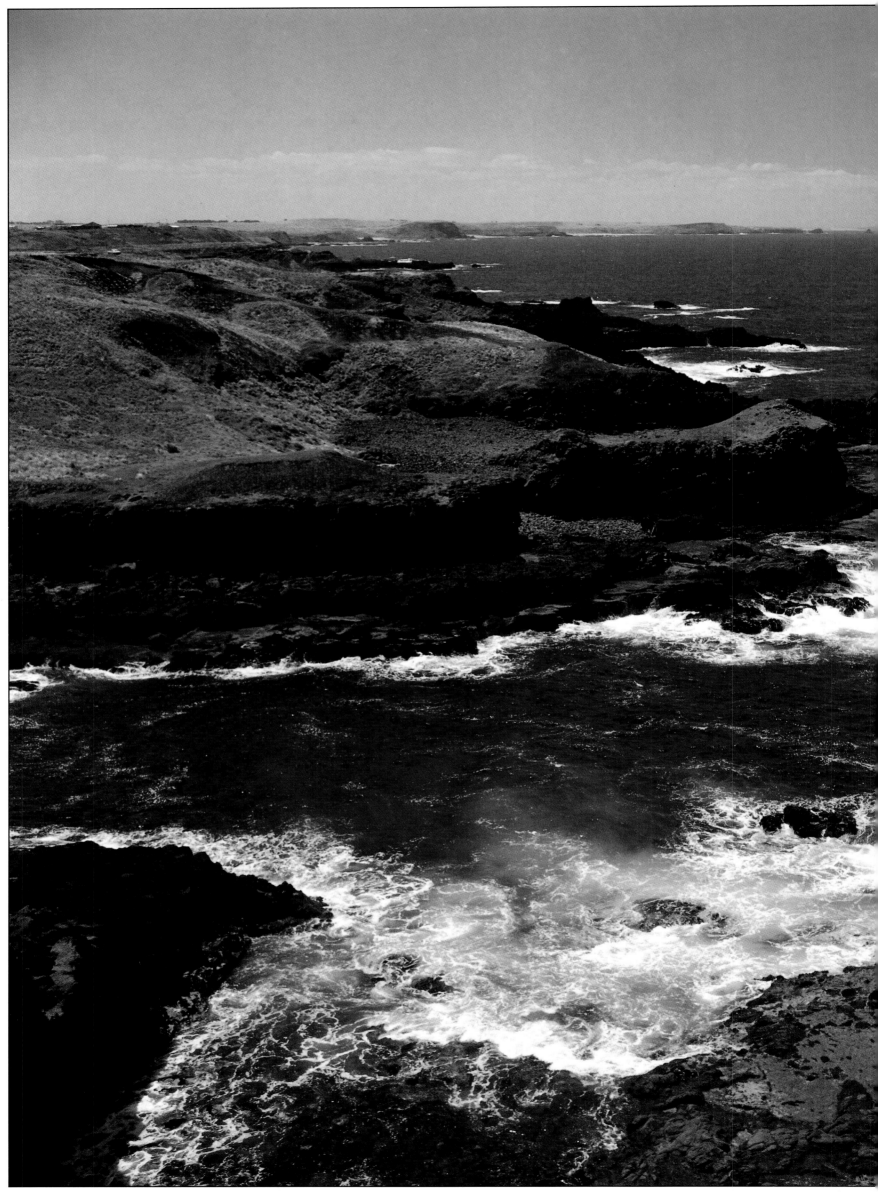

VICTORIA

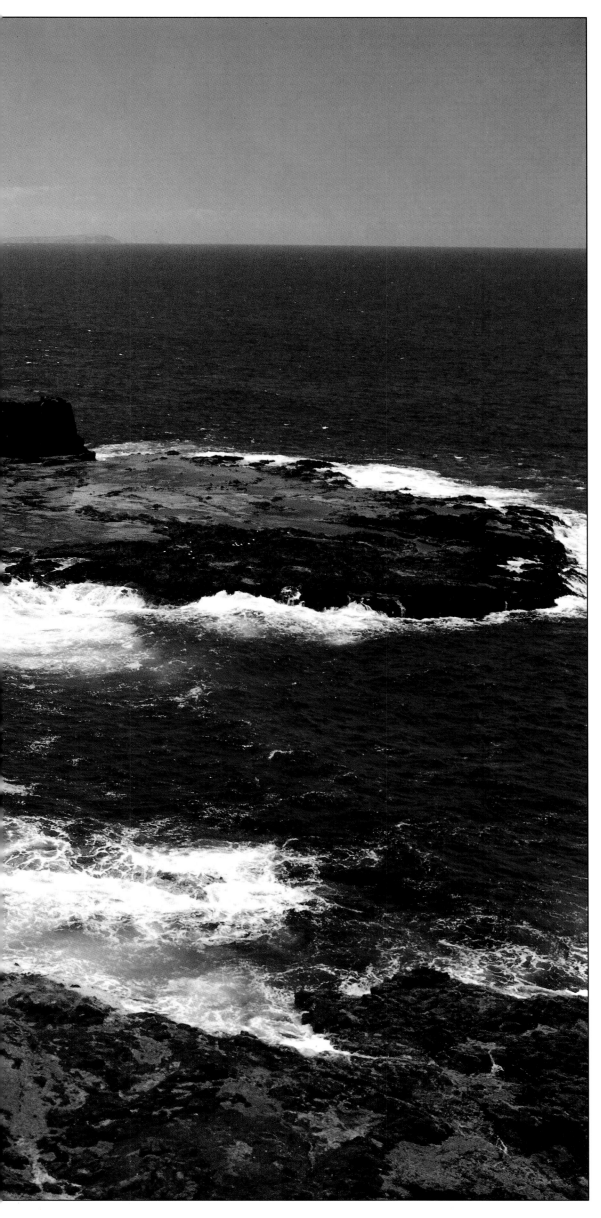

Below the stark headland at the southwest tip of Phillip Island stands a cluster of rocks known as The Nobbies (left). Here lives an established colony of some 5,000 fur seals, which can be seen from the headland with the use of telescopes. Phillip Island, a special place for animals, is renowned for its fairy penguins, which waddle back from the sea each evening, quite unperturbed by the people assembled to watch them. After the monolith Ayers Rock and the Great Barrier Reef, these penguins are Australia's greatest tourist draw. Further west along the Victorian coast lies Port Campbell National Park, the best known feature of which is the Twelve Apostles, a group of twelve golden towers of sandstone (overleaf) that rise several hundred feet above the sea.

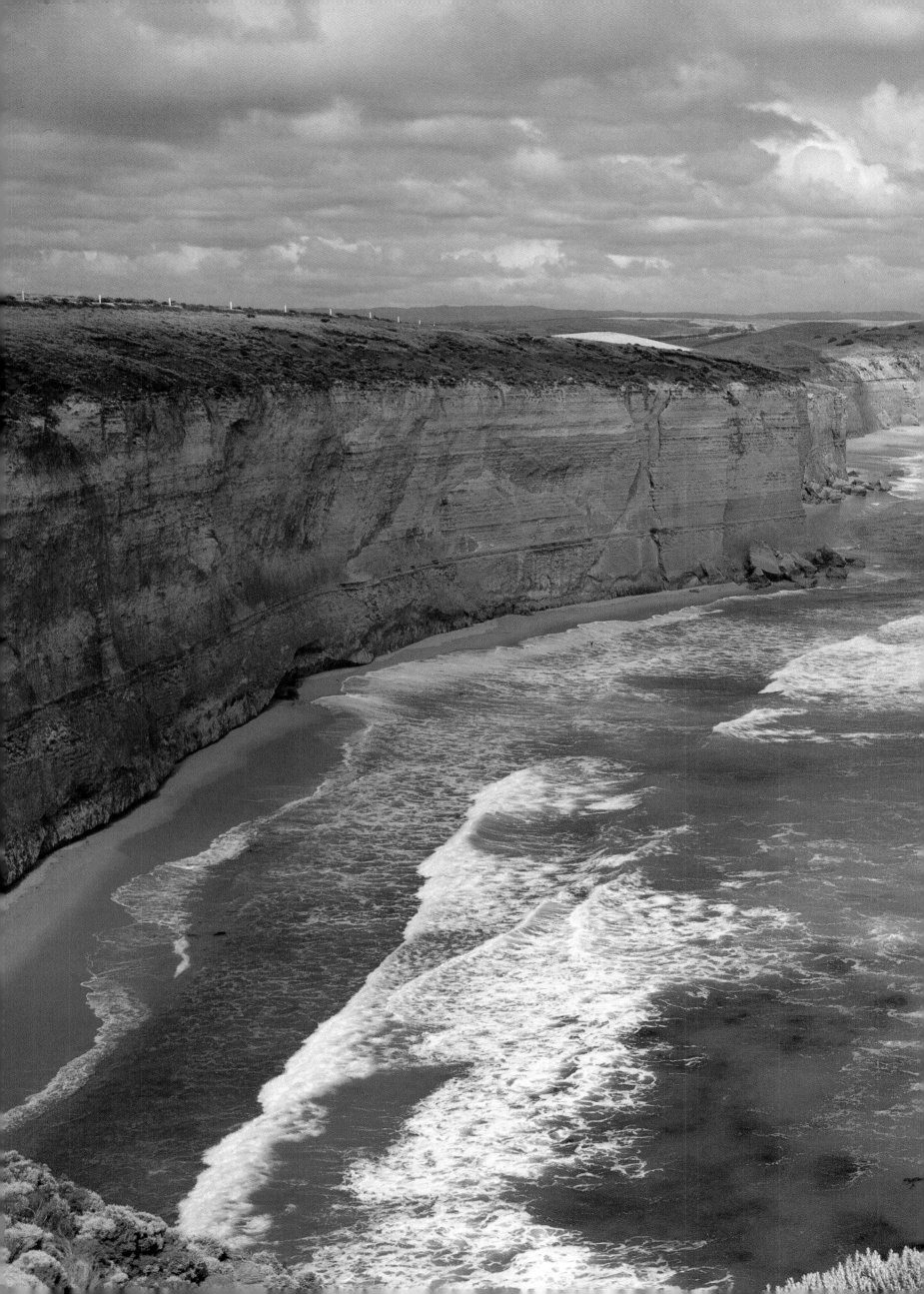

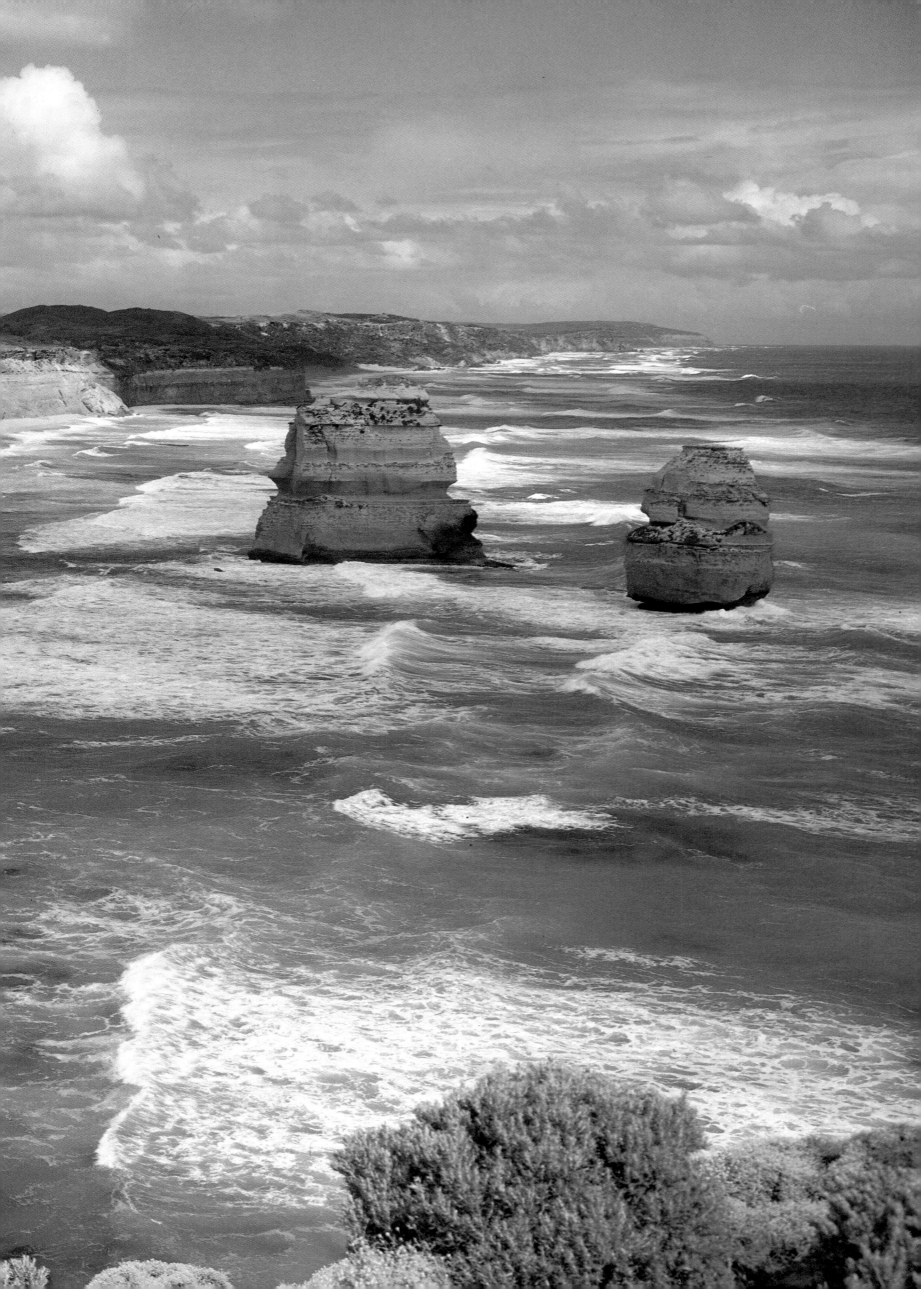

# VICTORIA

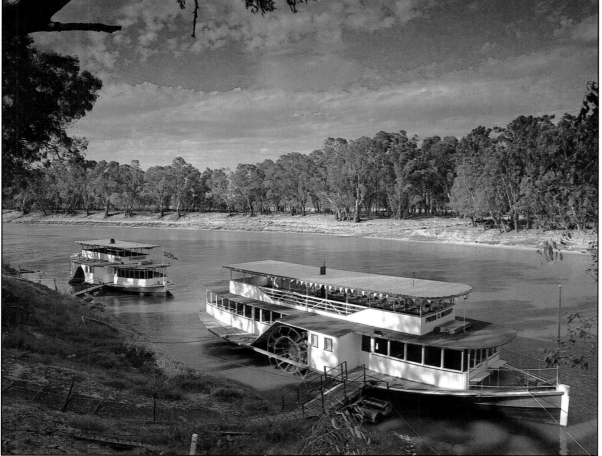

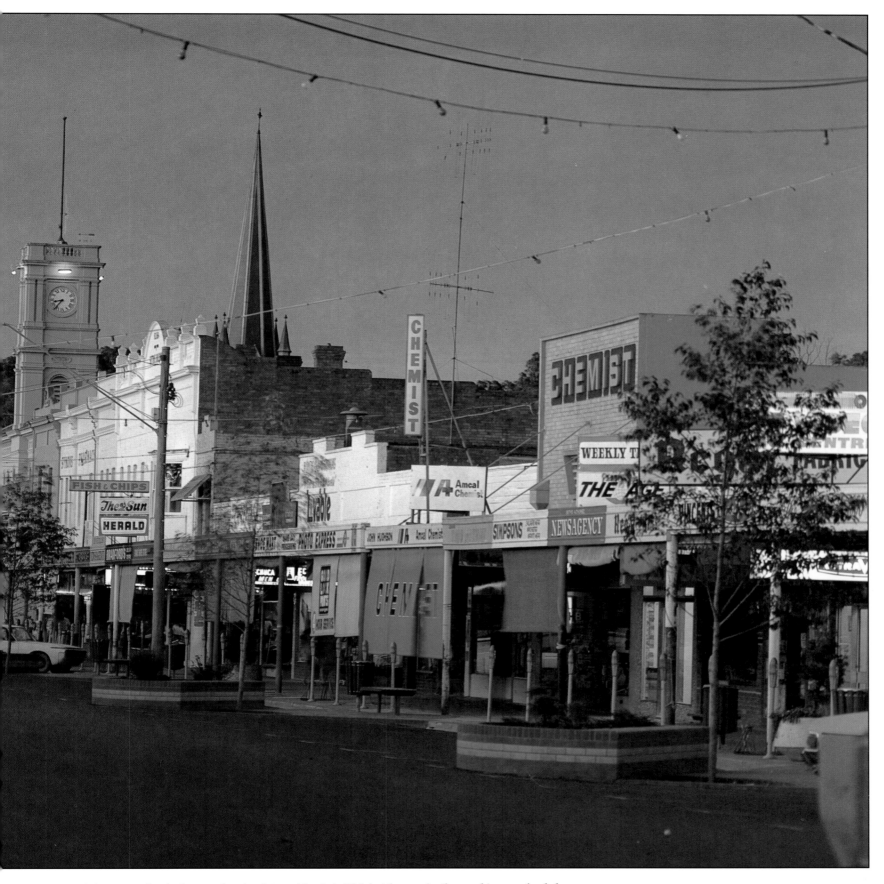

*Above left: reputedly the longest bar in the world – it is 298 feet long – in the workingmen's club at Mildura in the far northwest of the state. Mildura, set in a citrus-growing area, also claims to have the largest fruit-juice factory in the world and was responsible for constructing the biggest deckchair and the biggest talking Humpty Dumpty on earth – all of which are successful in their purpose of attracting visitors. Set beside the Murray River, this town offers cruises down Australia's chief waterway, as does Echuca (left and above), which was once the country's largest inland port for paddle-steamers en route to South Australia. When railways replaced the river as a means of transport, Echuca's importance diminished, but the river's did not – today it serves a vital role as a source of irrigation for the region's thriving agricultural produce: rice, cotton and linseed. Overleaf: Squeaky Beach in Wilson's Promontory National Park.*

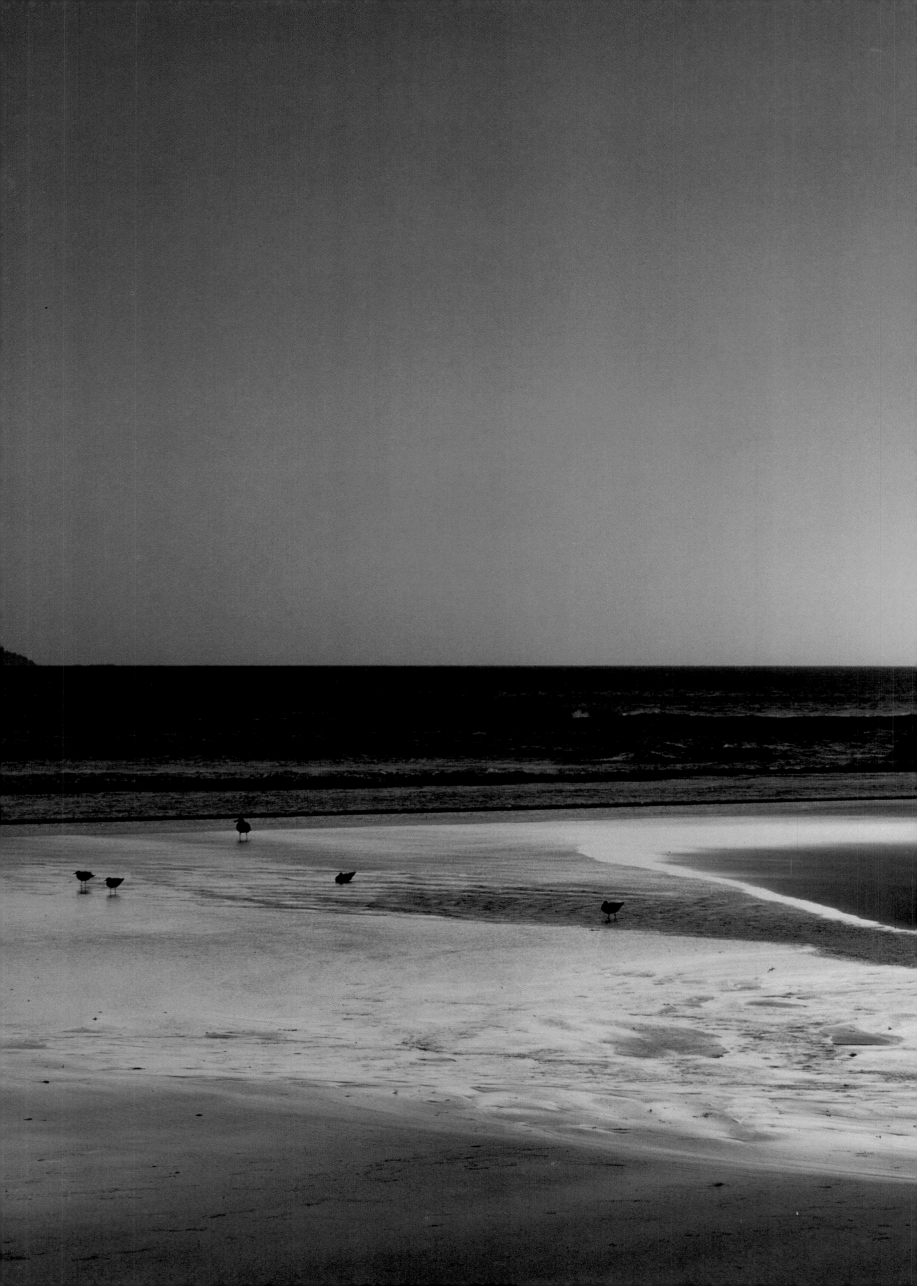

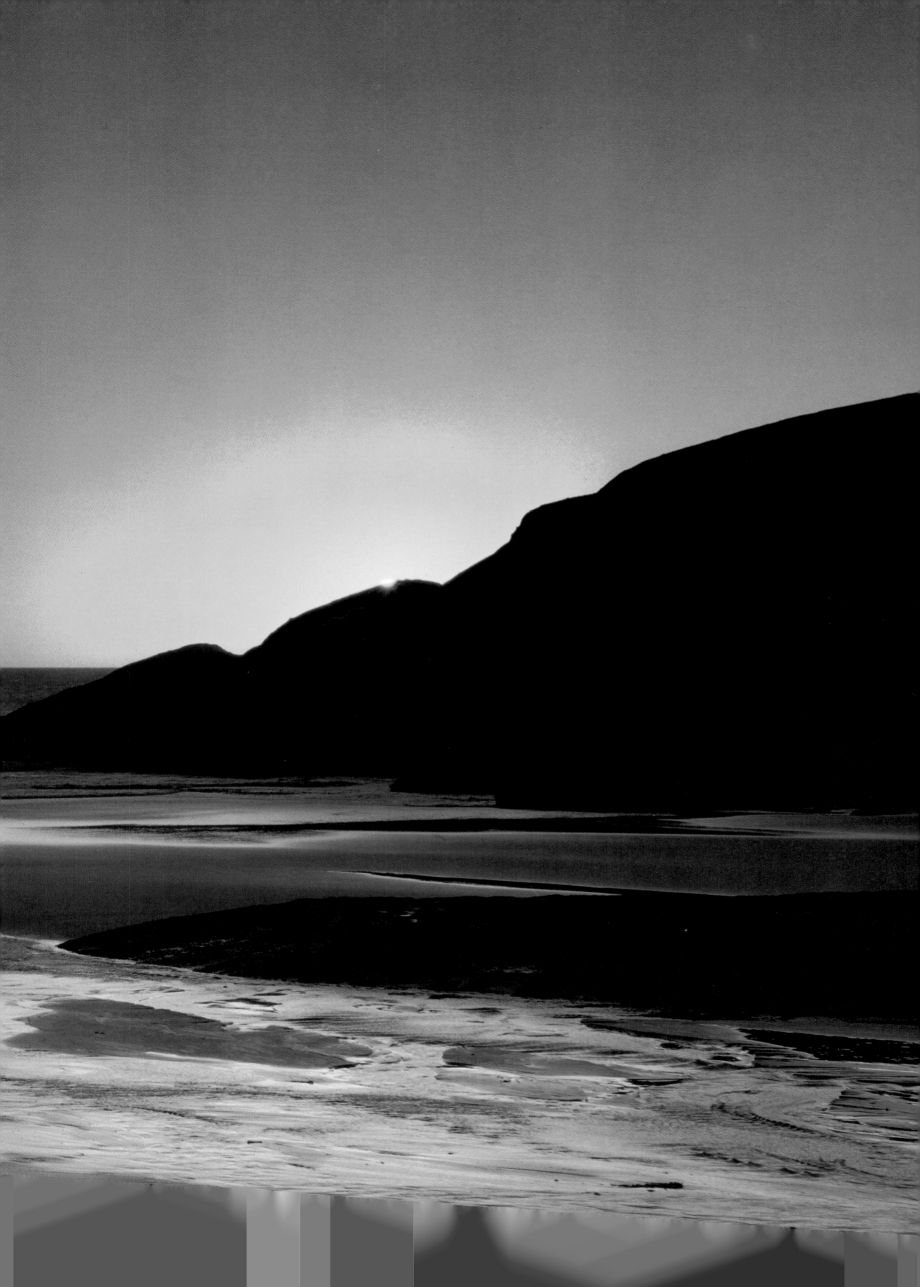

# TASMANIA

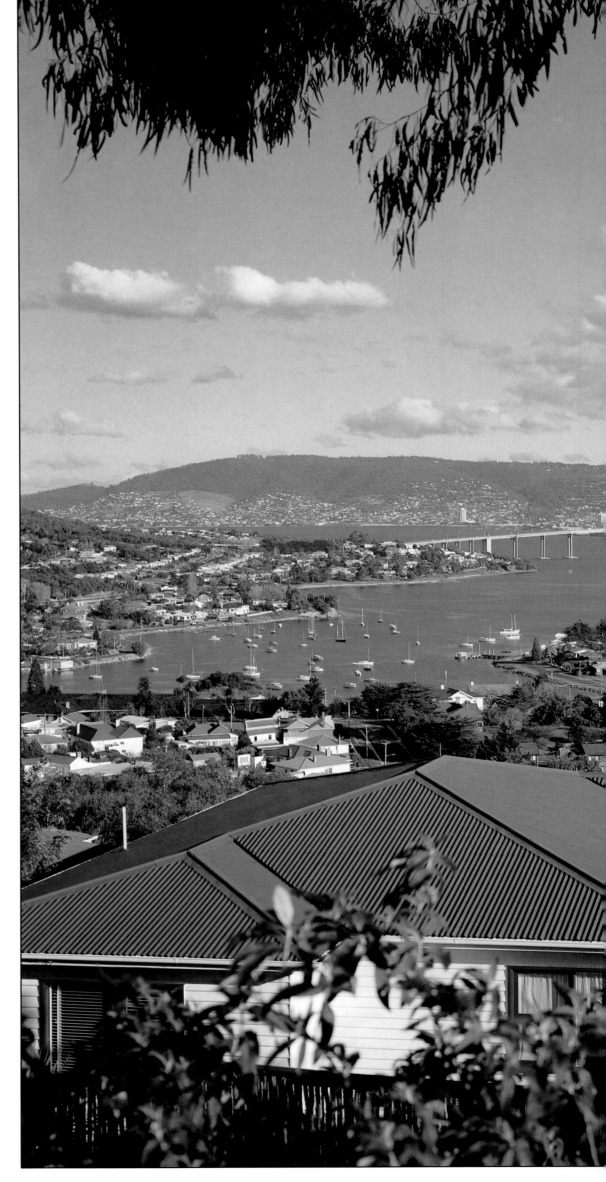

The capital of Australia's smallest state, Hobart (right and overleaf) is the country's second oldest city after Sydney and the nation's most southerly. Founded in 1804 by the British – who were eager to stake their claim to the island before the French did – Hobart was built by convict labor: the English saw the island as the ideal place for a penal colony. Once the convicts had served their time, they were given grants of land and could settle and farm. Today, Hobart's best known feature is the first legal casino in Australia, a distinctive round tower that overlooks the Derwent River in the suburb of Sandy Bay, but in a city full of well-preserved historical buildings there is still much to remind the visitor of Hobart's colorful colonial past.

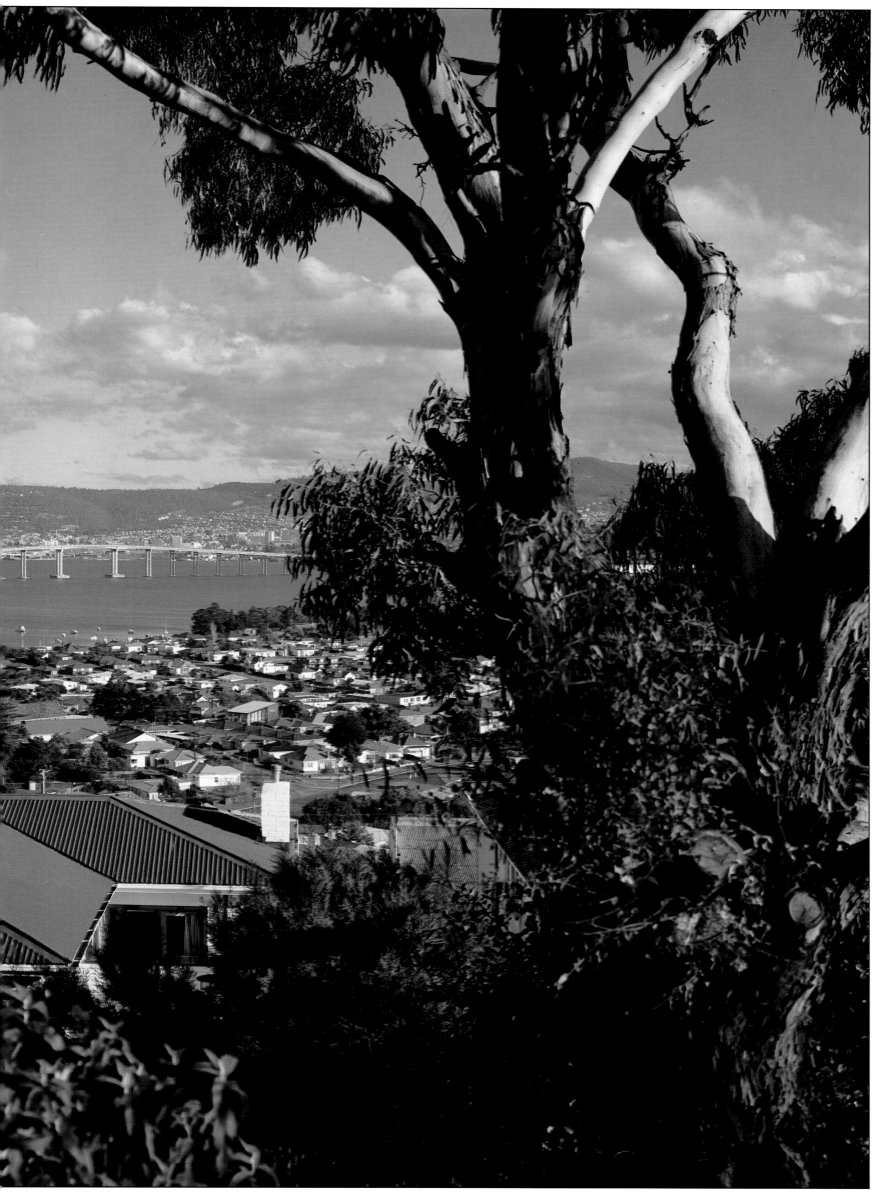

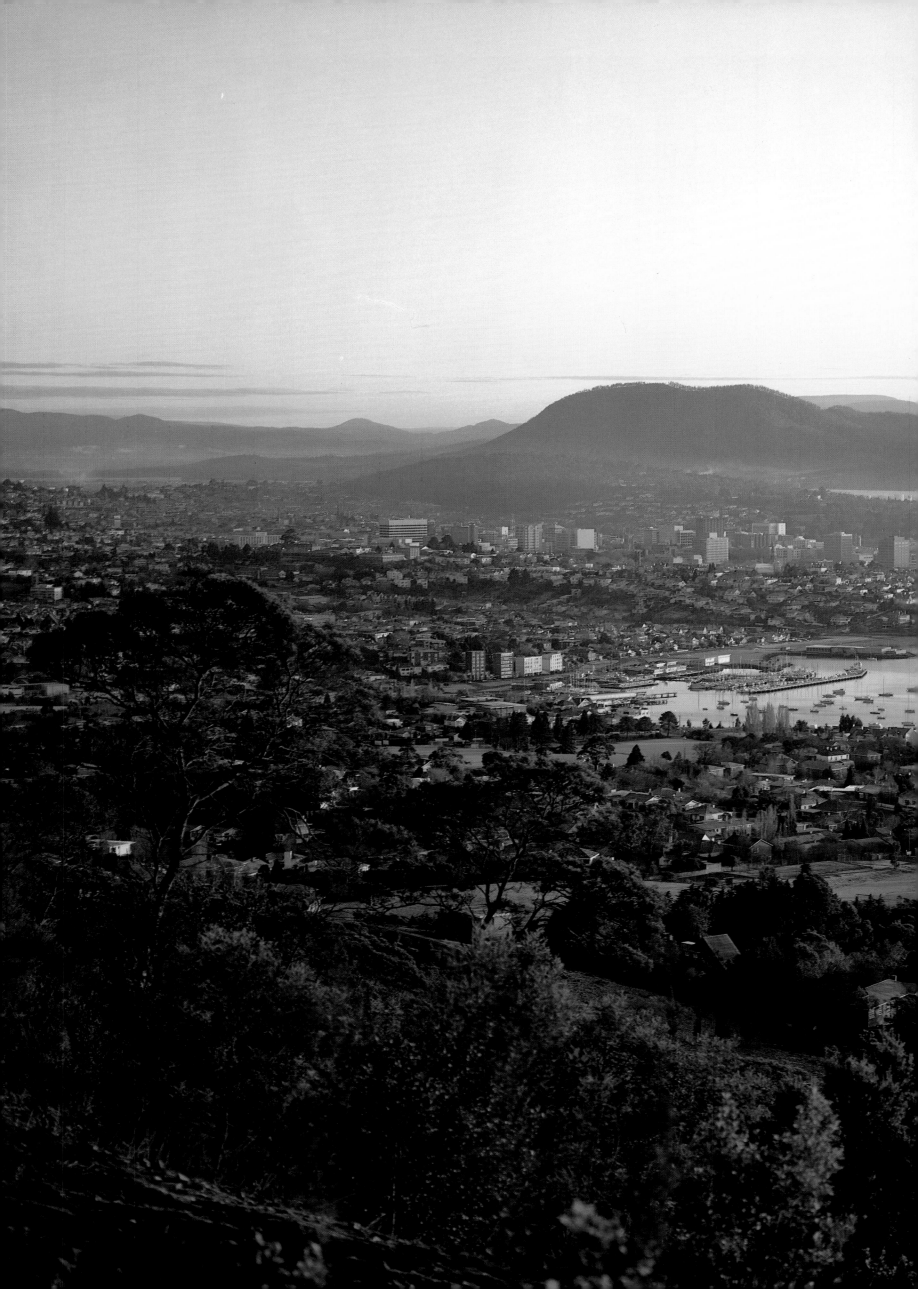

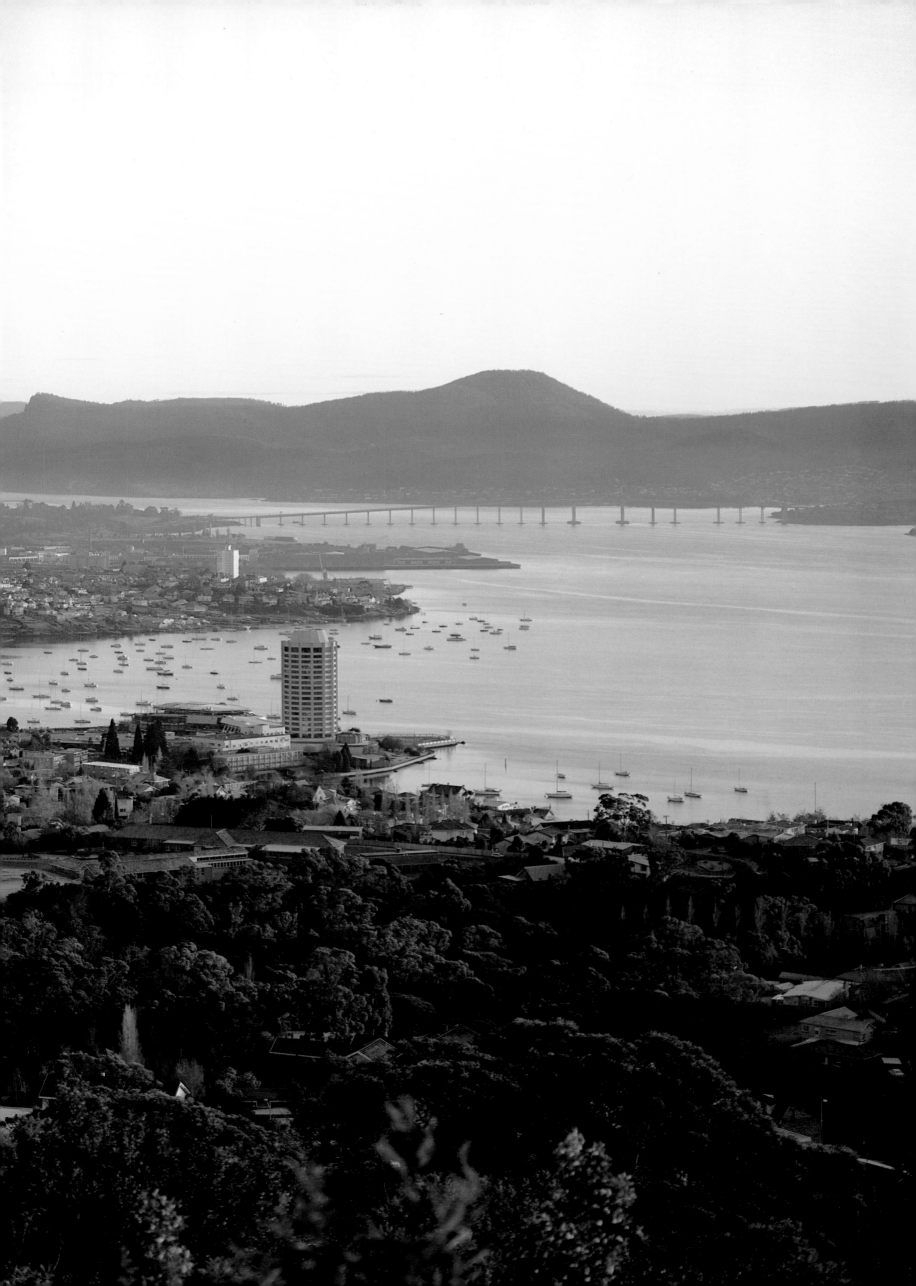

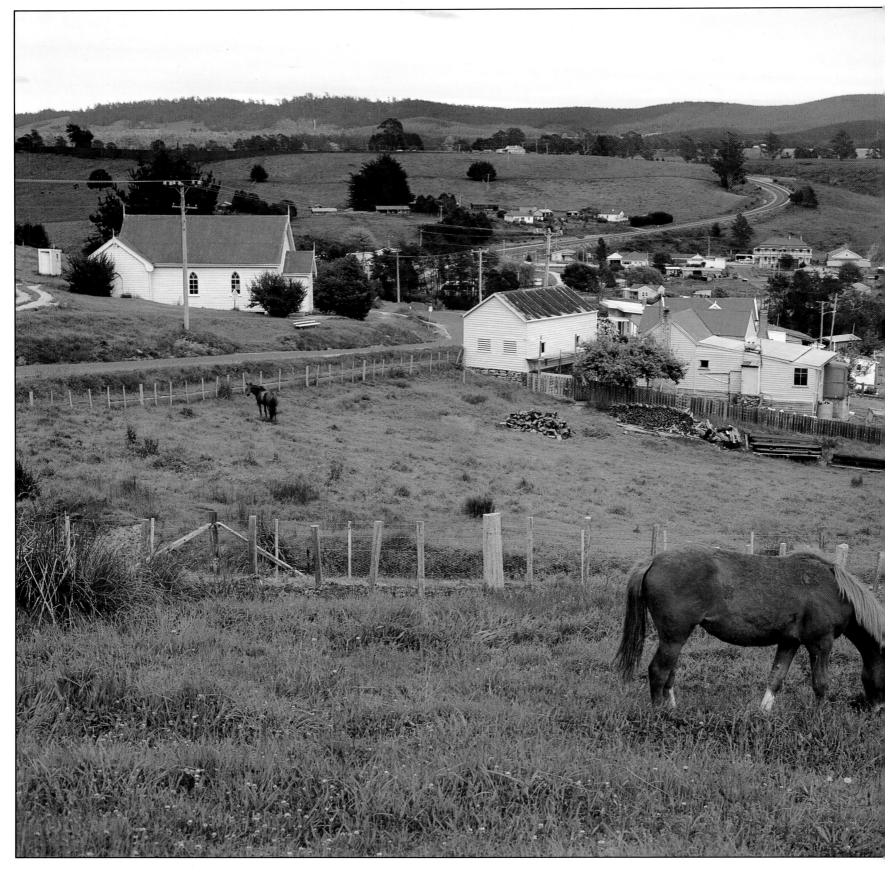

*Right: hop fields near Glenora, in the Derwent Valley near Hobart, in the south of the island, (above right) Ulverstone farmland in northern Tasmania, and (above) a chestnut yearling grazing alone in Branxholm, a former tin-mining village on the Tasman Highway. Northern Tasmania is blessed with fertile soil and is rich in minerals, a combination that has ensured the region considerable wealth. Long-established farming families here proudly trace their ancestors back to the first settlers and there is a general sense of Englishness in the architecture – even the farms, with their walled or neatly fenced fields, are reminiscent of the Old County. Overleaf: red pond weed forms an oddly colored foreground to pasture near Ouse, northwest of Hobart.*

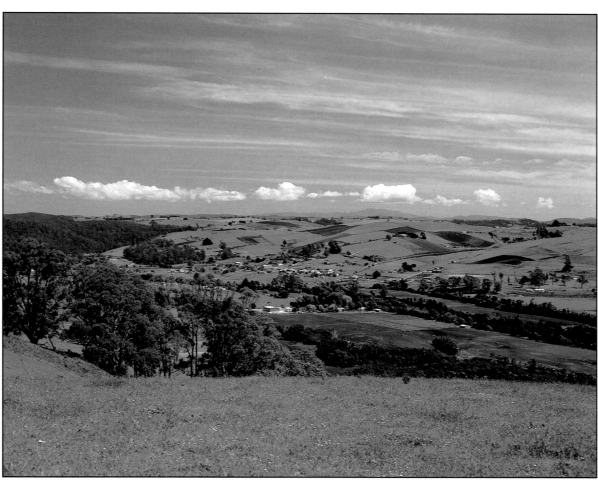

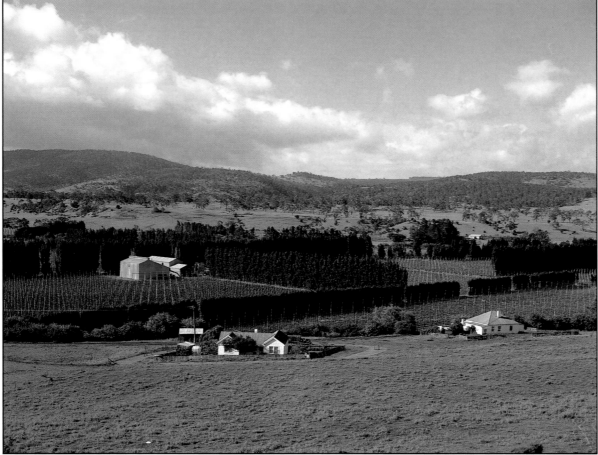

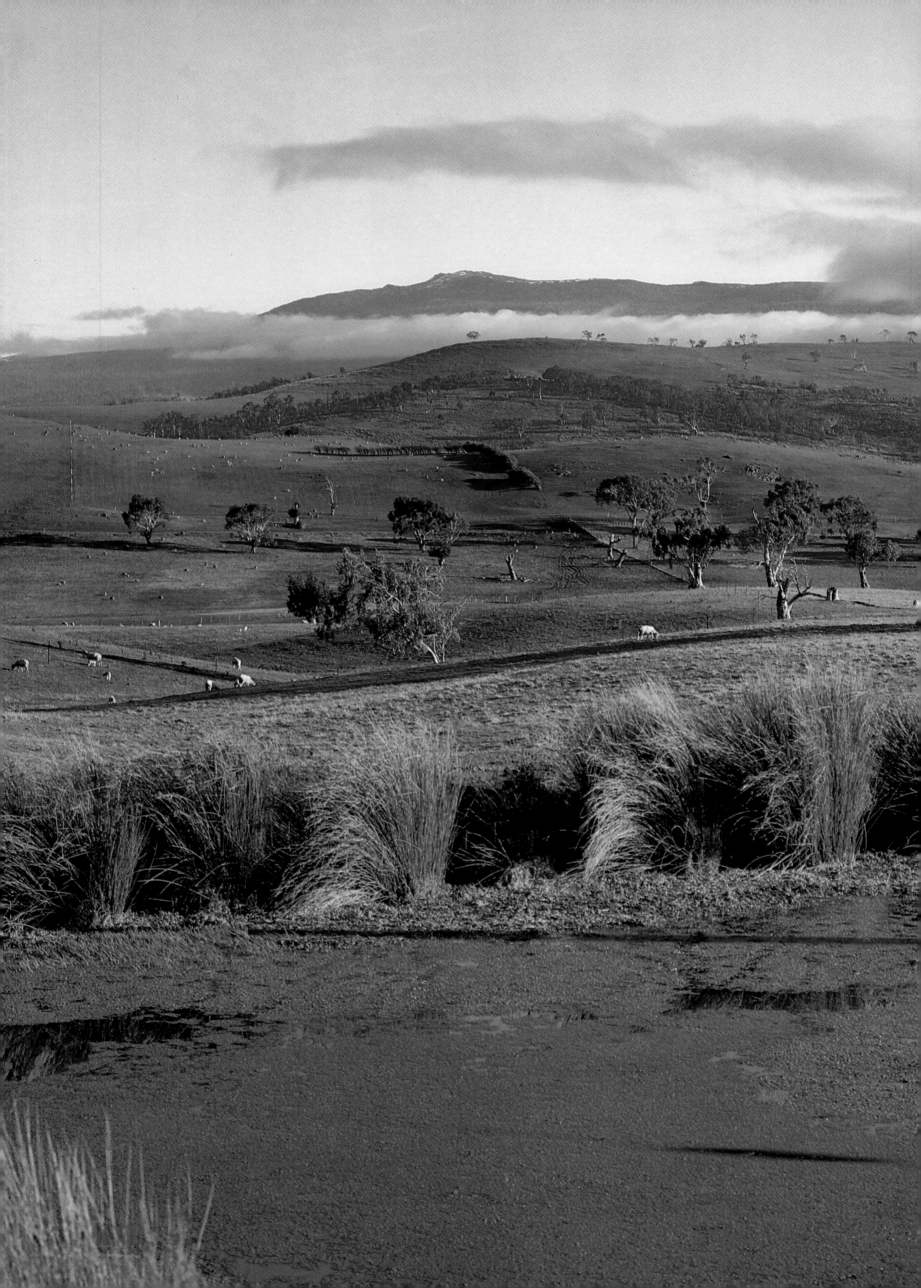

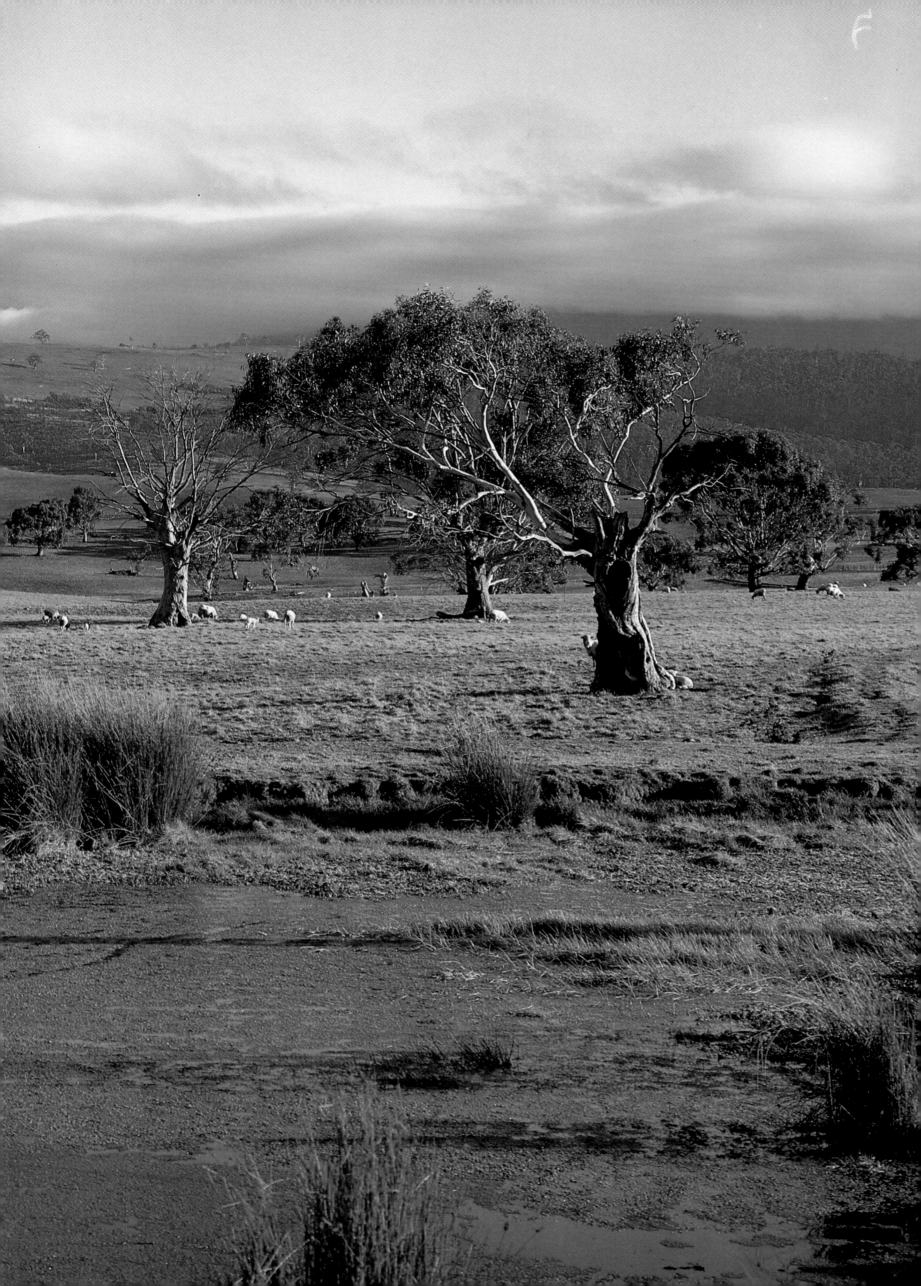

# NEW SOUTH WALES

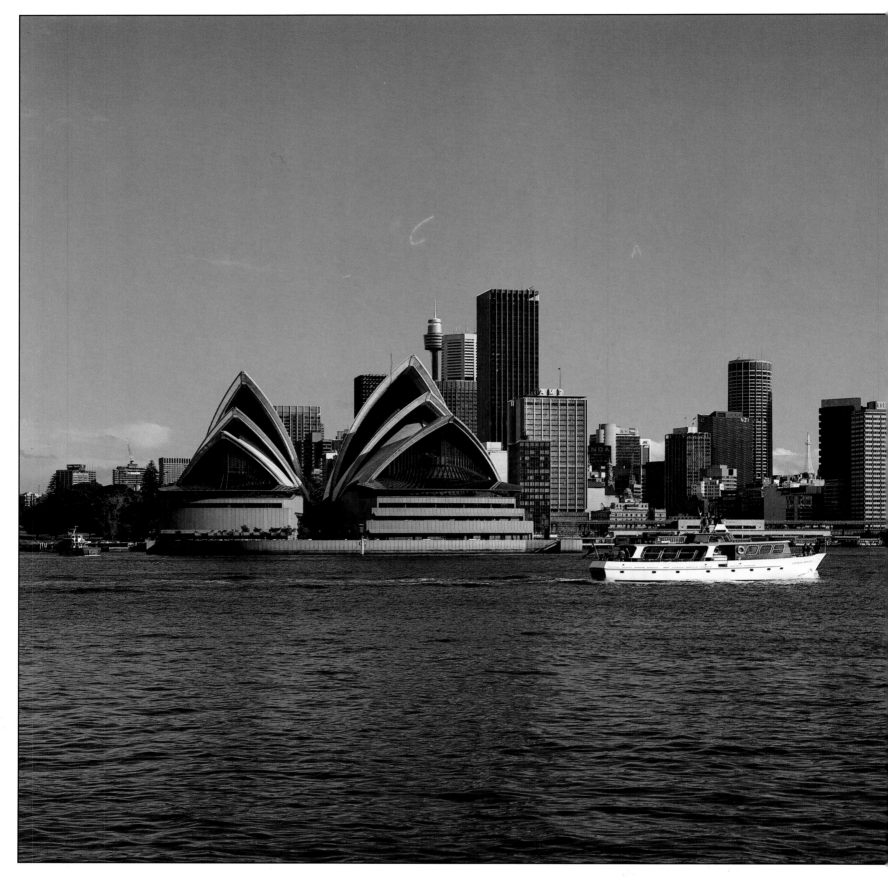

These pages and overleaf: Sydney, the capital of New South Wales and a city blessed with one of the most beautiful settings of any metropolis in the world. Twelve-and-a-half miles long and deep enough for a fleet of warships, Sydney harbor has long been admired by sailors, but its many secluded beaches, wooded inlets and rugged stone headlands also attract landlubbers. Above: the Opera House, a center for the performing arts that has become one of Australia's most famous landmarks, and (right) Sydney Harbour Bridge, the largest arch bridge in the world, known affectionately as "The Old Coat Hanger" by the locals. Above right: Sydney Tower, also known as Centrepoint Tower, which, at a thousand feet high, affords the visitor a magnificent view.

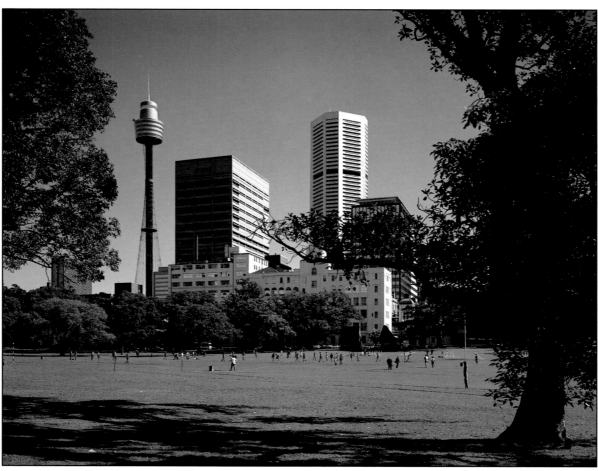

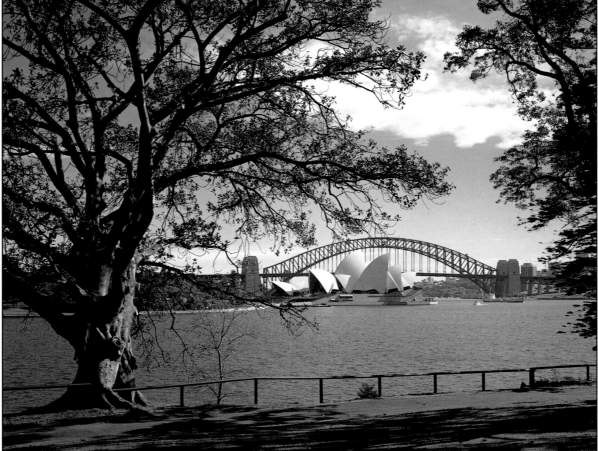

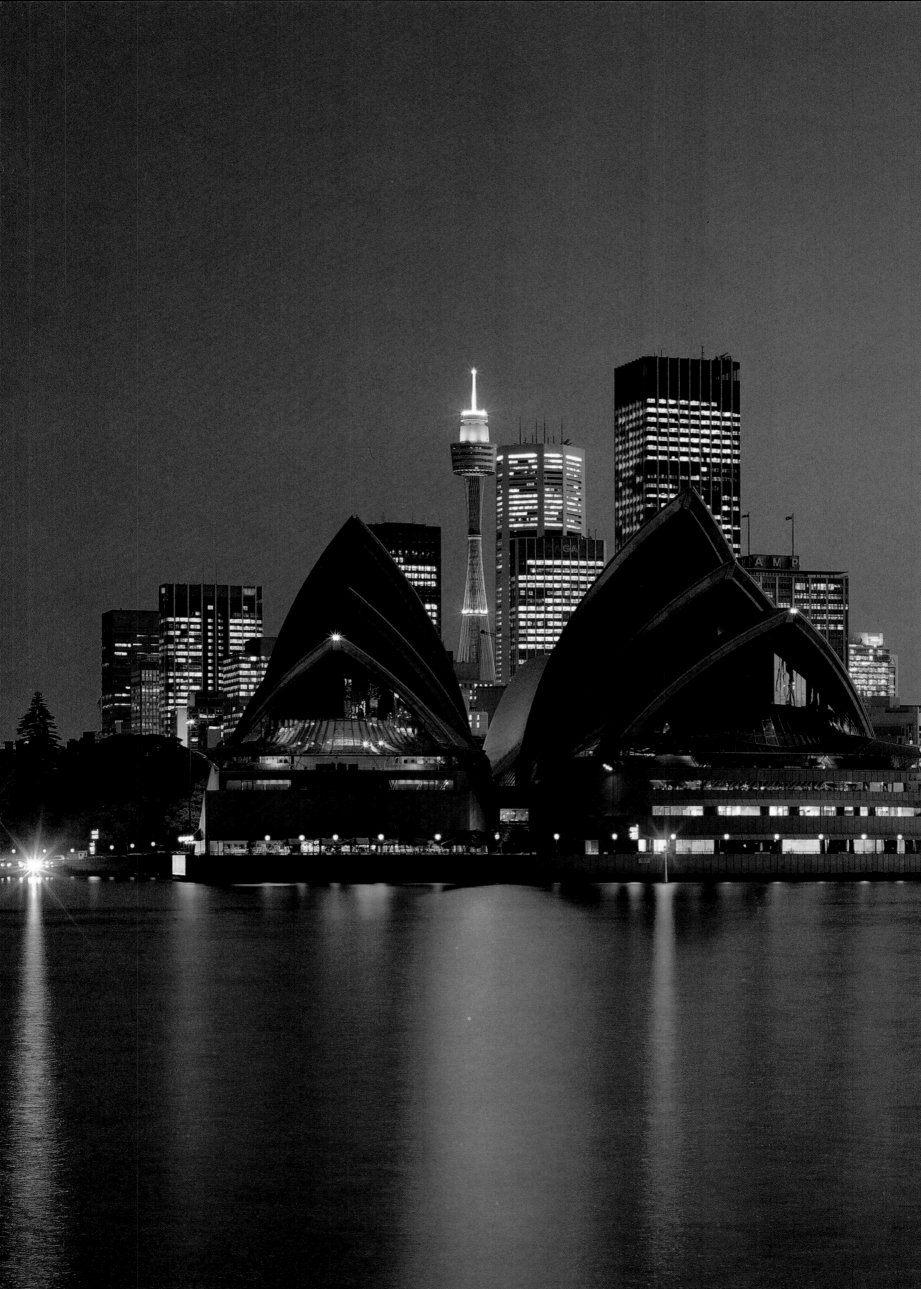

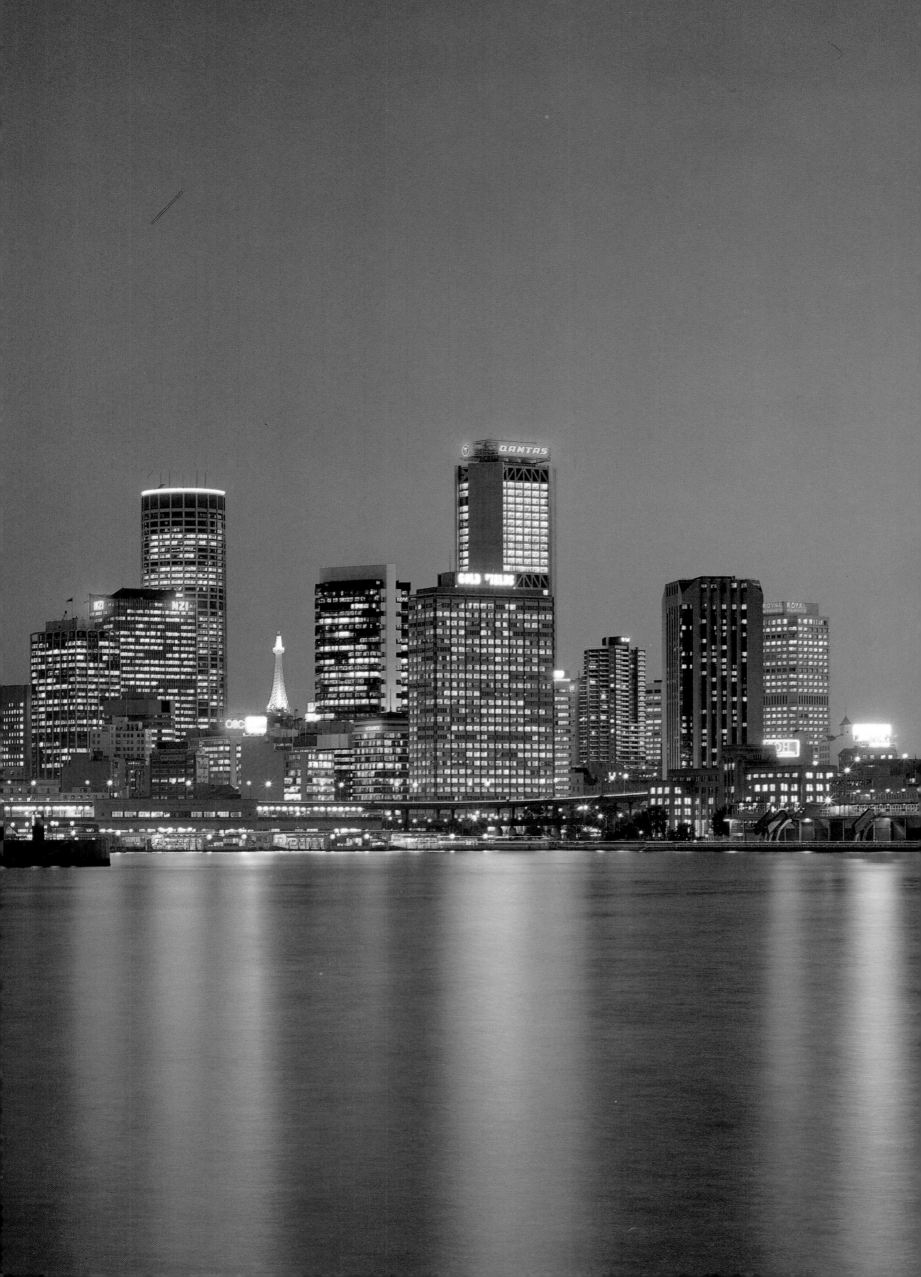

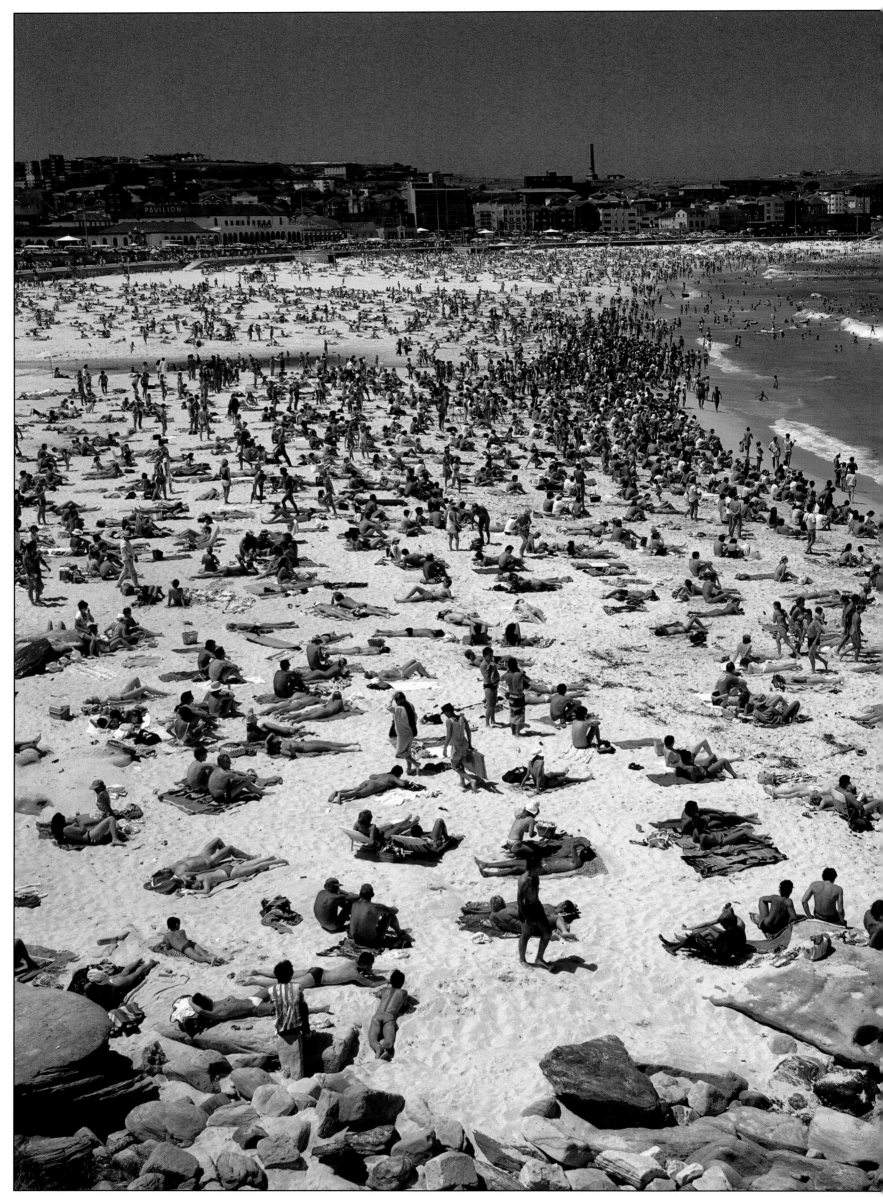

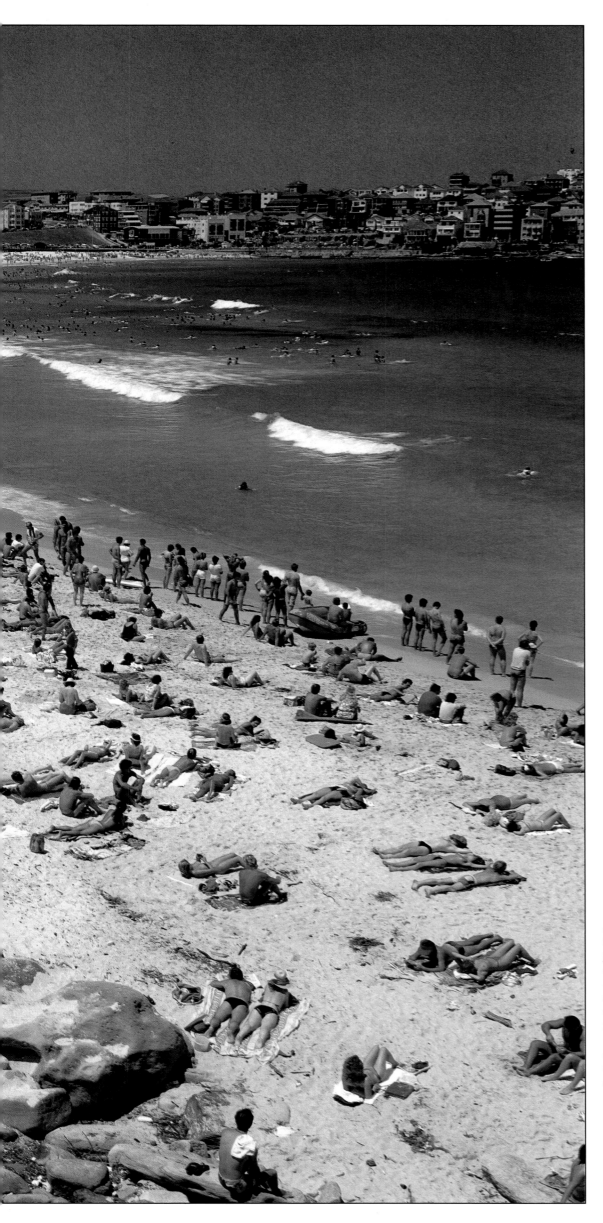

Left: Bondi Beach, Sydney's famous mile-long strip of sand which lies five-and-a-half miles from the city center. Rejoicing in the general belief that it is the perfect beach, Bondi is found between two sandstone headlands and is nearly always crowded in the summer, since it is the city's closest point for surfing. Sharks are only infrequently found off any of Sydney's beaches: there is an ever-present patrol of Surf Lifesavers and helicopters on the lookout for them and the occasional riptide and they give swimmers and surfers advance warning of any such dangers. Topless sunbathing is the norm here – it is easy to feel overdressed on Bondi.

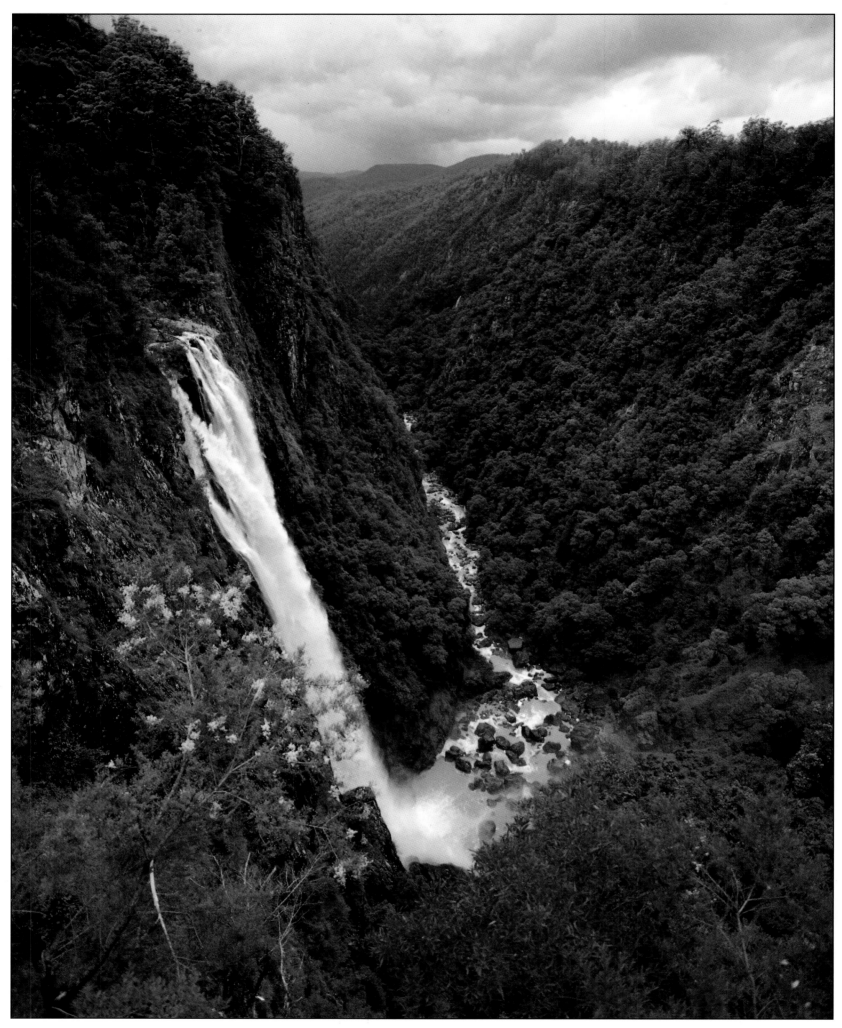

*Above: a creek becomes a veil of white water at Ellenborough Falls on the Comboyne Plateau, a day's excursion from Port Macquarie. These falls, which drop 490 feet, are one of many spectacular cascades hidden in a largely inaccessible wilderness of dense forest near the township of Comboyne. Facing page: bright golds and creams in the jagged limestone walls of the Kanangra Plateau startle the eye against the seemingly endless soft folds and shades of the Blue Mountains. Overleaf: a latticework of water and rock strata at Wentworth Falls that comprises one of the most breathtaking sights in Blue Mountains National Park, just sixty miles from Sydney.*

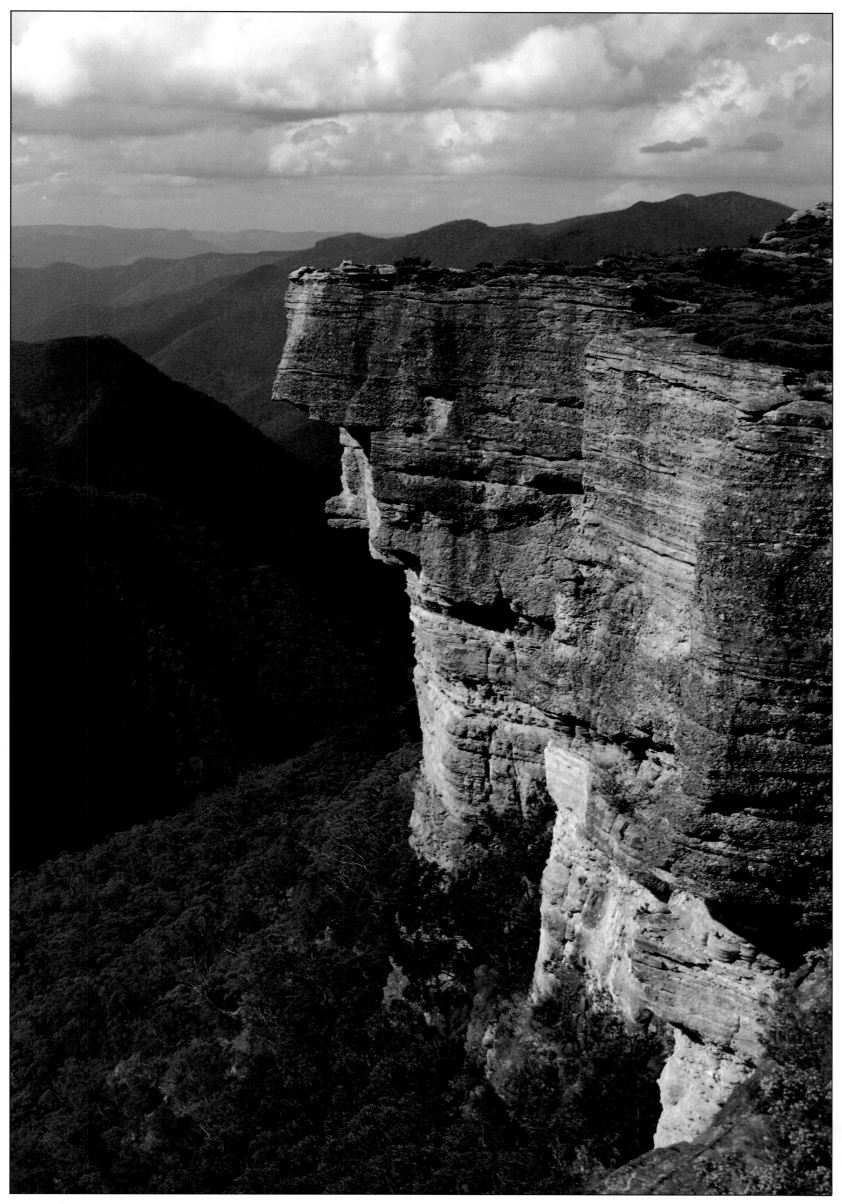

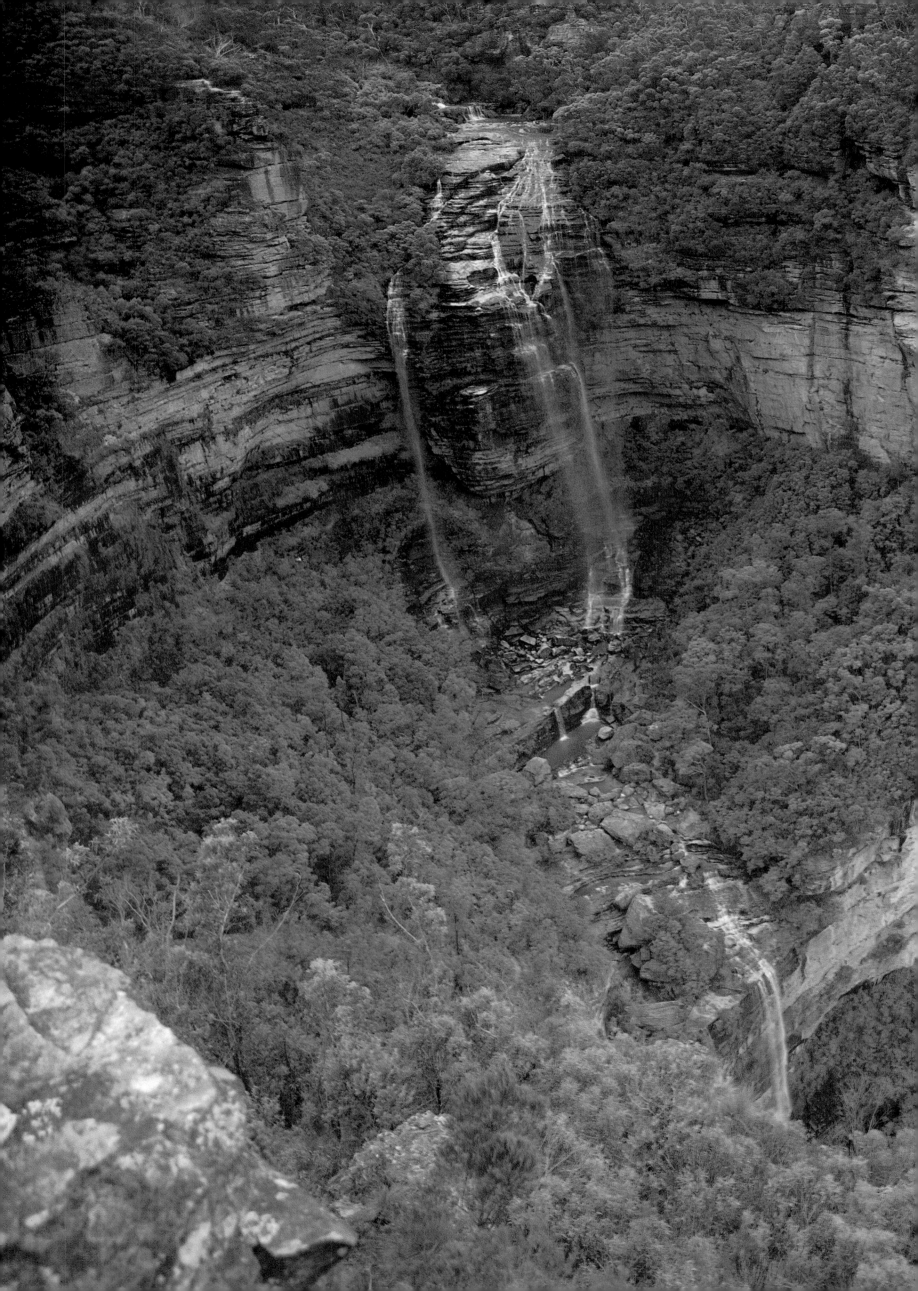

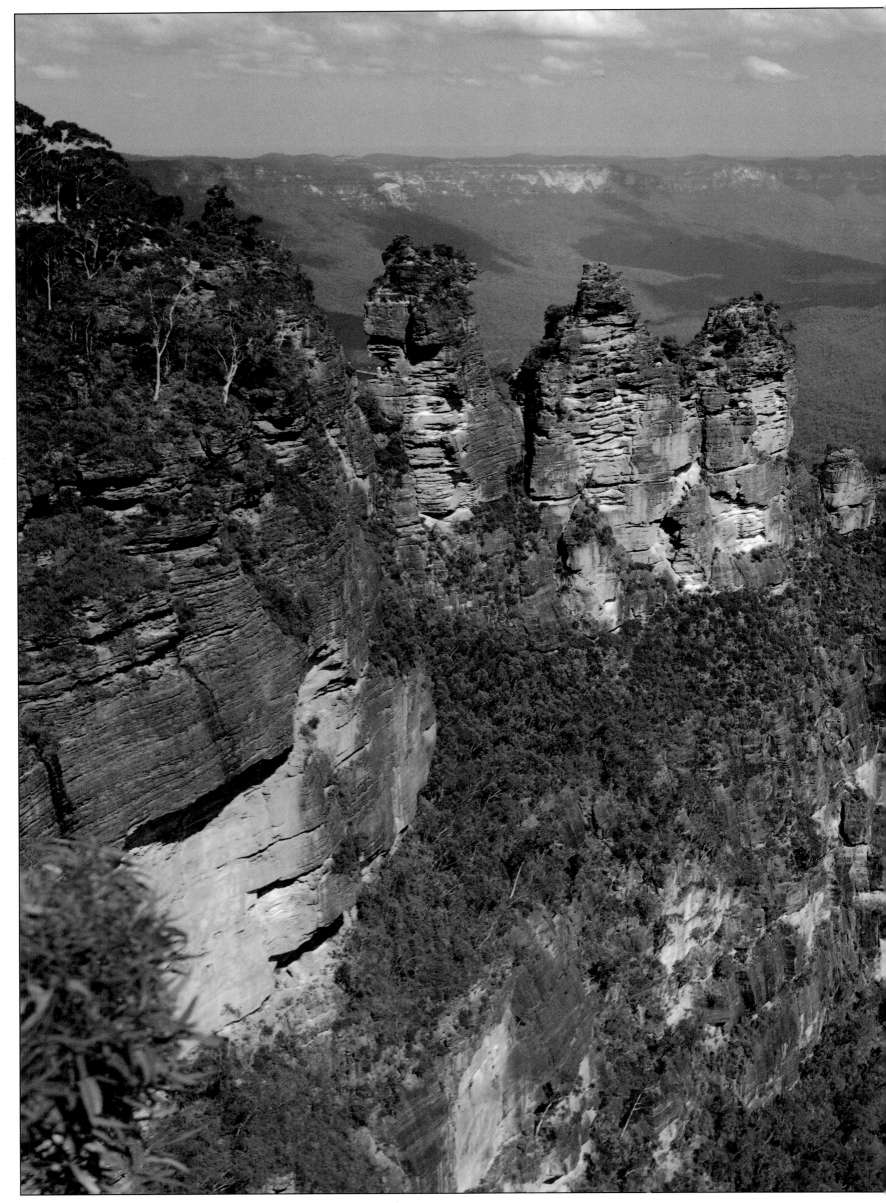

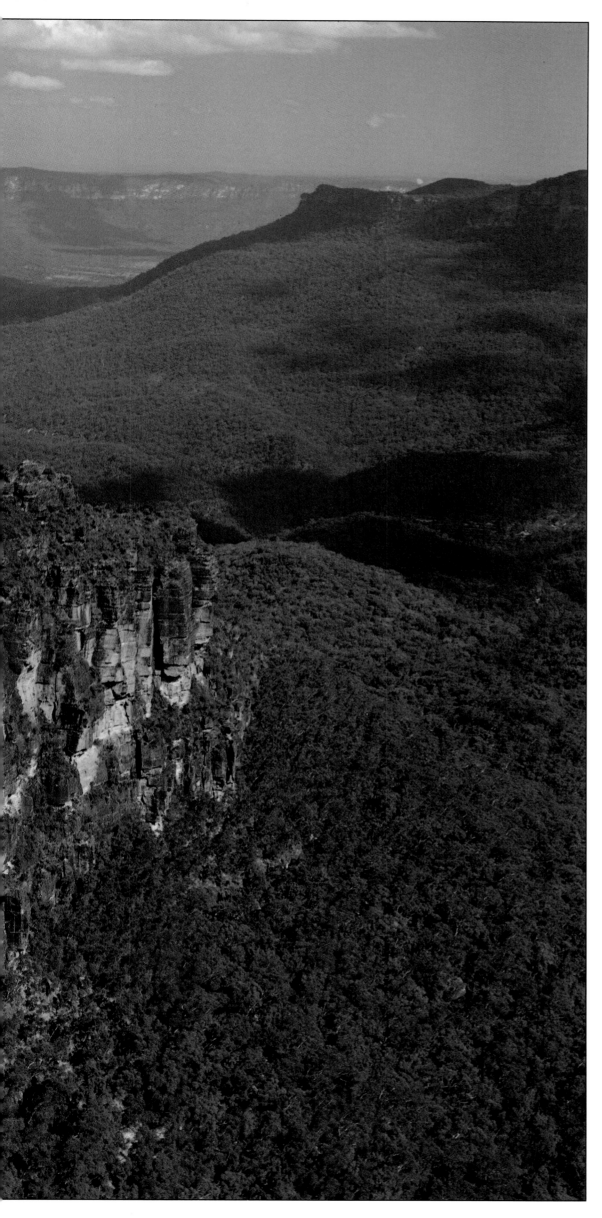

Left: the dramatic outcrop of rock pinnacles known as the Three Sisters, found at Echo Point near the township of Katoomba, in Blue Mountains National Park. The Blue Mountains are easily conquered today by means of a road that runs along the park's flat-topped ridges, but until this route was devised in 1813 by explorers Blaxland, Lawson and Wentworth, the terrain here posed an apparently insoluble problem for would-be settlers wishing to move west. Even today, parts of the thickly forested valley floor are so difficult to traverse that only skilled bushwalkers and climbers should explore them.

# NEW SOUTH WALES

*Above: an aerial view of the arid terrain between White Cliffs and Broken Hill, where hardy vegetation will follow the path of a dry river bed (overleaf) and water is at a premium. Yet, though this scrubland is infertile and apparently worthless to man, it is rich in minerals, and Broken Hill itself is built on the world's largest silver-zinc-lead deposit. Above right: the control center of the Flying Doctor Service of New South Wales, a service that provides medical attention for people isolated in the Outback, and (right) Banner Avenue, Griffith, one of three developing towns in the Murrumbidgee Irrigation Area. The Murrumbidgee, one of the country's largest rivers, is used here to bring life to over 500 square miles of formerly parched land.*

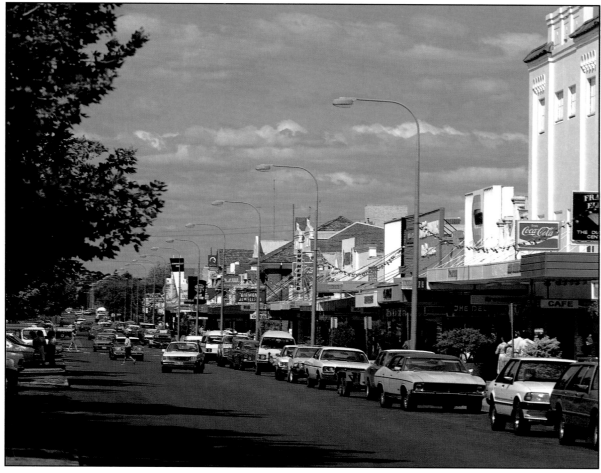

87

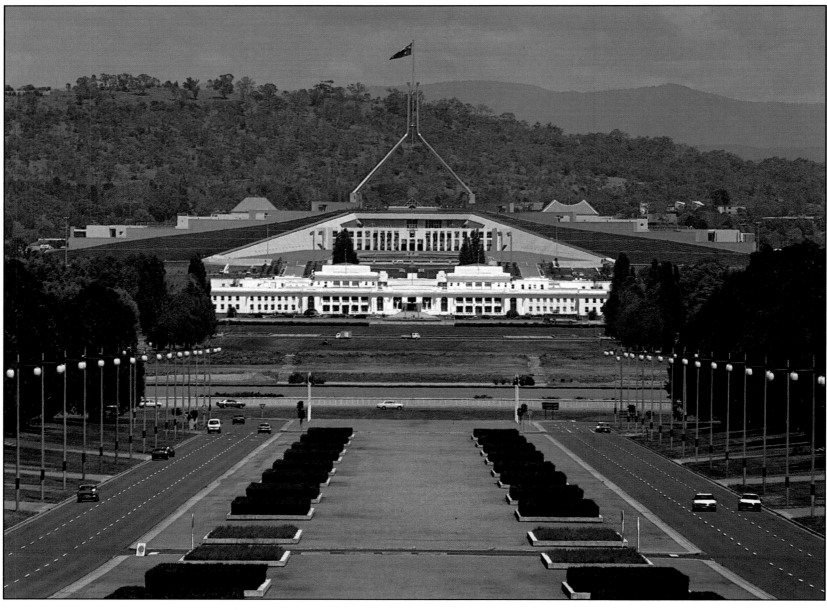

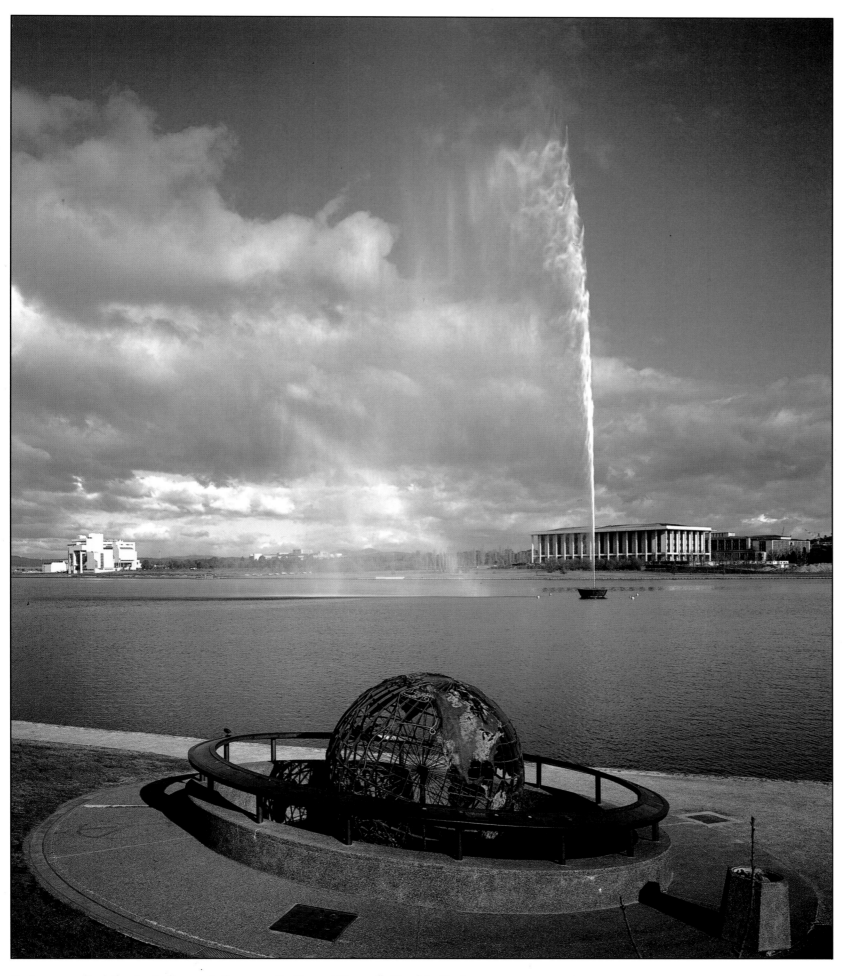

*Facing page: (top) the Australian coat of arms on Parliament House (bottom) in Canberra (overleaf), the country's capital. Canberra was built with a specific purpose in mind – to be the centerpoint for the government of Australia – and to that end, it had to be midway between the two great rival cities of Melbourne and Sidney. As a result it lies 185 miles southwest of Sidney and 370 miles northeast of Melbourne in its own territory known as the Australian Capital Territory. The "Bush Capital" is bursting with monuments, one of the most eye-catching being the Captain Cook Memorial (above), a 460-foot-high column of water in Lake Burley Griffin, a large artificial lake in the heart of the city fed by the Molonglo River.*

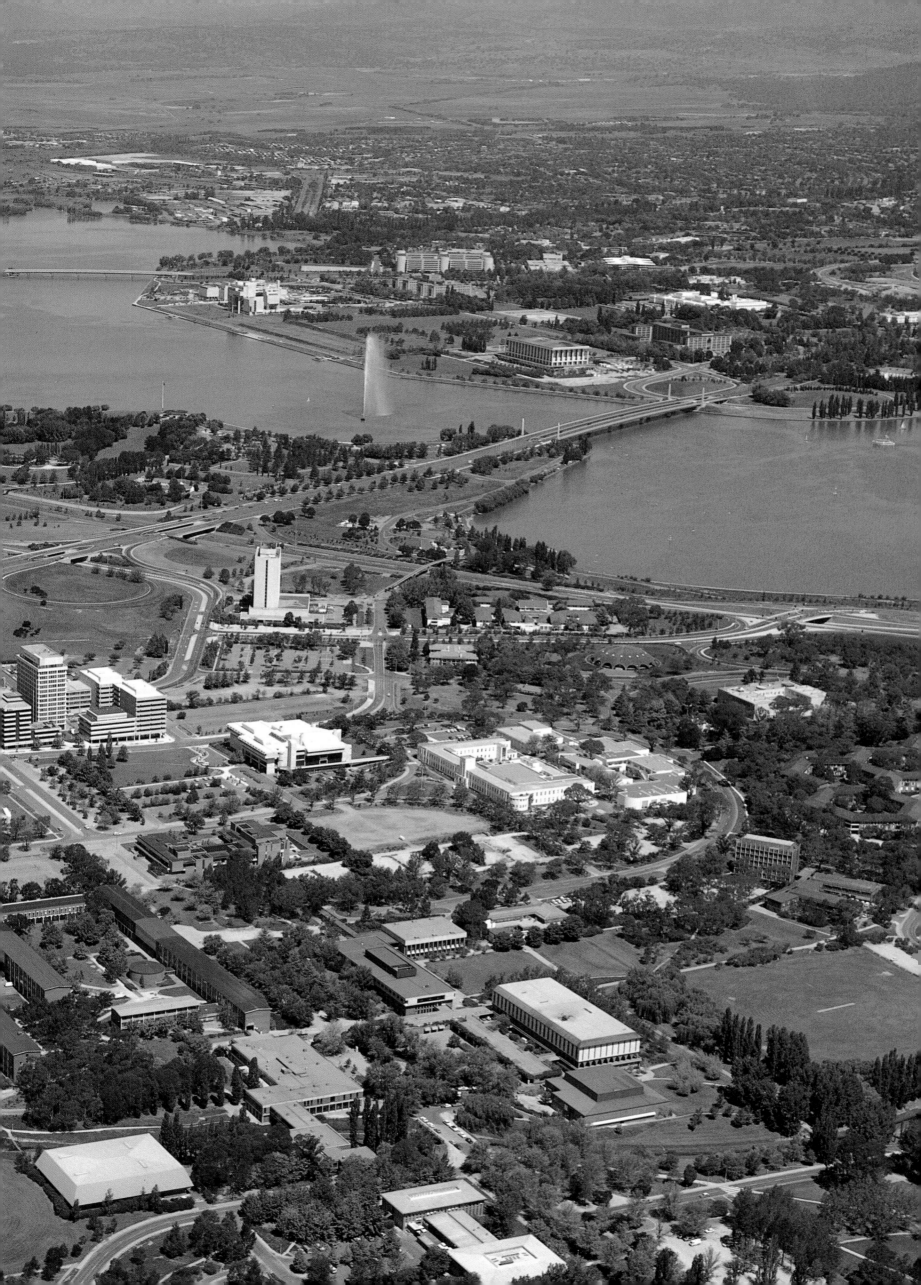

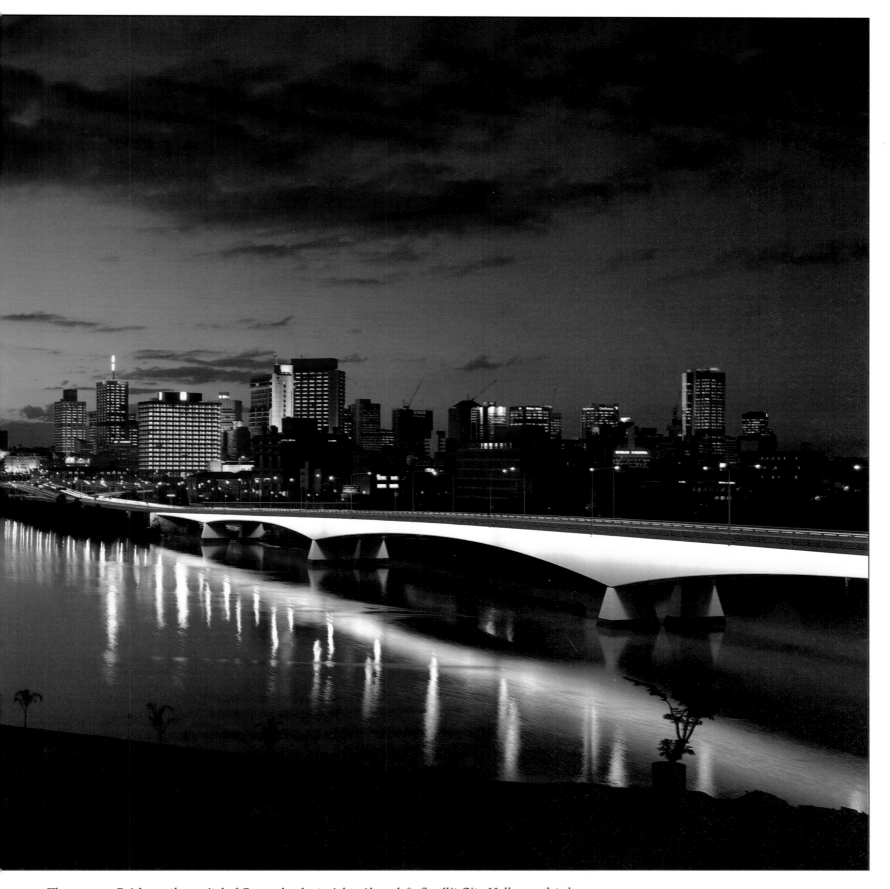

*These pages: Brisbane, the capital of Queensland, at night. Above left: floodlit City Hall, completed in 1930 and then the city's tallest structure, and (above) the more modern Captain Cook Bridge spanning the Brisbane River. Brisbane was established as a convict settlement in the mid 1820s; within two decades the area was opened up for free settlement and by 1859 the then-large colony was separated from its southern neighbor, New South Wales, and christened Queensland at Queen Victoria's personal suggestion. Within five years of this a great fire had destroyed all of Brisbane's center; today any buildings over 100 years old are carefully preserved. Much of the city is content to look forward, rather than back, however – rich with sugar, oil, gold and agriculture, this is the continent's Dallas, its numerous highrises bearing witness to the wealth to be found here.*

# QUEENSLAND

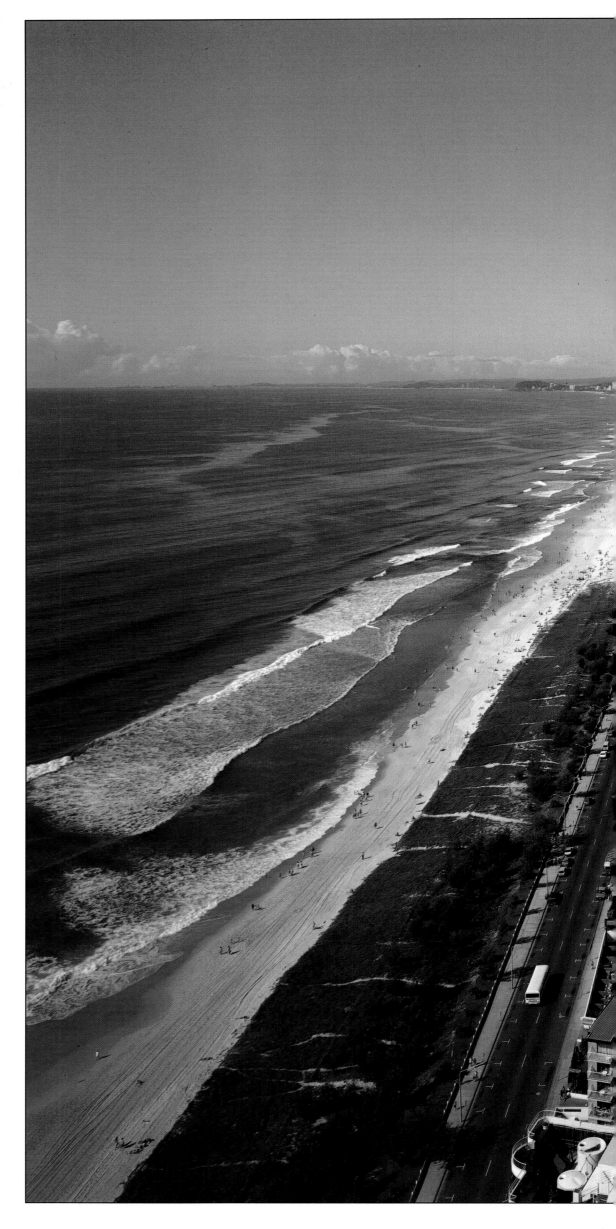

Queensland's Gold Coast is a twenty-mile-long
stretch of almost constantly sun-kissed coast
between Southport in the north and Coolangatta
on the New South Wales border. As the vacation
playground of the country, the population of the
Gold Coast swells considerably during the
Christmas break, when all Australia seems to
take its leisure on these fine sand beaches. The
main season, though, is the winter one, when
southern Australians seek the tropical warmth
then missing from more southerly resorts.

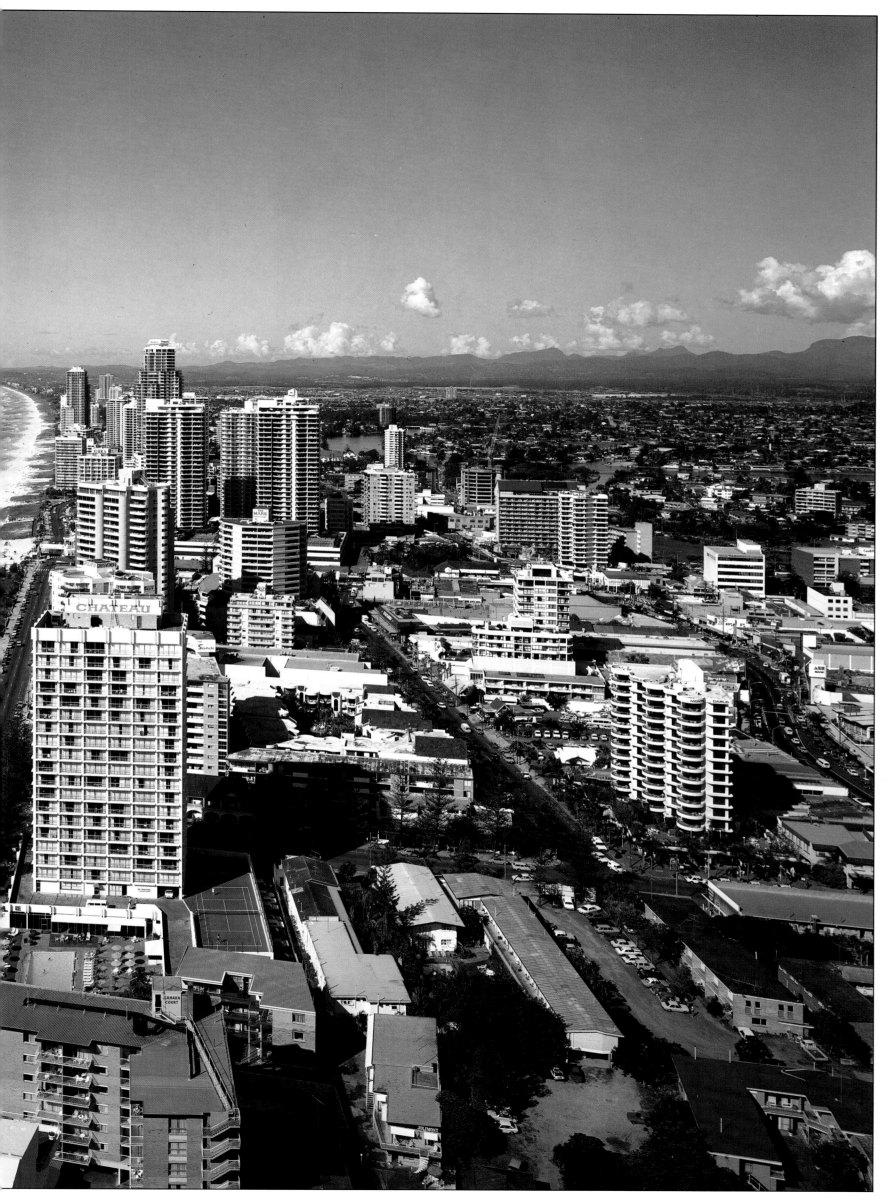

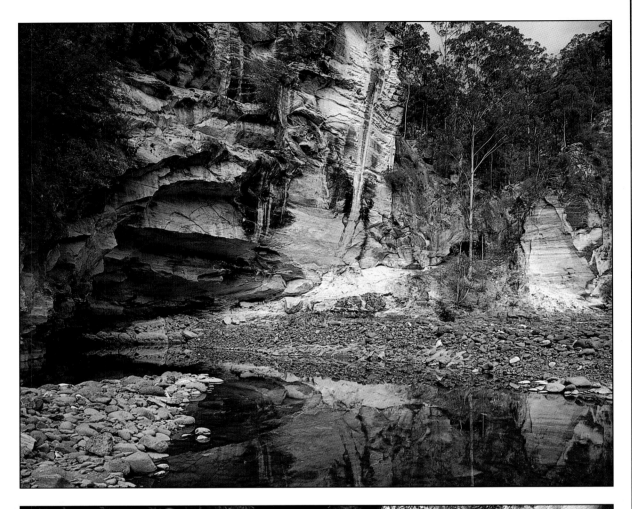

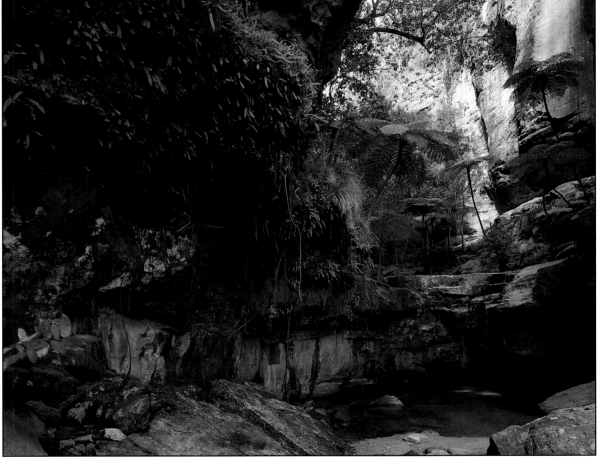

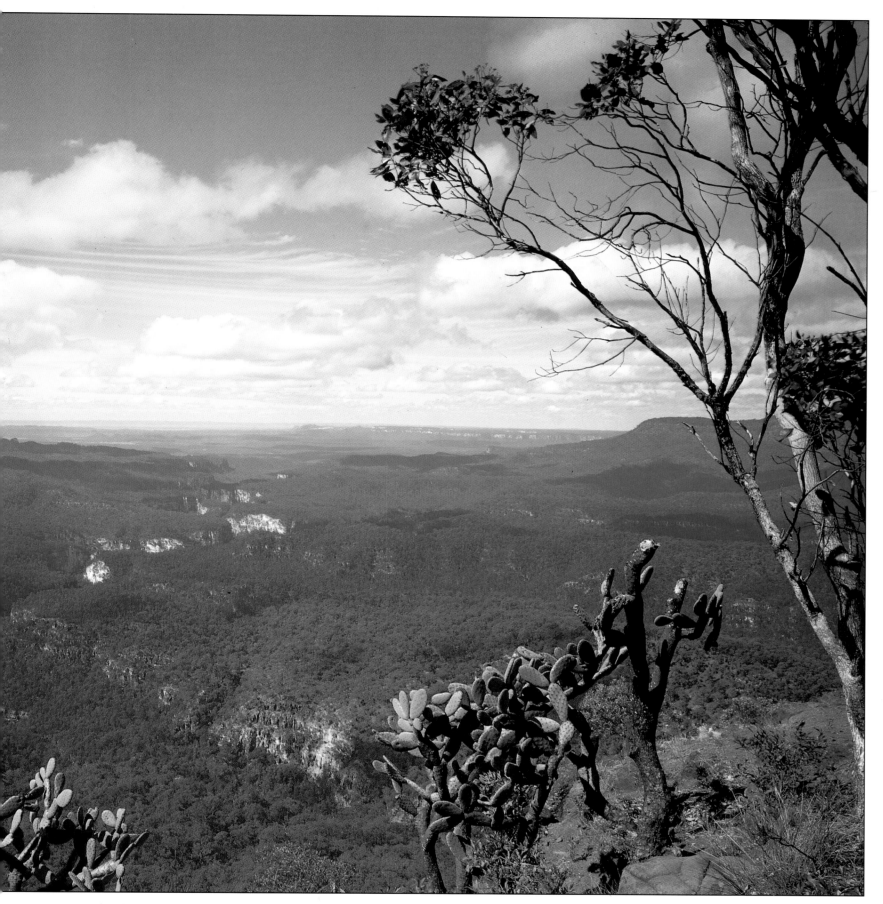

*Left: the moss garden in Carnarvon National Park, which lies over 400 miles northwest of Brisbane. This extensive reserve is dissected by Carnarvon Creek (above left), whose course can be easily charted across the Great Dividing Range (above) as it has scored a magnificent gorge through the sandstone. In some places the gorge walls rise to several hundred feet, though they are less than 200 feet apart. Carnarvon Creek never runs dry and, as a consequence, many species of wildlife have made the surroundings their home. The whip-tailed wallaby, the rare brush-tailed wallaby, the eastern gray kangaroo, and brush-tailed possum can all be found in the park.*

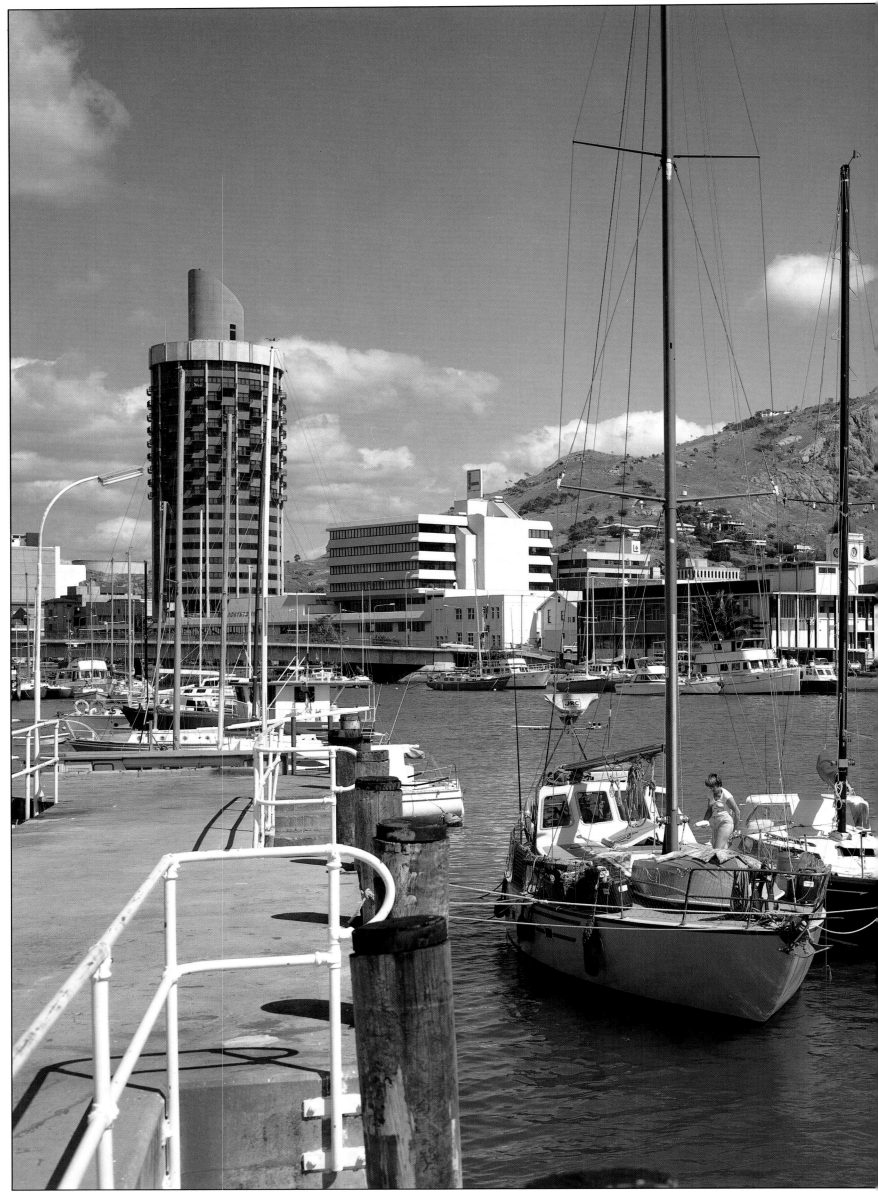

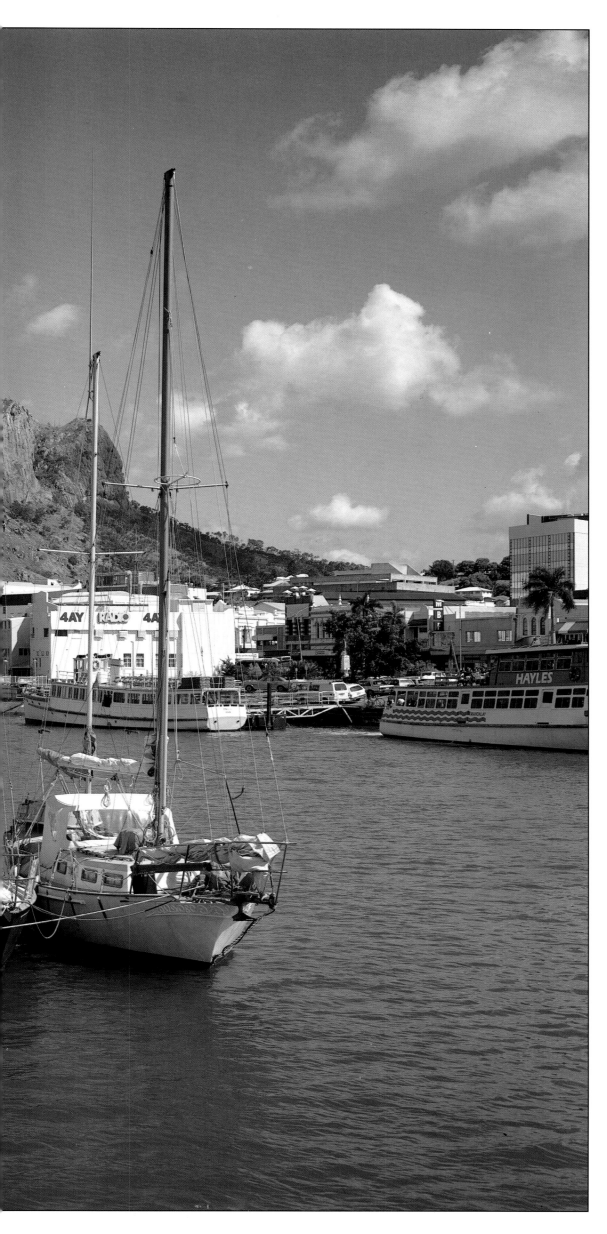

Townsville (left), Queensland's second largest city after Brisbane, lies on the Pacific Ocean in the north of the state and boasts more hours of sunshine than any other city in Australia. A leading center for marine and tropical research and the headquarters of the Great Barrier Reef Marine Park Authority, Townsville lies immediately to the west of the Great Barrier Reef and the very beautiful nearby Magnetic, Orpheus, Hinchinbrook and Dunk islands. The city is a major export outlet for the products of the mines of Mount Isa (overleaf), which garner some of the world's largest copper, silver, lead and zinc deposits. "The Isa" is the state's largest single industrial enterprise and the world's biggest city, its municipal boundaries stretching across the Outback to encompass a region of some 15,000 square miles.

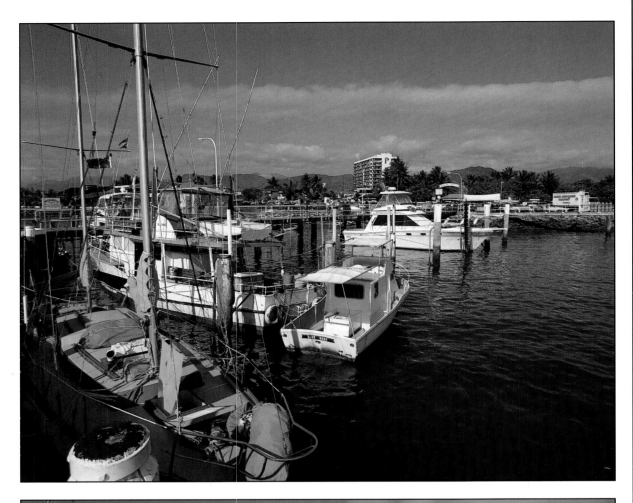

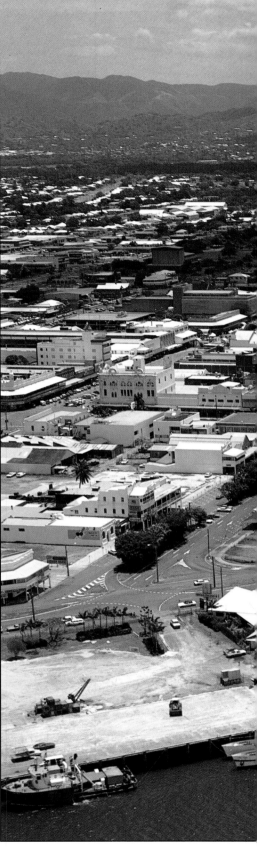

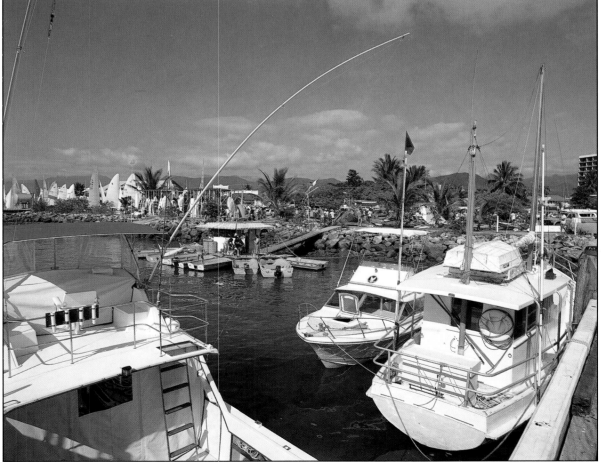

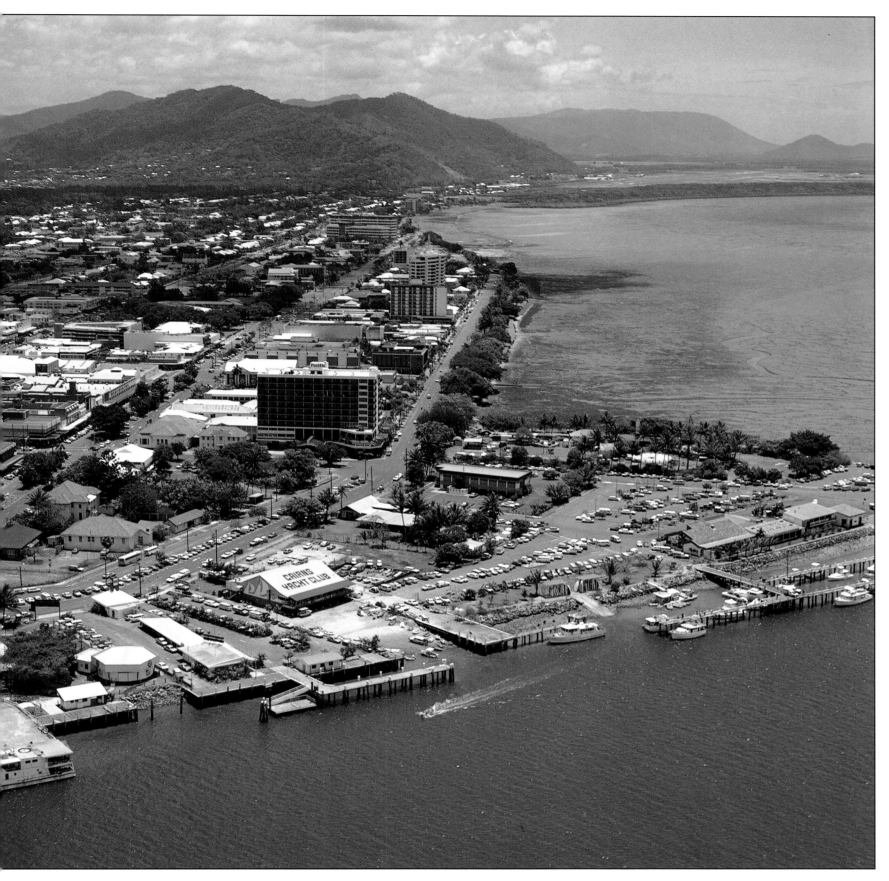

*These pages: Cairns, the most northerly city in Queensland and a center for sport fishing. Black marlin, the world's foremost game fish, is hunted here during the famous "Marlin Meet" in September, and the harbor (above left and left) is full of game-fishing boats for hire during the hunting season between August and December. Cairns is a beautiful tropical resort just over a century old that overlooks the deep blue of Trinity Bay and is surrounded by sugar cane fields – during the sugar-harvesting season, when the cane is crushed and the stalks burnt, a sweet aroma pervades the city. Overleaf: flanked by shallows of fine sand, a river curves at the foot of jungle-clad hills in what the locals abbreviate to FNQ – Far North Queensland.*

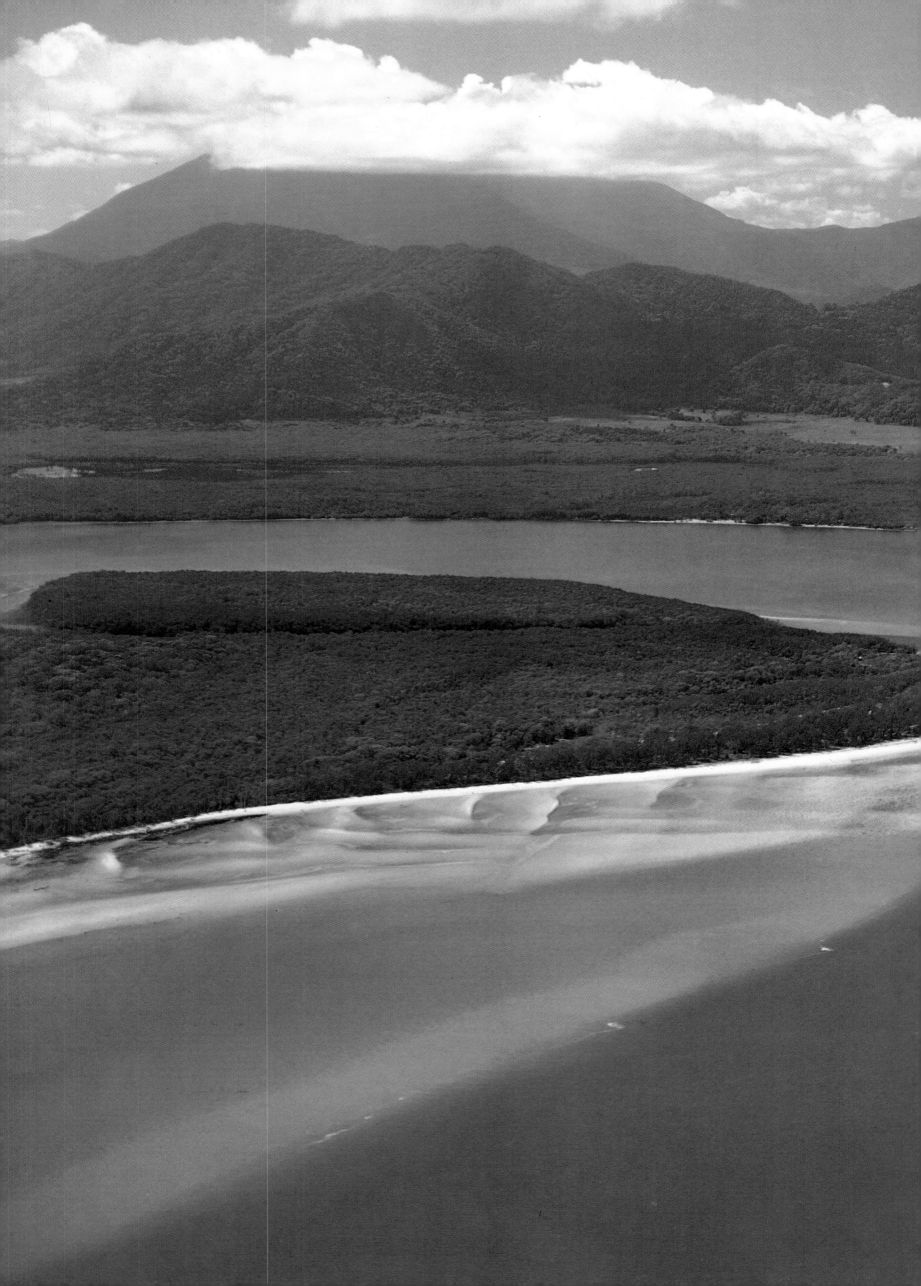

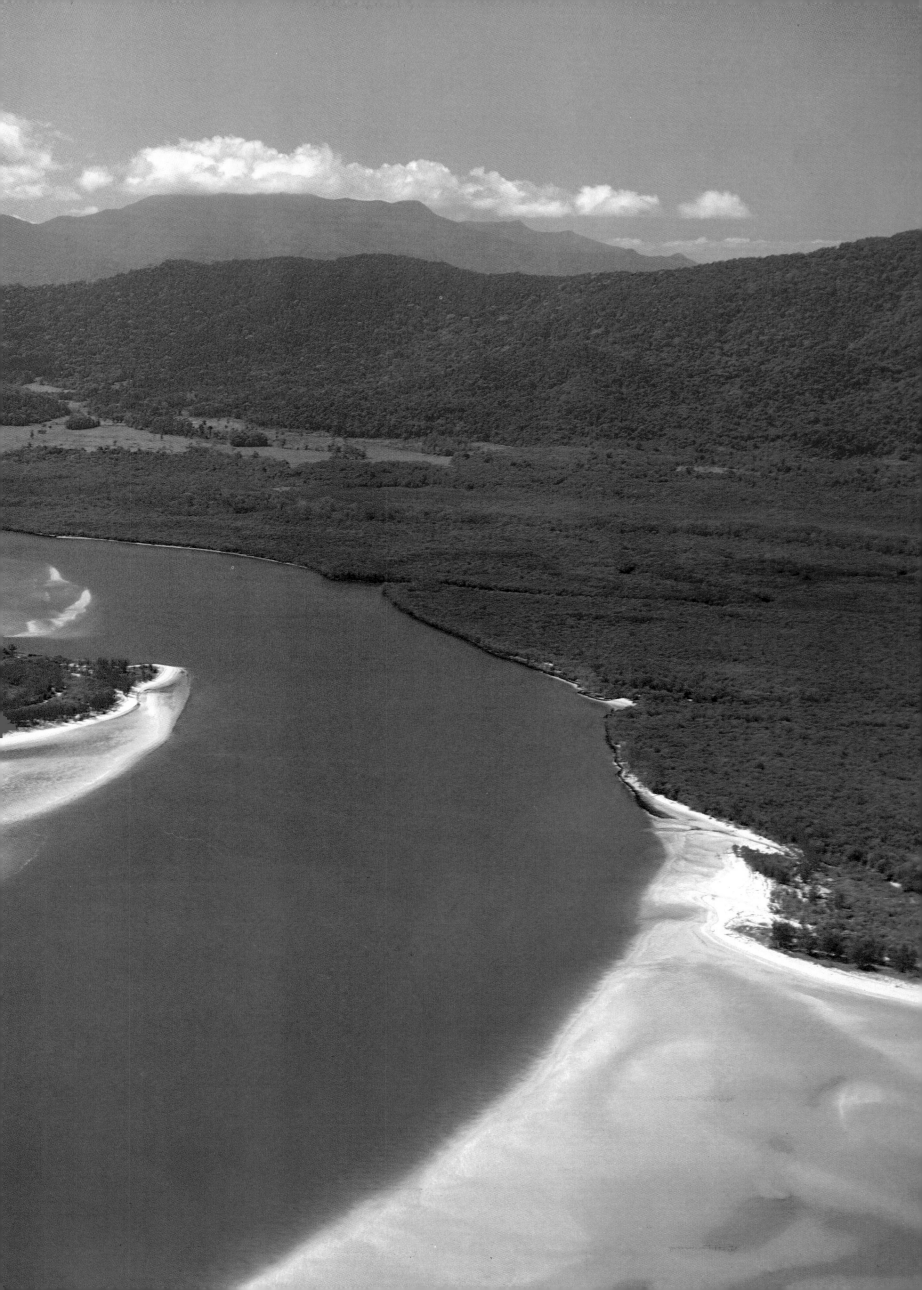

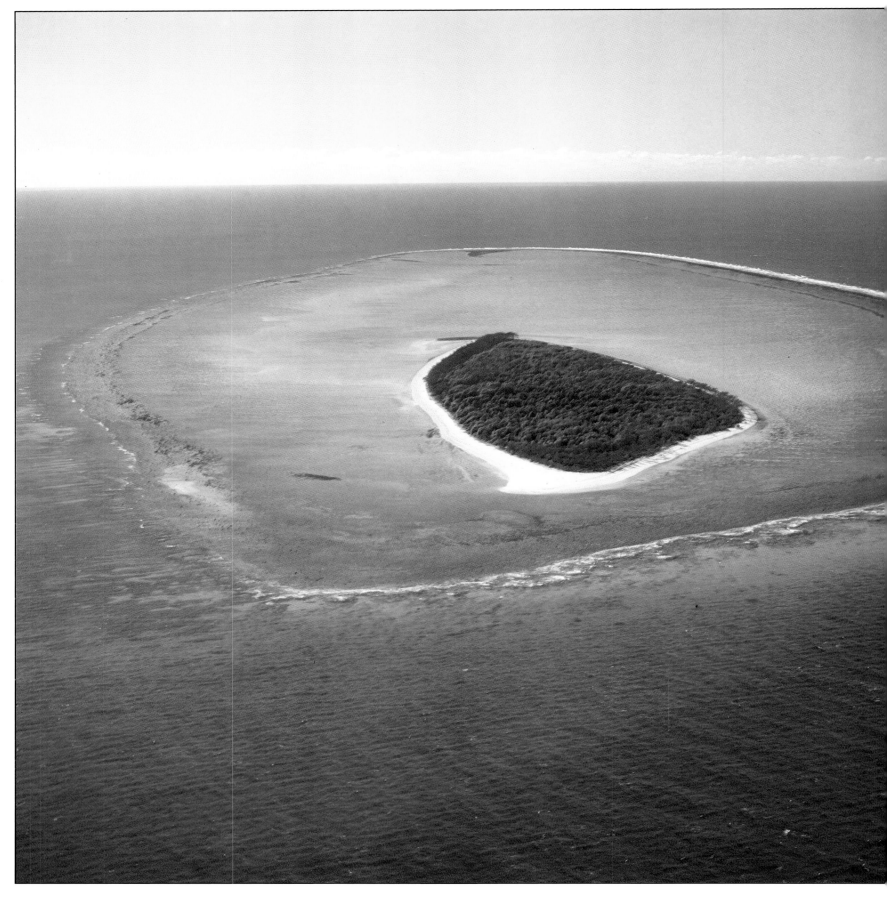

*These pages and overleaf: islands and sandbars along the world famous Great Barrier Reef, the largest structure ever built by living creatures, which stretches from the coast of western Papua to the coast of Queensland as far as the town of Rockhampton. At over 1,200 miles in length, this is the longest reef in the world and one of the most spectacular, displaying a staggering array of coral gardens inhabited by shoals of shining fish – each a sprinkling of gemstones against the backcloth of deep blue waters. A fantastic variety of shellfish – over 4,000 types – and 2,000 species of fish are found here. Ninety-eight percent of the reef is protected in the Great Barrier Reef Marine Park.*

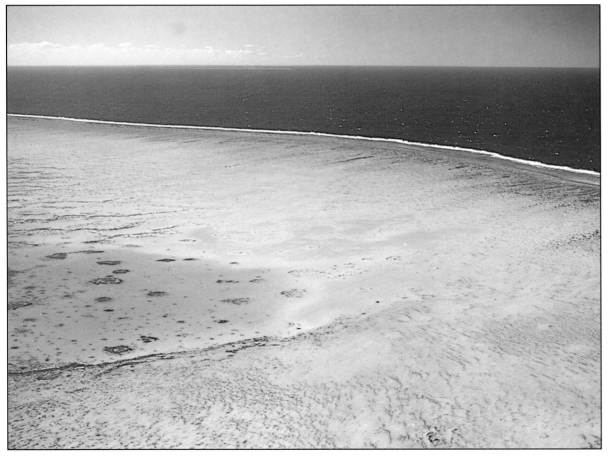

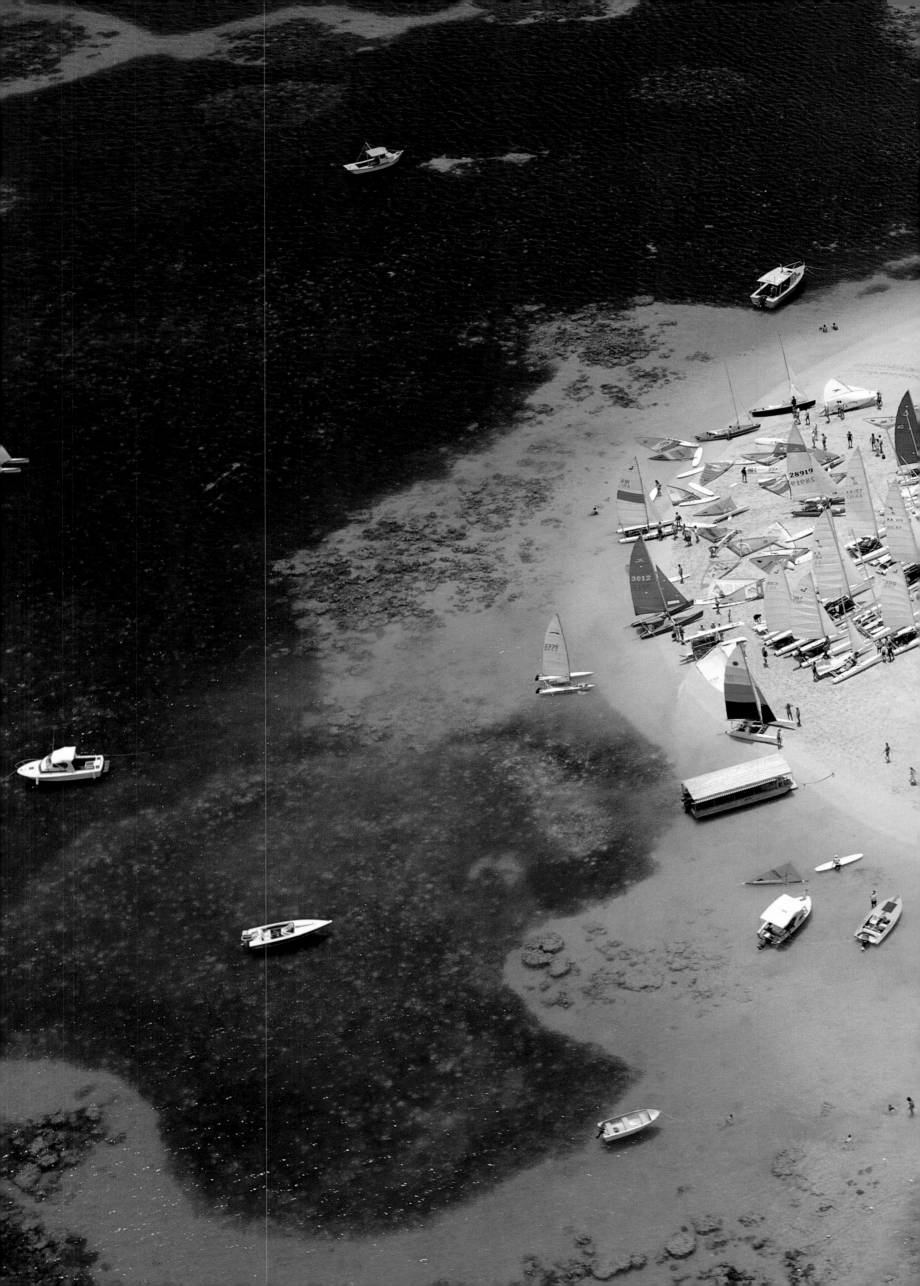

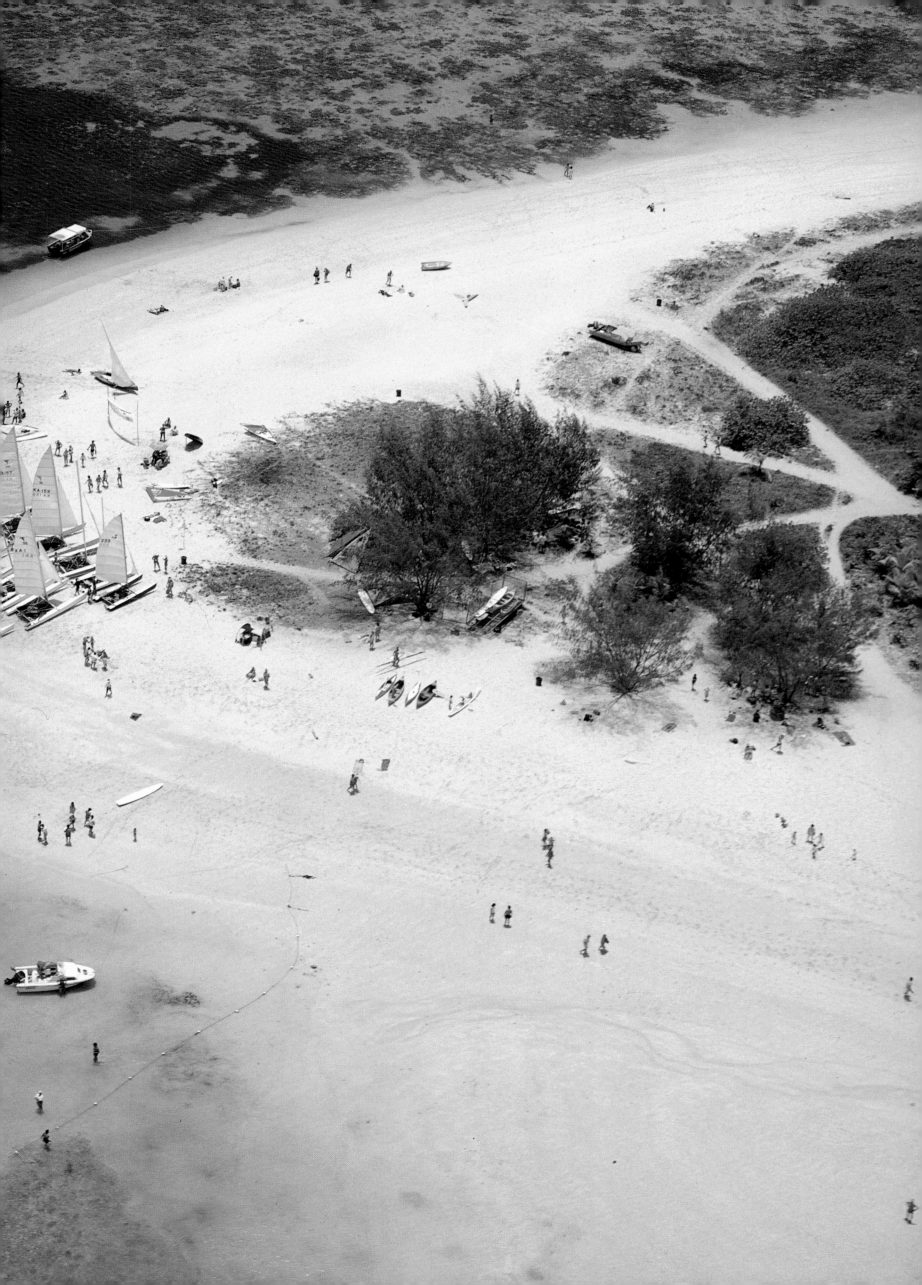

# NORTHERN TERRITORY

Left: Darwin's Diamond Beach Hotel Casino, designed to be cyclone proof in an ultra-modern style. All new buildings in this, the Northern Territory capital, are designed to withstand a severe hurricane ever since Cyclone Tracy devastated Darwin on Christmas Eve 1974. The port beside which the city stands was named for the English naturalist, Charles Darwin, by the Captain of HMS Beagle in 1839. The town that was established here thirty years later is somewhat isolated from the rest of Australia – Darwin (overleaf) is nearer to Hong Kong than to Sydney and paid for this during the Second World War, when it was bombed extensively by the Japanese. It remains strategically important as Australia's first defence against any invasion from the north and retains a certain Asian atmosphere, having a strong cosmopolitan mix of population – Vietnamese, Malays, New Guineans and Pacific Islanders rub shoulders with Japanese, Indonesians and Australians.

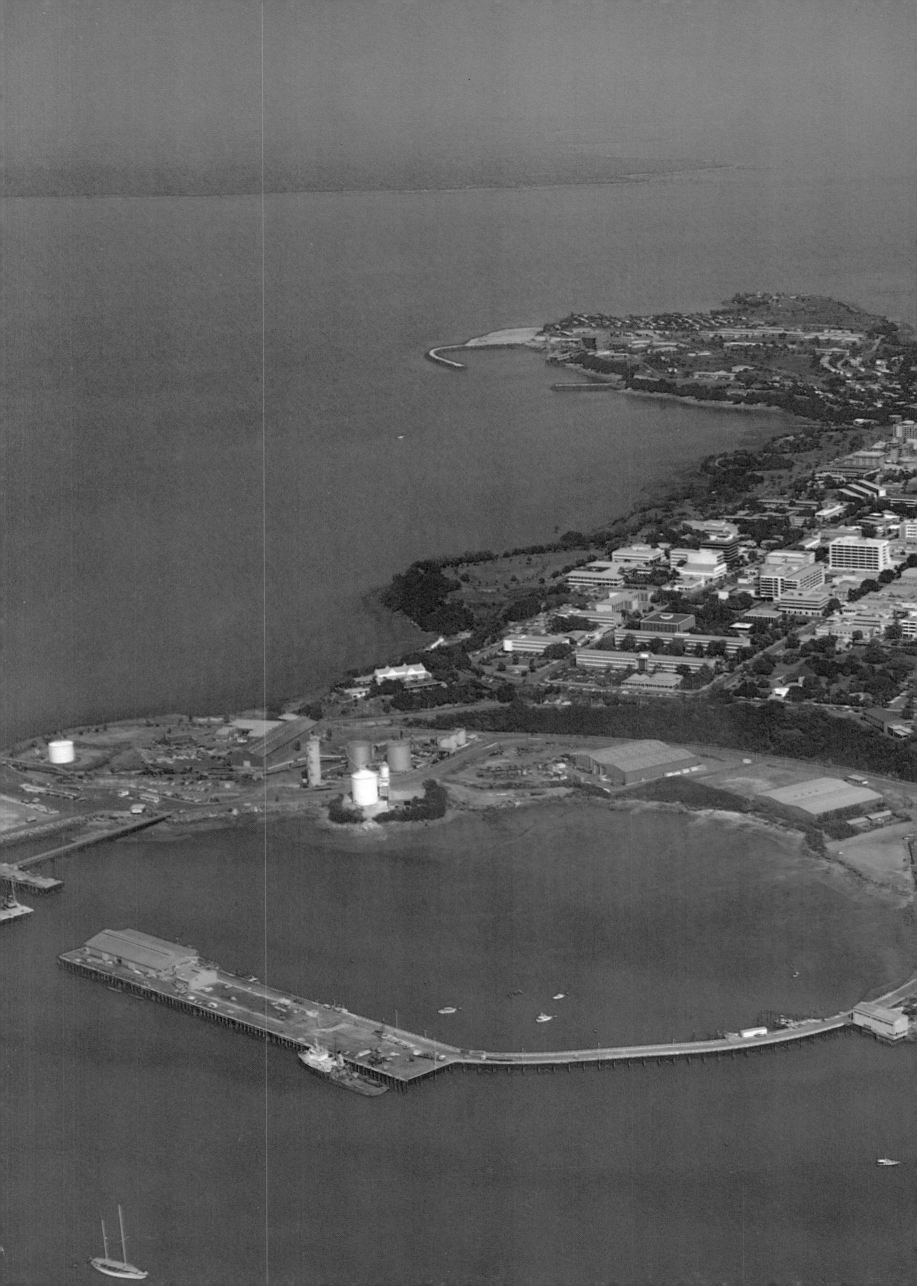

# NORTHERN TERRITORY

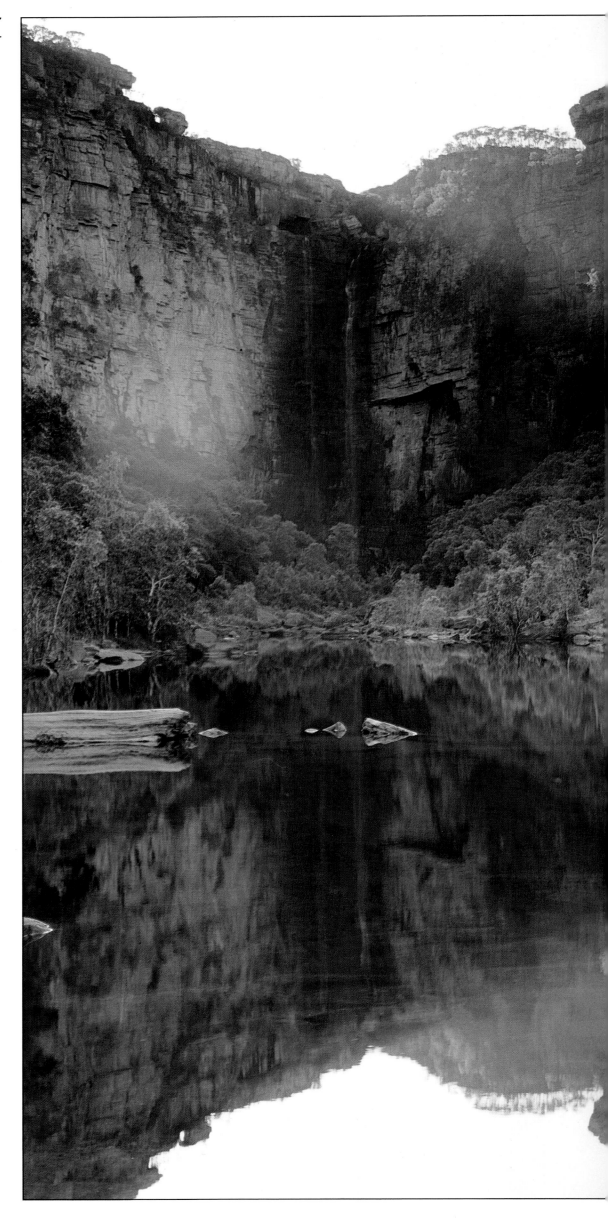

*Right: Jim Jim Falls, which are over a hundred feet high, in the extreme south of Kakadu National Park, part of the Arnhem Land Aboriginal Reserve leased back to the Australian government for use as a national park. This is a superb place to watch wildlife, since during the dry season all animals are obliged to seek out the few remaining creeks and waterways that are still viable, so many can be seen in a comparatively small space within the course of just a day. Kakadu is considered to be the country's premier bird sanctuary; wedge-tailed eagles and green pygmy geese are common, as are herons and egrets. The major animal attraction, however, has to be the saltwater crocodile, one of the fiercest of creatures, and one of the few that will deliberately hunt humans.*

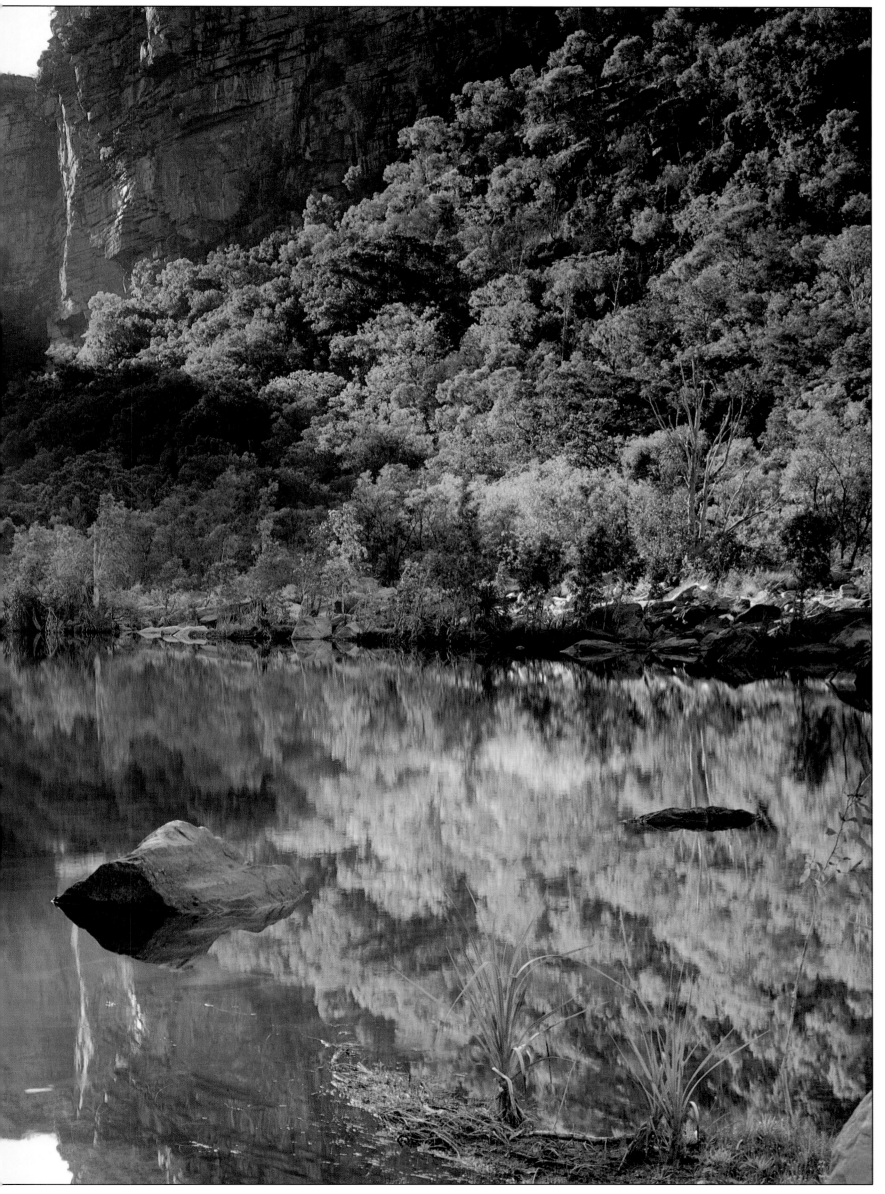

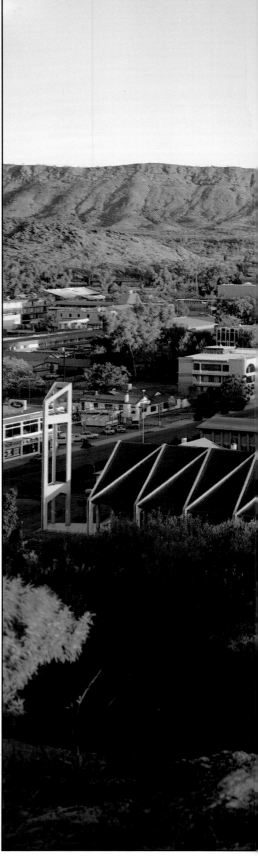

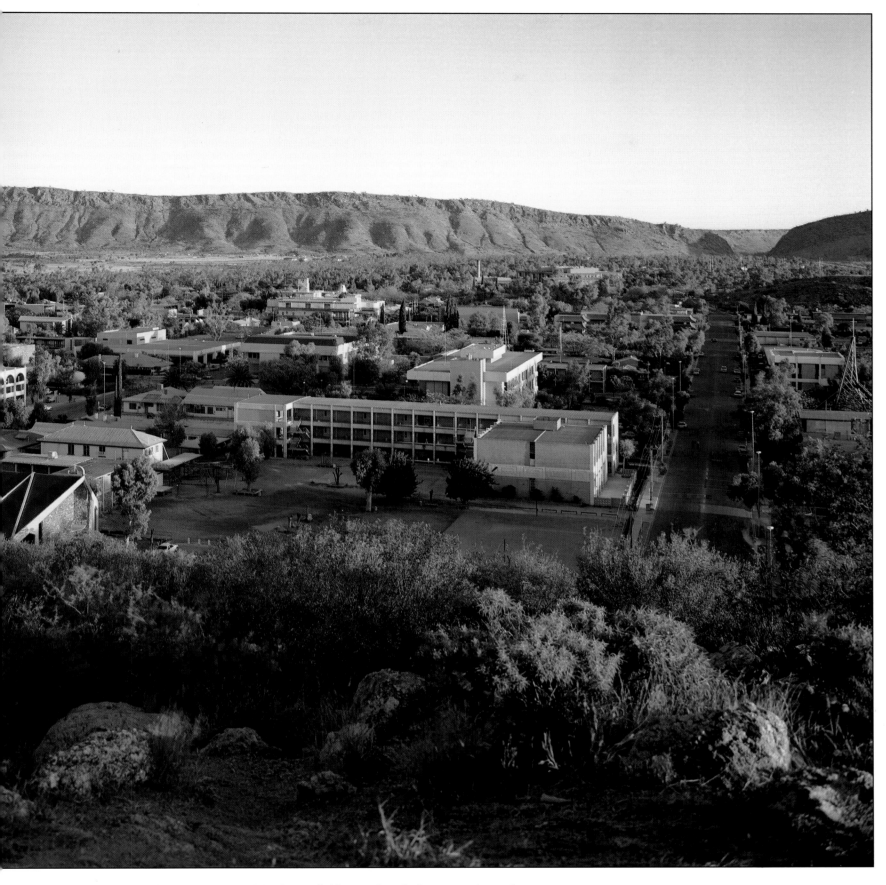

*Tennant Creek, with its prestigious Civic Centre (left), owes its relative prosperity to the presence of gold, silver and other precious minerals in the surrounding hills. It is the first town on the Stuart Highway – known as the "Track" – after leaving Alice Springs (above) in the Centre, over 300 miles away. "The Alice," as it is referred to by the locals, has the air of a frontier town, though it is situated near the geographical center of the continent; the visitor is always aware, despite the town's fine hotels and shops, of the harsh desert stretching out in all directions just beyond this little patch of civilization. Above left: a road train at Dunmarra, over 200 miles north of Tennant Creek at the junction of the "Track" and the Buchanan Highway.*

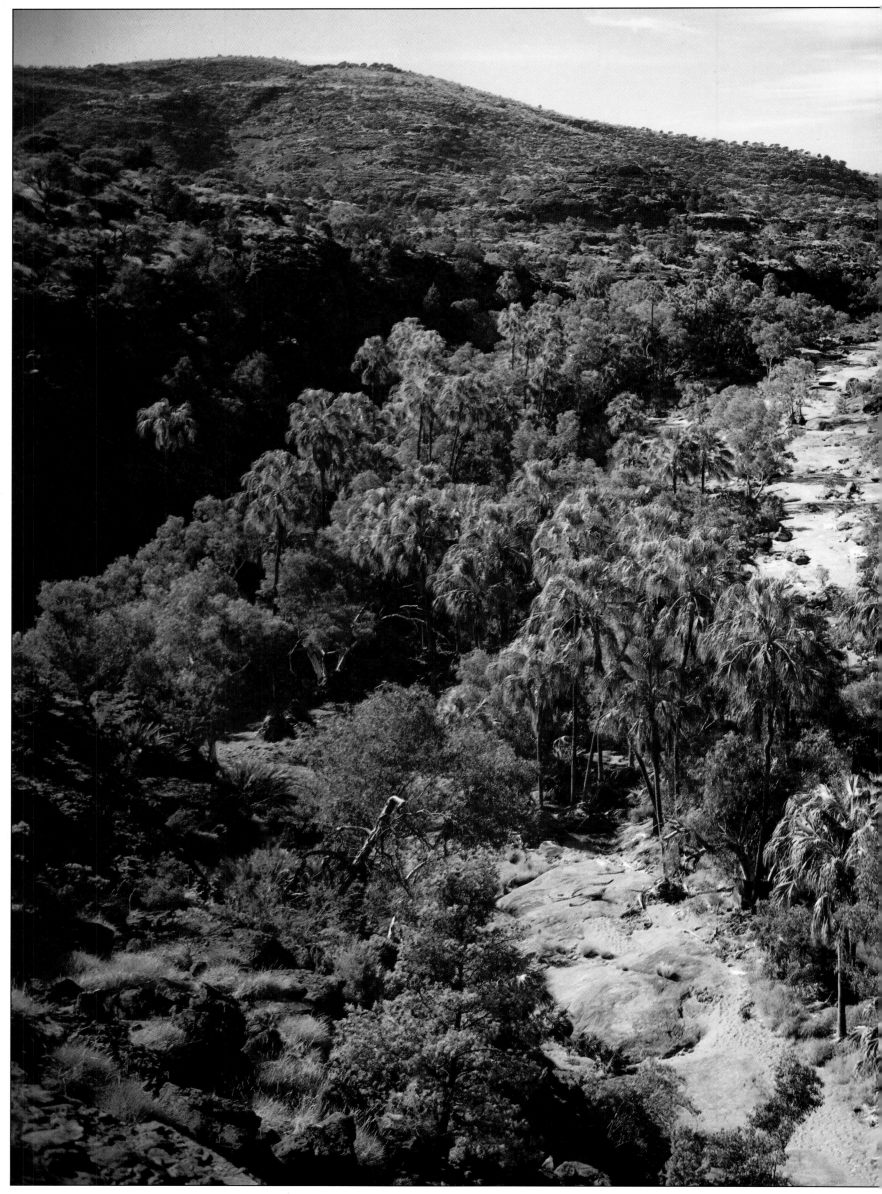

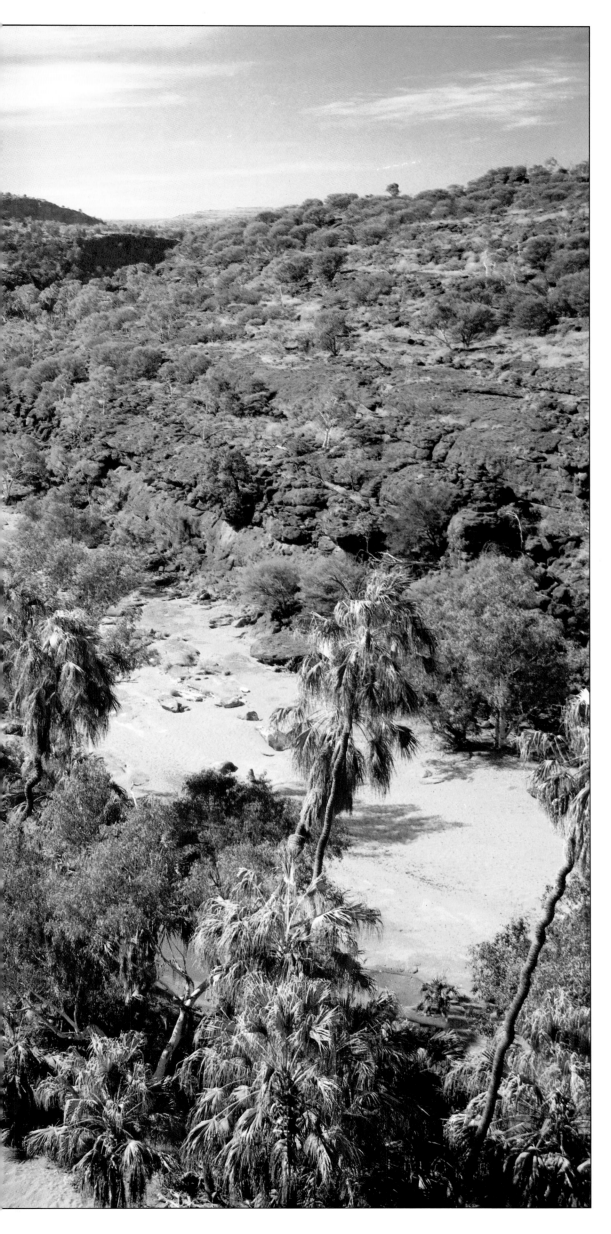

*Left: Palm Valley Flora and Fauna Reserve, which lies west of Alice Springs in the Macdonnell Ranges. The reserve takes its name from the* Livistona mariae *palms which, unique to this valley, are much in evidence in the long, twisting gorge of the Finke River that forms its centerpiece. The palms, which surround an oasis, have remained unchanged for the past 10,000 years, reflecting an era when central Australia was a tropical paradise. The valley was discovered in 1872 by the explorer Ernest Giles, who was the first white man to see the Olgas.*

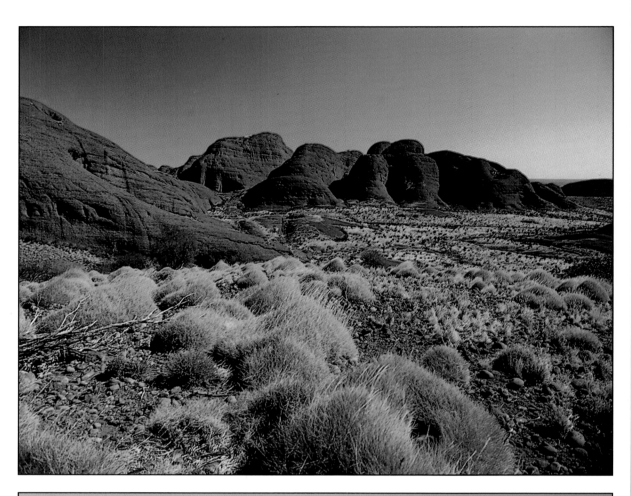

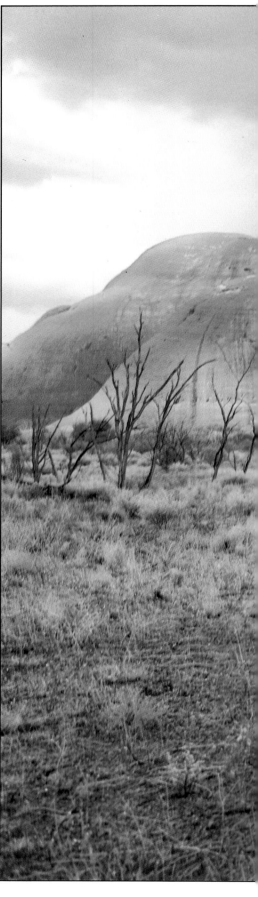

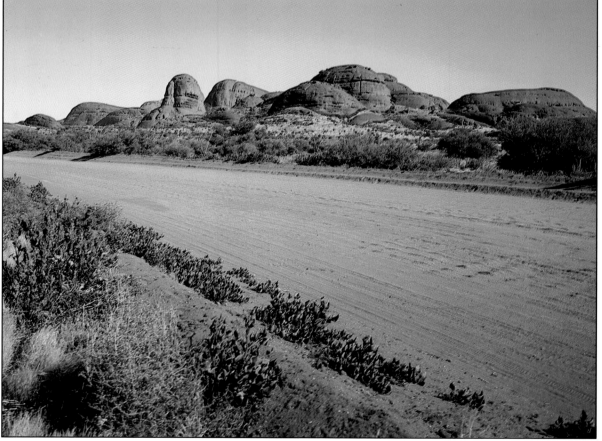

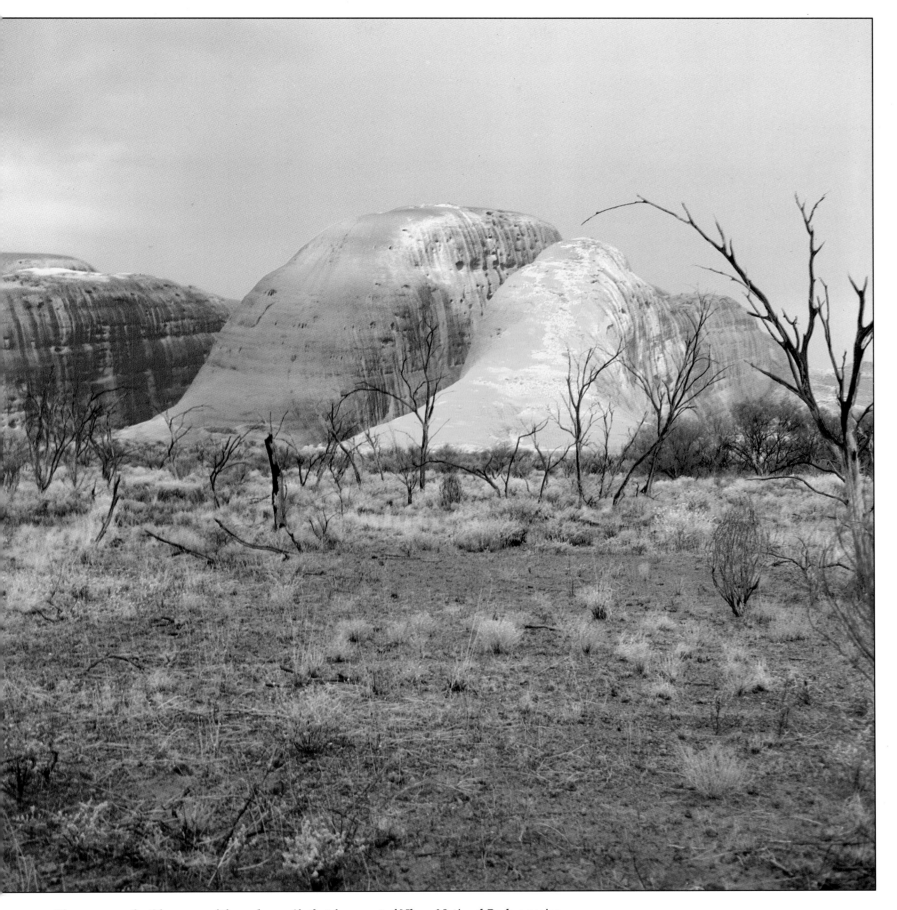

*Theses pages: the Olgas, one of the rock massifs that form part of Uluru National Park, a region now deeded to the Aborigines and leased by them back to the nation. The Olgas, whose highest peak, Mount Olga, was named for a nineteenth-century queen of Spain, are a range of mountains over four miles long and nearly 1,700 feet high that is held sacred by Aboriginal tribes of the area. They call the range Kata Tjuta, meaning "mountain of many heads," and indeed, although there are many separate domes in the range, this sandstone massif is one entity under the desert, buried up to its "neck" in soil. Out of respect for Aboriginal beliefs – they have a strong spiritual attachment to these monoliths – the Aboriginal name is often used when referring to the Olgas.*

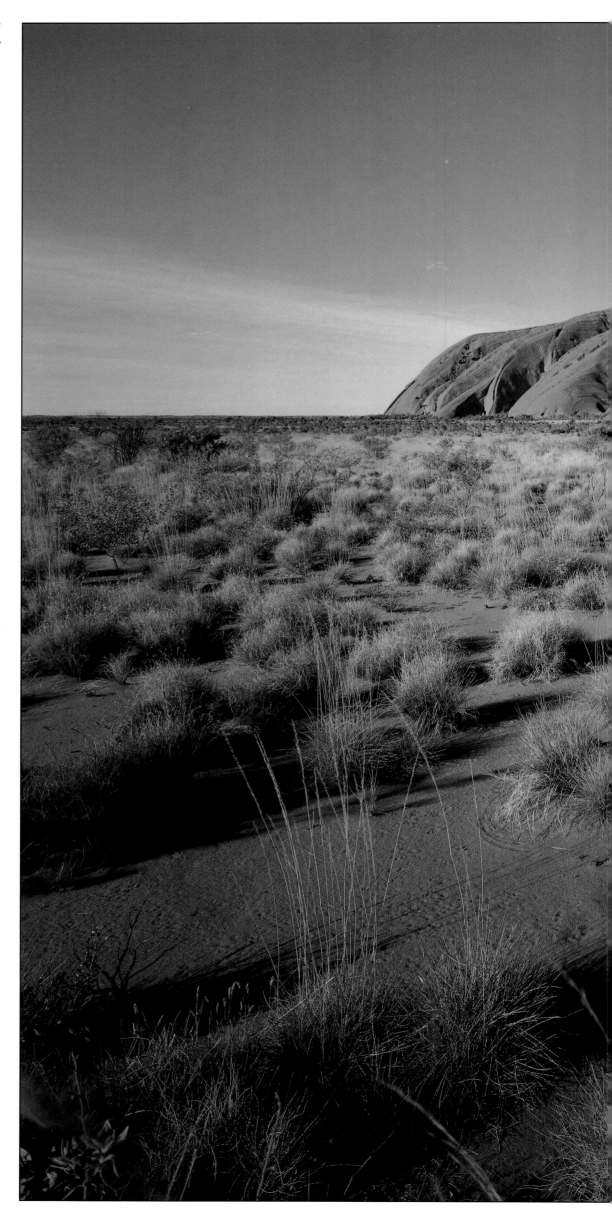

*Rising abruptly out of the featureless plain of sand and scrub that forms Uluru National Park, the brooding majesty of Ayers Rock (these pages, overleaf and following page) stands as the continent's most unforgettable natural image. The magical changes in the color of the monolith during the course of the day have attracted much attention, and certainly these variations are a photographer's delight. Yet it is when the sun has gone and the visitor considers the phenomenon without the shield of a camera that the significance of this place starts to penetrate. At night, as the great dome, blacker than the sky, looms in the darkness, no technical wizardry can hope to capture the sense of eternity to be felt at this most holy Aboriginal shrine.*

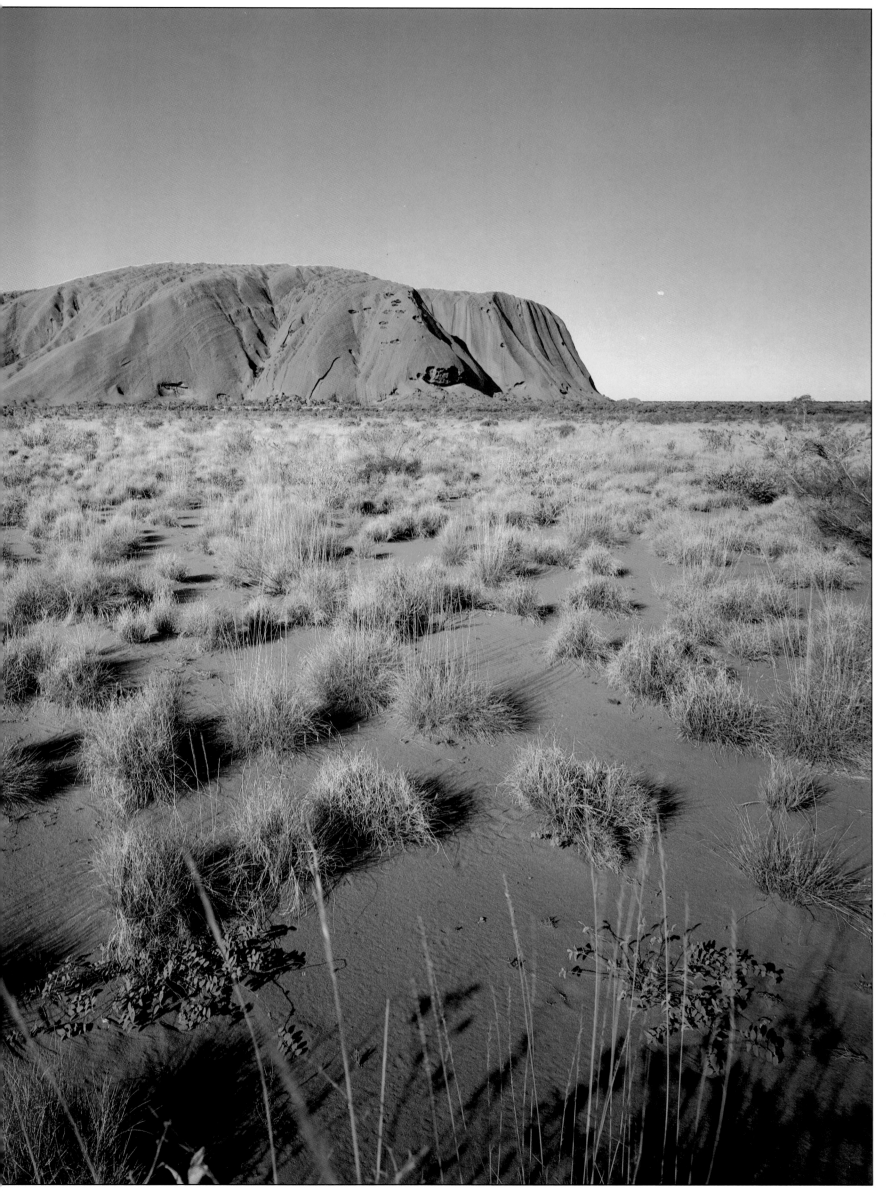

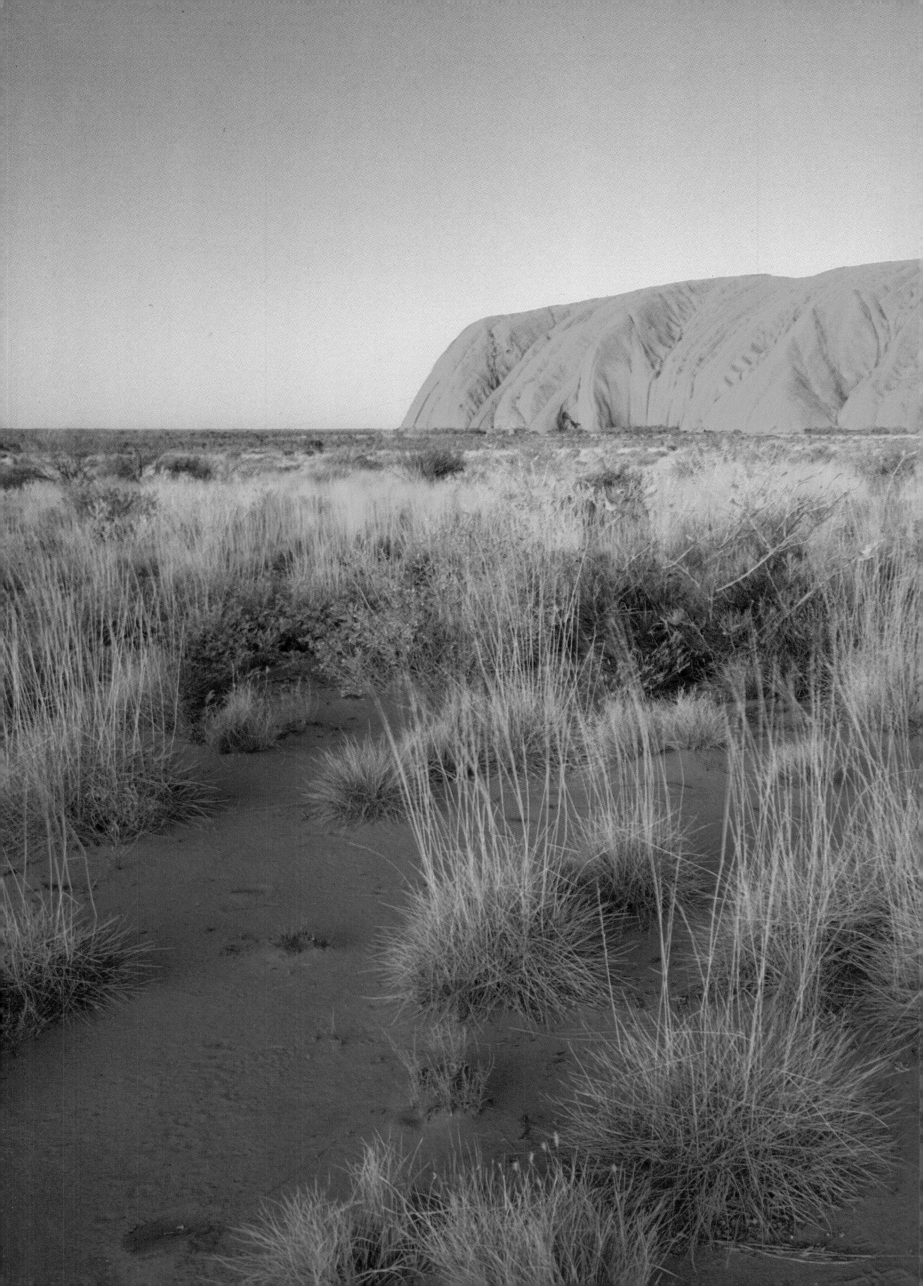

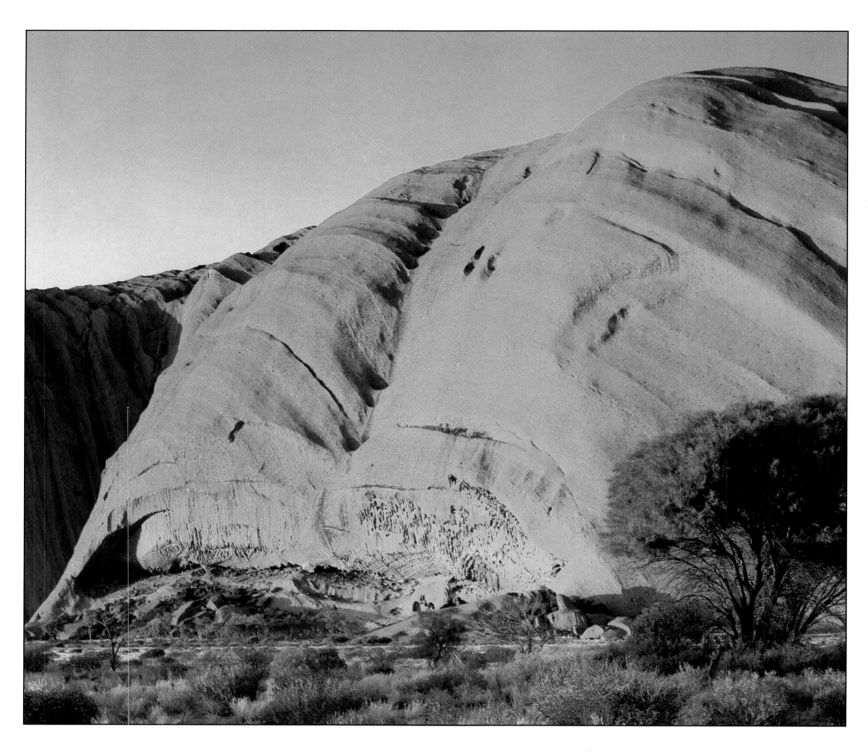

# INDEX